THE BEST OF

Wedding Photography

TECHNIQUES AND IMAGES FROM THE PROS

Bill Hurter

AMHERST MEDIA, INC. ■ BUFFALO, NY

Front cover photo by Phil Kramer.
Back cover photo by David Anthony Williams.

Published by:
Amherst Media, Inc.
P.O. Box 586
Buffalo, N.Y. 14226
Fax: 716-874-4508
www.AmherstMedia.com

Publisher: Craig Alesse
Senior Editor/Production Manager: Michelle Perkins
Assistant Editor: Barbara A. Lynch-Johnt

ISBN: 1-58428-085-9
Library of Congress Control Number: 2002103396
Printed in Korea.
10 9 8 7 6 5 4 3 2 1

Table of Contents

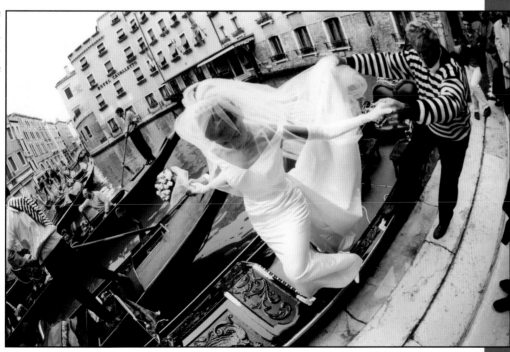

Photo by Joe Photo

Photo by David Anthony Williams

Foreword

We live in the midst of a great renaissance of wedding photography. It is a time when divergent styles collide with changing attitudes to produce the finest imagery this genre has ever known. At this crossroads, it is indeed a pleasure to be writing a book with the title *The Best of Wedding Photography*. At no other time since photographers began recording the wedding ceremony to preserve its history has the style and artistic merit of wedding photography been so remarkable.

■ THE EVOLUTION OF WEDDING PHOTOGRAPHY

In the earliest days of photography, weddings were photographed in styles that captured the bride and groom in stuffy, overly formal poses. Even with the emergence of "the wedding album," which incorporated group portraits of the groomsmen and bridesmaids, and the bride and groom with family members, posing remained stiff and lifeless—no doubt a byproduct of the required length of early exposures. As the style and variety of wedding photography progressed,

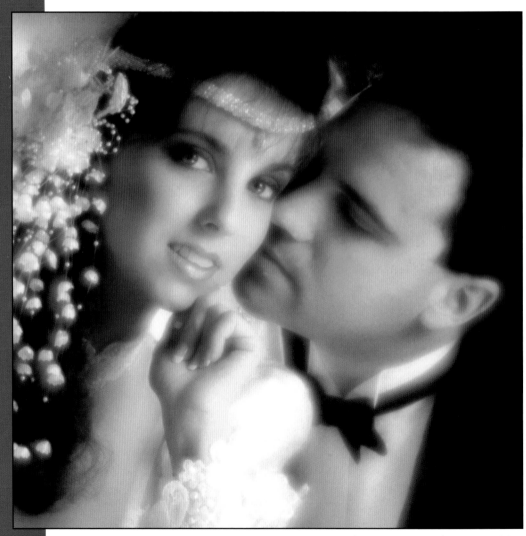

Classical posing and lighting techniques that never go out of style, courtesy of master wedding photographer Monte Zucker. This image was made over fifteen years ago using Photogenic lights and Westcott Mini-Apollos. Diffusion was accomplished using a Rodenstock Imagon lens on a Hasselblad. This is the exact diffusion technique that everyone tries to copy in Photoshop. A fill light that was two f-stops less than the main was also used.

posing techniques closely mimicked the classical arts, and there remain many flawless wedding portraits in evidence today from those early years.

It is against this backdrop that wedding photography evolved—or rather, *rebelled*. In this early style, each shot was a check mark on a long list of posed and often prearranged images. Even spontaneous events like the bouquet toss and cake cutting were orchestrated to reflect the classical posing techniques. Spontaneity and the joy of life had all but disappeared from this most joyous of ceremonies. Amidst such a controlled environment, it is not difficult to see why there was an active rebellion in the world of wedding photography.

A class of wedding photographers known as wedding photojournalists, spurred on by their leader, the articulate, provocative and talented Denis Reggie, rebelled against the formality of the art form. The photojournalists believed (and still believe) that capturing the emotion of the moment is the most important aspect of a good wedding image. The story of the true and natural unfolding of the day's events had to be the end result of such efforts. Furthermore, everything about their methods and procedures was different than those of the traditional wedding photographer. They shot unobserved with fast film using available light. They used 35mm SLRs with motor drives—and flash became a last resort for the wedding photojournalist.

As you might guess, the traditionalists recoiled in horror at this new breed of wedding photographer. They denounced the grainy and often out-of-focus "grab shots" created by the photojournalists, and they predicted that the final days of wedding photography as a profitable and predictable livelihood were at hand.

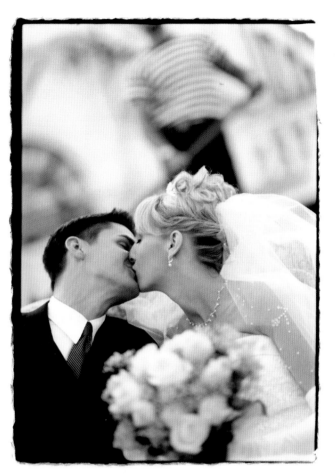

As at many other times in history, a spirited clash of ideas and artistic differences spawned a new era of enlightenment. For the first time, brides were able to make real choices about how they wanted their once-in-a-lifetime day recorded. In addition to pristine color and a wealth of storytelling black & white imagery, brides can now choose from a diverse range of styles, imagery and presentation. Add to the mix the incredible and explosive creativity introduced by the advent of digital imagery and one finds oneself in the midst of a truly great time.

Once viewed as a near-deplorable way to make a living, wedding photography now draws the best and brightest photographers into its ranks. It is an art form that is virtually exploding with creativity—and with wedding budgets that seem to know no bounds, the horizons of wedding photography seem almost limitless.

To illustrate this book, I have called upon some of the finest and most decorated wedding photographers in the world. Most of the photographers included in this book have been honored consistently by the country's top professional organizations, the Professional Photographers of America (PPA) and Wedding and Portrait Photographers International (WPPI). I want to take the opportunity to thank all of these great photographers for their participation in this book. Without them, this book would not have been possible. While no book can equal years of wedding photography experience, it is my hope that you will learn from these masters how the best wedding photography is created—with style, artistry, technical excellence and professionalism.

Michael J. Ayers (*MPA, PPA-Certified, M.Photog.,Cr., CPP, PFA, APPO, ALPE, Hon. ALPE*). The 2001–02 International Photographer of the Year (WPPI) and the 2001 United Nations' Leadership Award recipient, Michael J. Ayers is considered one of the best wedding album designers in the world. As the pioneer of exotic wedding album layouts such as pop-up, fold-out, and standup pages, he has developed an engineering discipline called album architecture—now the basis for a popular book and video! Michael was also one of the first six AN-NE Award winners (PPA) and was named WPPI's 1997 International Portrait Photographer of the Year.

Vladimir Bekker. Vladimir Bekker, the owner of Concord Photography in Toronto, Canada, specializes in weddings and environmental portraits. An immigrant from the Ukraine, Vladimir took up photography when he was a boy. He is a graduate of Lvov Polytechnical University with a master's degree in architecture, which explains why many of his wedding images include architectural details. His studio photographs over 100 weddings a year. He has won numerous international awards for his prints and albums.

David Bentley. David Bentley owns and operates Bentley Studio, Ltd. in Frontenac, Missouri. With a background in engineering, he calls upon a systematic as well as creative approach to each of his assignments. His thirty years of experience and numerous awards speak to the success of the system.

Bambi Cantrell. Bambi is a decorated photographer from the San Francisco Bay area. She is well known for her creative photojournalistic style and is the recent co-author of a best-selling book on wedding photography, entitled *The Art of Wedding Photography* (AmPhoto).

Carrillo. Carrillo is an up-and-coming wedding photographer from Beverly Hills, California. He has been a photographer for only a few years, yet has been highly decorated in print competition by the WPPI. In 2001, he scored eleven honorable mentions in one competition—the most in that organization's history. His style is photojournalistic, and his goal is to create lasting art for his clients.

Anthony Cava (*BA, MPA, APPO*). Born and raised in Ottawa, Ontario, Canada, Anthony Cava owns and operates Photolux Studio with his brother, Frank. Frank and Anthony's parents originally founded Photolux as a wedding/portrait studio, thirty years ago. Anthony joined WPPI and the Professional Photographers of Canada ten years ago. At thirty-three years old, he is the youngest "Master of Photographic Arts" (MPA) in Canada. One of his accomplishments is that he won WPPI's Grand Award for the year with the first print that he ever entered in competition.

Frank Cava. Brother of Anthony Cava and co-owner of Photolux Studio in Ottawa, Frank is a successful and award-winning wedding and portrait photographer in his own right. Frank is a member of the Professional Photographers of Canada and WPPI and in 2003, he will be speaking to professional organizations in the U.S. and Canada along with his brother Anthony.

Jerry D. Jerry D owns and operates Enchanted Memories, a successful portrait and wedding studio in Upland, California. Jerry has had several careers in his lifetime, from licensed cosmetologist to black-belt martial arts instructor. Jerry has been highly decorated by WPPI, and has achieved many national awards since joining the organization.

Ira and Sandy Ellis. This team of photographers owns and operates Ellis Portrait Design in Moorpark, California. The Ellis team, in addition to twenty or so weddings a year, produces children's fantasy portraits—a type of high-end image created around an imaginative concept. Both Ira and Sandy have been honored in national print competitions at PPA and WPPI, and had their work featured in national ad campaigns.

Don Emmerich (*M.Photog., M.Artist, M.EI, Cr., CEI, CPPS*). Don Emmerich is a virtuoso of the visual arts and one of the pioneers of applied photographic digital imaging. He belongs to a select group of professionals who have earned all four photographic degrees, and was chosen to be a member of the exclusive Camera Craftsmen of America, a society that is comprised of the top forty portrait photographers in the United States. Don has been *Professional Photographer's* technical editor for the past

twelve years, with some 150 articles published in various magazines, nationally and internationally.

Gary Fagan (*M.Photog.Cr., CPP*). Gary, along with his wife, Jan, owns and operates an in-home studio in Dubuque, IA. Gary concentrates primarily on families and high-school seniors, using his half-acre outdoor studio as the main setting. At the 2001 WPPI convention, Gary was awarded WPPI's Accolade of Lifetime Excellence. He was also awarded the International Portrait of the Year by that same organization. At the Heart of America convention, he had the Top Master Print and the Best of Show. For the highest master print in the region, Gary received the Regional Gold Medallion award at the PPA National convention ASP banquet.

Rick Ferro (*CPP*). Rick Ferro has served as senior wedding photographer at Walt Disney World. In his twenty years of photography experience, he has photographed over 10,000 weddings. He has received numerous awards, including having prints accepted into PPA's permanent Loan Collection. He has won numerous awards from WPPI and is the author of *Wedding Photography: Creative Techniques for Lighting and Posing*, published by Amherst Media.

Frank A. Frost, Jr. (*PPA-Certified, M.Photog.,Cr., APM, AOPA, AEPA, AHPA*). Located in the heart of the Southwest, Frank Frost has been creating his own classic portraiture in Albuquerque, New Mexico for over eighteen years. Believing that "success is in the details," Frank pursues both the artistry and business of photography with remarkable results, earning him numerous awards from WPPI and PPA along the way. His photographic ability stems from an instinctive flair for posing, composition and lighting.

Kelly Greer. Kelly Greer, of Lexington, Kentucky, co-owns The Gallery studio with her mother, Winnie Greer. Her younger sister, Leeann, a graduate of Brooks Institute of Photography, recently joined the staff. Kelly has won awards for album design, which she markets as European art books. She specializes in engagement portraits and weddings. Winnie, a portrait photographer, specializes in children, families and seniors.

Jeff and Kathleen Hawkins. Jeff and Kathleen Hawkins operate a fully digital high-end wedding and portrait photography studio in Orlando, Florida. Together they have authored *Professional Marketing & Selling Techniques for Wedding Photographers* and *Professional Techniques for Digital Wedding Photography*, both published by Amherst Media. Jeff Hawkins has been a professional photographer for over twenty years. Kathleen Hawkins holds a Masters degree in business administration and is a former president of the Wedding Professionals of Central Florida (WPCF), and past affiliate vice president for the National Association of Catering Executives (NACE). They can be reached via their web site: www.jeffhawkins.com.

Travis Hill. Travis Hill is the son of Barbara Fender Rice and Patrick Rice. Although only a teenager, he has won awards from both WPPI and PPA and was named the Photographer of the Year by the Society of Northern Ohio Professional Photographers.

Elaine Hughes. Along with husband Robert, Elaine Hughes is half of Robert Hughes Photography. She has only been photographing professionally for a few years but has already achieved national notoriety. In her first ever print competition, Elaine scored the third highest print case in the WPPI 2001 print competition and one of her images, *They Didn't Think*

I Would Make It, was awarded second place in the photojournalism category.

Robert H. Hughes (*M.Photog.,Cr., MEI, AHPA, ASP, PPA Certified MEI & M.Photog.*). Robert Hughes is among the most decorated photographers in the country, having attained WPPI's Accolade of Highest Photographic Achievement as well as PPA's Master of Photography and Master of Electronic Imaging degrees. In addition, he has been the Ohio Photographer of the Year and won numerous national awards from Kodak, Fuji and other prestigious organizations. He has scored perfect 100s in competition three times. He and his wife Elaine own and operate Robert Hughes Photography in Columbus, Ohio.

Phil Kramer. In 1989, after graduating from the Antonelli Institute of Art and Photography, Phil Kramer opened his own studio, Phil Kramer Photographers, specializing in fashion, commercial and wedding photography. Today, Phil's studio is one of the most successful in the Philadelphia area and has been recognized by editors as one of the top wedding studios in the country. Recently, he opened offices in Princeton, New Jersey, New York City, Washington, D.C. and West Palm Beach, Florida. An award-winning photographer, Phil's images have appeared in numerous magazines and books, both in the U.S. and abroad, and he is regularly a featured speaker on the professional photographer's lecture circuit. His photograph is featured on the cover of this book.

Frances Litman. Frances Litman, is an internationally known award-winning photographer from Victoria, British Columbia. She has been featured by Kodak Canada in national publications, and has had her images published in numerous books, magazine covers and in FujiFilm advertising campaigns. She was awarded Crafts-

man and Masters degrees from the Professional Photographers Association of Canada. She has also been awarded the prestigious Kodak Gallery Award and was named the Photographer of the Year by the Professional Photographers Association of British Columbia.

Rita Loy. Rita Loy is the co-owner of Designing Portrait Images, along with her husband, Doug, in Spartanburg, South Carolina. Rita is a seventeen-time recipient of Kodak's Gallery Award of Photographic Excellence, an eight-time winner of the Fuji Masterpiece Award and she has been voted South Carolina's Photographer of the Year a record seven times. She has won awards, both national and regional, too numerous to mention. Rita is also a member of Kodak's prestigious Pro Team.

Stephen Maclone. Stephen Maclone is one of the most sought-after photographers in Boston, Massachusetts. He is a third-generation photographer whose craft has won him a recent Grand Award at WPPI, as well as First Place honors in that same competition. Maclone believes that each couple's tale of romance is unique and that the resulting photographic narrative should include contemporary as well as photojournalistic images with just the appropriate touch of traditionalism.

Charles Maring. Charles and Jennifer Maring own and operate Maring Photography Inc. in Wallingford, Connecticut. Charles is a second-generation photographer, his parents having operated a successful studio in the New England area for many years. His parents now operate Rlab (resolutionlab.com), a digital lab which does all of the work for Maring Photography, as well as for other discriminating photographers needing high-end digital work. Charles Maring is the winner of the WPPI 2001 Album of the Year Award.

Heidi Mauracher *(M.Photog.,Cr., CPP, FBIPP, AOPA, AEPA).* Heidi Mauracher has presented programs before audiences around the world. She has taught at several affiliated schools as well as the PPA's Winona School of Professional Photography. Her articles and photographic images have been featured in a variety of professional magazines and books, and her unique style has won her many PPA Loan Collection prints and more than one photograph that has scored a perfect 100 in international competition. Her album was the album of the year at WPPI 2002.

Ferdinand Neubauer *(PPA Certified, M.Photog.,Cr., APM).* Ferdinand Neubauer, started photographing weddings and portraits over thirty years ago. He has won many awards for photography on state, regional, and international levels. He is also the author of *Adventures in Infrared: Fine Art Portraiture* (self-published). His work has appeared in numerous national publications and he has been a speaker at various photographic conventions and events.

Norman Phillips *(AOPA).* Norman Phillips has been awarded the WPPI Accolade of Outstanding Photographic Achievement (AOPA), is a registered Master Photographer with Britain's Master Photographers Association, is a Fellow of the Society of Wedding & Portrait Photographers and a Technical Fellow of Chicagoland Professional Photographers Association. He is a frequent contributor to photographic publications, a print judge and a guest speaker at seminars and workshops across the country. He is the author of *Lighting Techniques for High Key Portrait Photography*, from Amherst Media.

Joe Photo. Joe Paulcivic III is a second generation photographer who goes by the name of Joe Photo. He is an award-winning photojournalist from San Juan Capistrano, CA.

Stephen Pugh. Stephen Pugh is an award-winning wedding photographer from Great Britain. He is a competing member of both WPPI and the British Guild and has won numerous awards in international print competitions.

Barbara Rice *(PPA Certified, M.Photog.,Cr., PFA, ALPE, Hon.–ALPE).* Barbara Rice is a graduate of the Rhode Island School of Photography. Her sensitive portraits have won numerous awards in local, state, national and international competitions. She holds the Master of Photography and Photographic Craftsman degrees from the PPA, as well as the designation Certified Professional Photographer. In addition, she holds the Accolade of Lifetime Photographic Excellence and Honorary Accolade of Lifetime Photographic Excellence Degrees from WPPI. Barbara, her husband Patrick Rice and her son Travis Hill are all highly decorated, award-winning photographers.

Kimarie Richardson. Kimarie Richardson owns and operates Fantasy Stills by Kimarie in Ukiah, California. She is a professionally trained makeup artist and a self-taught photographer, who made the transition to full-time photography ten years ago. She is well known in the Northern California area, and more recently nationally, for her hand-painted "Angel Baby" portraits, children's portraits and Hollywood '40s-style glamour photographs. Two years ago she entered an international print competition for the first time and won a Grand Award for her print, *Angelica's Light*.

Brian and Judith Shindle. Brian and Judith Shindle own and operate Creative Moments in Westerville, Ohio. This studio is home to three enterprises under one umbrella: a working photography studio, an art gallery and a full-blown event-planning business. Brian's work has received numerous awards from WPPI in international competition.

Kenneth Sklute. Beginning his wedding photography career at sixteen in Long Island, New York, Kenneth quickly advanced to shooting an average of 150 weddings a year. He purchased his first studio in 1984, and soon after received his Masters degree from PPA in 1986. In 1996, he moved to Arizona, where he enjoys a thriving business. Kenneth is much decorated, having been named Long Island Wedding Photographer of the year fourteen times, PPA Photographer of the Year and APPA Wedding Photographer of the Year. In addition, he has earned numerous Fuji Masterpiece Awards and Kodak Gallery Awards.

Scott Streble. Scott Streble is a location photographer who lives with his family in Minneapolis, Minnesota. He received a degree in Professional Photography from Rochester Institute of Technology. Specializing in photographing people with a fine-art inclination, he works for a wide range of clientele including individual wedding a portrait clients, corporations, magazines and nonprofit organizations. His work is done predominately in black & white, and he is available for location assignments worldwide.

Alisha and Brook Todd. The Todds are young photographers, and their studio in Aptos, California (near San Francisco) is fast becoming known for its elite brand of wedding photojournalism. Both Alisha and Brook photograph the wedding with "one passion and two visions." The Todds are members of both PPA and WPPI and have been honored in WPPI's annual print competition.

David Anthony Williams *(M.Photog., FRPS).* David Anthony Williams owns and operates a wedding studio in Ashburton, Victoria, Australia. In 1992 he achieved the rare distinction of earning the Associateship and Fellowship of the Royal Photographic Society of Great Britain (FRPS) on the same day. Through the annual Australian Professional Photography Awards system, Williams achieved the level of Master of Photography with Gold Bar—the equivalent of a double master. In 2000, he was awarded the Accolade of Outstanding Photographic Achievement from WPPI, and was a Grand Award winner at their annual conventions in both 1997 and 2000.

Monte Zucker. When it comes to perfection in posing and lighting, timeless imagery and contemporary, yet classical photographs, Monte Zucker is world famous. He's been bestowed every major honor the photographic profession can offer, including WPPI's Lifetime Achievement Award. In 2002, Monte received the IPC's International Portrait Photographer of the Year Award, presented at the United NAtions. In his endeavor to educate photographers at the highest level, Monte, along with partner Gary Bernstein, has created the information-based web site for photographers, Zuga.net.

Introduction

The rewards of being a successful professional wedding photographer are great—not only financially, but also in terms of community status. The wedding photographer of the new millennium is not regarded as a craftsman, but as an artist.

■ DEMANDS OF WEDDING PHOTOGRAPHY
To be successful, you have to master a variety of different types of photography, perform under pressure and in a very limited time frame. No other photographic subject is more demanding. The wedding photographer is under a great deal of stress, as the couple and their families have made a considerable financial investment, and also because it is a once-in-a-lifetime (hopefully) event. Should anything go wrong photographically, the event cannot be reshot. To be a successful wedding photographer, aside from the obvious photographic skills, takes calm nerves and the ability to perform at the highest levels under stress. The couple who hired you is not looking for general competence; they are looking for excellence. This pressure is why many gifted photographers do not

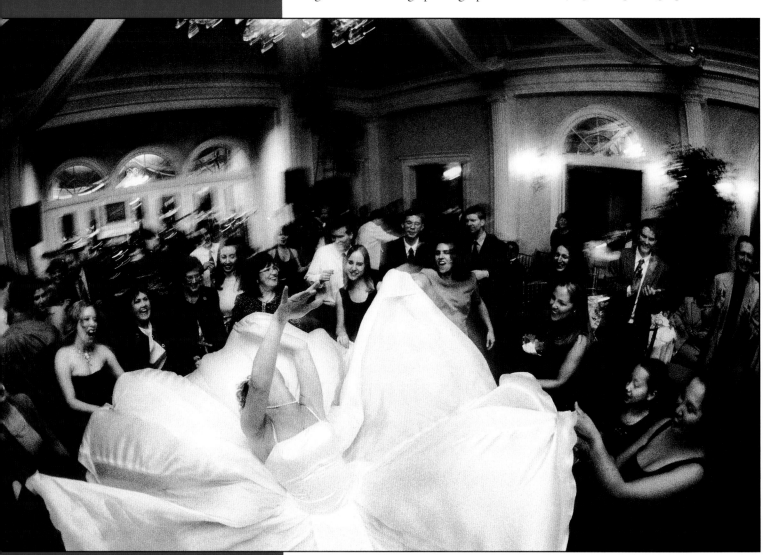

Fast, grainy film and low light levels are not necessarily the normal ingredients for making great wedding pictures. However, noteworthy wedding photographer Carrillo made this unforgettable image under these conditions. The sheer joy and excitement are evident everywhere in this image.

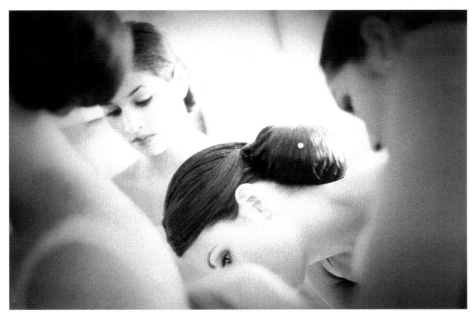

This is a moment that was visible to the photographer, Carrillo, for only an instant. A great wedding photographer is a gifted observer and one who has the timing to capture these moments before they disappear.

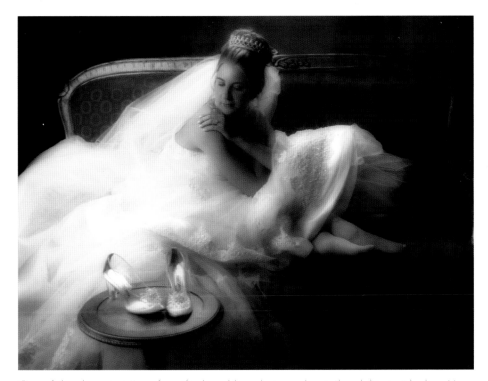

One of the characteristics of a gifted wedding photographer is the ability to idealize. Here, photographer Jerry D, with an unusual pose and elegant lighting, creates a dream world in which the bride, soft and delicate, is lost in a daydream about her shoes, which resemble glass slippers.

pursue wedding photography as their main occupation.

The wedding day is the culmination of months of detailed preparations. It is the day of dreams and, as such, the expectations of clients are high. Couples don't just want a photographic "record" of the day's events, they want inspired, imaginative images and an unforgettable presentation. To all but the jaded, the wedding day is the biggest day in peoples' lives, and the images should capture all of the romance, joy and festivity with style.

Many wedding photographers religiously scour the bridal magazines, studying the various forms of editorial and advertising photography. Editorial style has become a major influence on wedding photography. These magazines are what prospective brides look at and, as a result, they want their wedding photography to emulate what they see in the brides' magazines.

The truly gifted wedding photographer is a great observer. He or she sees the myriad of fleeting moments that all too often go unrecorded. The experienced pro knows that the wedding day is overflowing with these special moments and that capturing them is the essence of good wedding photography.

One of the traits that separates the competent wedding photographer from the great one is the ability to idealize. Using all of the tools of composition and design, as well as the entire photographic arsenal of skills, the exceptional photographer produces extraordinary images in which the people look great. The photographer must be skilled at hiding pounds and knowing a sleepy eye and recognizing a person's "best side." This recognition must be instantaneous and the photographer must also have the skills to make these adjustments in the pictures. In short, wedding photographers need to be magicians. Through careful posing and lighting, many of these "imperfections" can be rendered unnoticeable.

The wedding photographer must idealize in other ways, as well. It is important that the bride be made to look as beautiful as possible. Most

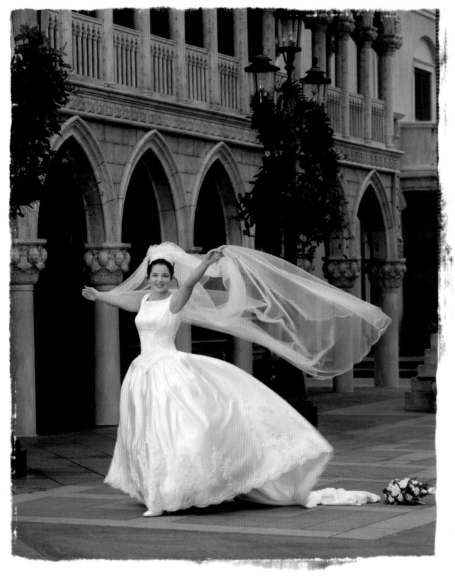

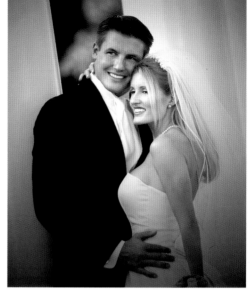

Left: On the bride's wedding day she will look more beautiful than any other day in her life. Here, award-winning wedding photographer Rick Ferro has created a beautiful portrait of a beautiful bride in a beautiful location. The veil, suspended by the wind, enhances the illusion of perfection. Rick used light flash fill to open up the shadows and to get the beadwork on the dress to sparkle. **Above:** Jeff Hawkins, who captures all of his weddings digitally, made this gorgeous portrait. A very slight vignette (or digital burn-in) is applied to all four corners of the image so that the faces are most prominent. With a slight slant to the image and an elegant pose, Hawkins has produced a memorable wedding portrait.

women will spend more time and money on their appearance for their wedding day than for any other day in their lives. The photographs should chronicle just how beautiful the bride really looked. The truly talented wedding photographer will also idealize the events of the day, looking for every opportunity to infuse emotion and love into the wedding pictures.

■ GREATNESS

In preparing the text for this book, I searched for the right words to define what makes *great* wedding photography and, consequently, *great* wedding photographers. Consistency is surely one ingredient of greatness. Those

photographers who produce splendid albums each time out are well on their way to greatness. Great wedding photographers also seem to have great people skills. Through my association with Wedding and Portrait Photographers International (WPPI) and *Rangefinder* magazine, I talk to hundreds of wedding photographers each year. A common thread among the really good ones is an affability and a likeability. They are fully at ease with other people and more than that, they have a sense of personal confidence that seems to inspire trust.

Seeing. David Anthony Williams, the inspired Australian wedding and portrait photographer, believes that

the key ingredient to great wedding photos is something he once read that was attributed to the great Magnum photographer, Elliot Erwitt: "Good photography is not about zone printing or any other Ansel Adams nonsense. It's about seeing. You either see or you don't see. The rest is academic. Photography is simply a function of noticing things. Nothing more." Williams, who is quite articulate on the subject, goes on to say, "Good wedding photography is not about complicated posing, painted backdrops, sumptuous backgrounds or five lights used brilliantly. It is about expression, interaction and life! The rest is important, but secondary."

Immersion. In talking to Williams and a great many other successful wedding photographers, what seems to make them good (and an experience they all talk about) is total immersion. They involve themselves in the event and with the people. As Williams says, "I just love it when people think I'm a friend of the couple they just haven't met yet, who happens to do photography."

With the best wedding photographers, technical skills are practiced and second nature. Another friend, Ken Sklute cut his teeth doing 150 to 200 weddings per year for over a decade. To say he has his technique down is an understatement, yet his images are always refreshing and beautiful. He is also a devotee of the concept of immersion. Ken believes that the emotion within the moment is the heart of every great picture. And it's no surprise that he is phenomenal with people—getting them to both relax and be themselves and yet be more beautiful or handsome than they've ever been before.

Interaction. Both Williams and Sklute can make anyone look good, but their real gift is that ability to create the animated, filled-with-life portrait. It is the best of both worlds—the real and the idealized. Certainly part of the success is posing, but the less tangible ingredient is the interaction—the bringing out of the person who's alive and well in there. It's interaction and communication, but also a little magic.

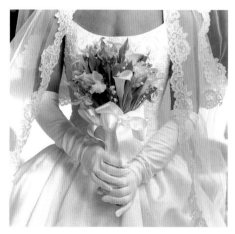

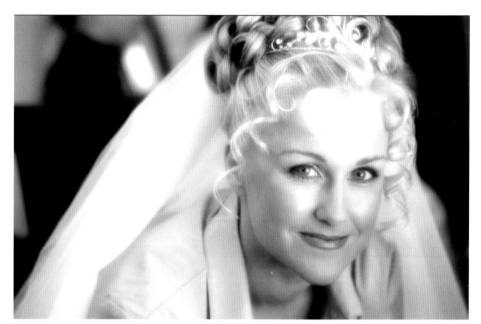

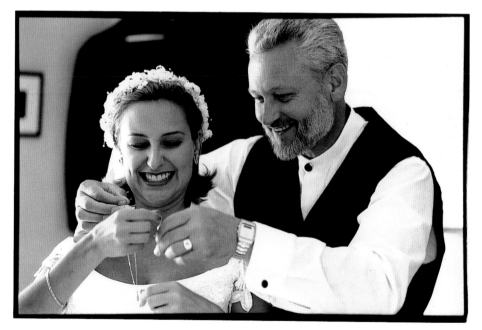

Above: Combining the beauty of the bouquet and the elegant detail of the wedding dress, talented wedding photographer Phil Kramer has produced a memorable still life, choosing to delete the bride's face in favor of the details. Note the incredible control of the lighting in this image, capturing detail in every nuance of white in the image. **Top Right:** David Anthony Williams is one of the finest wedding photographers I've ever met. This portrait of the bride seems to glow from within—the bride radiates a beauty that is uncommon. Part of the illusion results from the flawless lighting. Highlights in her hair and on her cheeks seem to glow, and the soft diffusion gives the portrait an angelic quality. **Bottom Right:** Noted photojournalist Scott Streble captured this loving moment before the wedding. A wedding picture that is animated and filled with life is a gift that is priceless.

Wedding Photojournalism vs. Traditional Wedding Photography

■ WHY IS WEDDING PHOTOJOURNALISM SO POPULAR?

One of the reasons wedding photojournalism has taken off in popularity is that it emulates the style of editorial photography that is seen in the brides' magazines, like *Martha Stewart Bride* and *Town & Country*. Before brides even interview photographers, they have become familiar with this type of storytelling imagery.

Traditional Images Can Lack Variety. Another big reason for the backlash against traditional wedding photography is the "sameness" of it. When scripted coverage is employed, similar shots will show up in albums done by different traditional photographers. Another reason for the similarity is the types and numbers of formal groups. Even with elegant posing and lighting, shots can look similar if they are arranged similarly—bride and groom in the middle, bridesmaids and groomsmen staggered boy-girl on either side. In contrast, when a photojournalist makes groups, he or she might make them from the top of a stairwell or put them all in profile marching down a beach, or do something otherwise unpredictable and different. Today's bride doesn't want the "cookie-cutter" approach to wedding photographs. She wants unique, heartfelt images that tell the story of this important day.

Traditional Images Are More Time-Consuming. Another potential drawback of the traditional type of wedding coverage is that all those carefully posed pictures take lots of time. In fact, the bigger the wedding, the bigger the bridal party and the bigger the list of "required" shots to make. As a result, the bride and groom can be missing for a good part of the

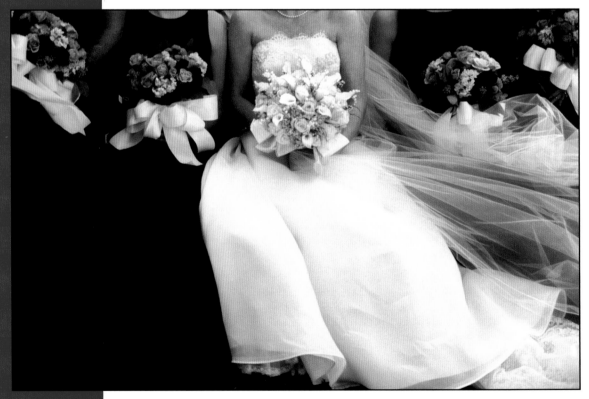

Alisha and Brook Todd are up-and-coming photojournalists who incorporate a strong sense of design into their images. Here, the gently curved line formed by the bouquets and the tight cropping combine with the sweep of the veil and wedding dress to produce a charming still life that captures the elegance of the day.

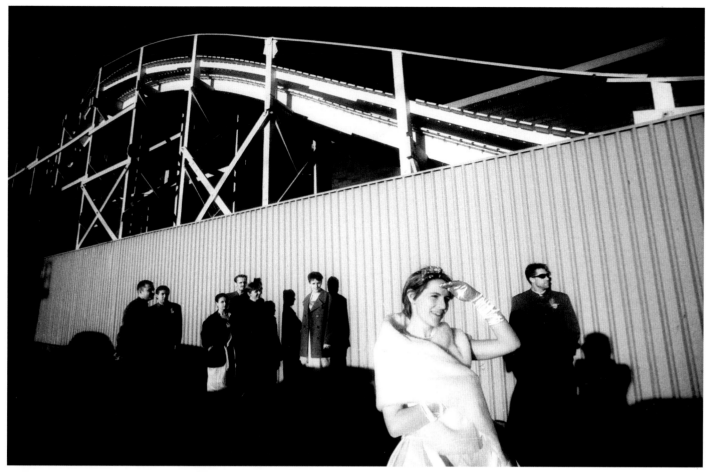

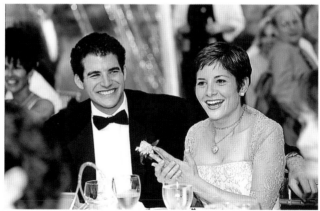

Above: Modern brides don't want the cookie-cutter approach to group wedding photos. Here, David Anthony Williams has carefully crafted a beautiful group photo of the wedding party using infrared film. The groomsmen and bridesmaids seem randomly arranged, but they are positioned to support the gentle curve of the roller coaster above and contrast the line of the fence. When the inferred lines are combined you find a dynamic "Z" shape to the composition. **Left:** A good observer, like Phil Kramer, won't miss genuine opportunities for great pictures. Here the bridal couple is thoroughly amused by something that was said. Working unobserved with the 35mm format and moderate telephotos gives the photographer an ability to capture these moments unhindered by recognition.

wedding day while they are working with the photographer. The less formal approach leaves couples free to enjoy more of their wedding day.

In this aspect, the photojournalistic system has mutual benefits. While the bride has more time to enjoy her day, the photographer also has more time to observe the subtleties of the wedding day and do his or her best work. I have heard many photographers say that brides and family have

told them, "We don't even want to know you're there," which is just fine for most wedding photojournalists.

■ TRADITIONALISTS FIGHT BACK
Those photographers who still provide traditional coverage argue that the wedding photojournalist's coverage produces below-average photographs. In truth, the photojournalists (who do not disrupt the flow of the day to "make" pictures and don't isolate the

bride and groom) can't possibly be as in tune with posing and lighting principles as the masters of the traditional style. They don't claim to be. Nor do they stop the action to dictate posing, which, in their view, ruins the flow of things. But in the traditionalists' defense, one must acknowledge that the most elegant features of traditional portraiture are being thrown out in this "creative new" approach. It's very true—you can look at a masterful

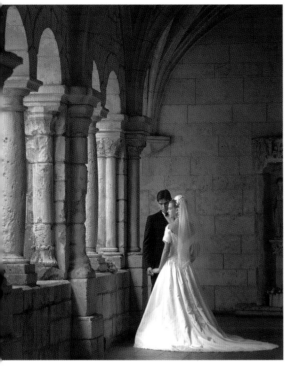

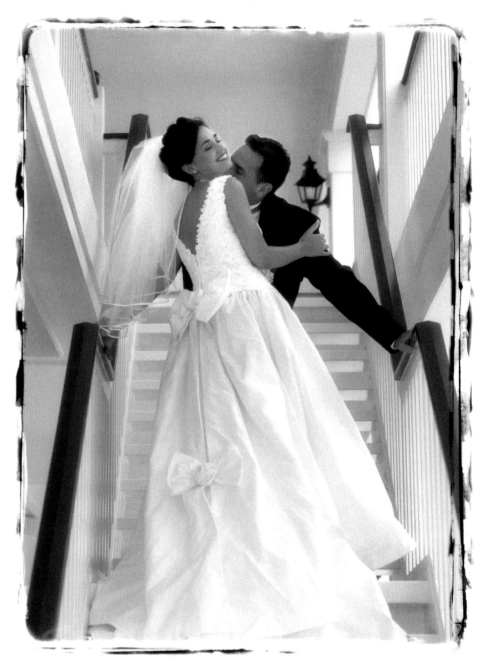

Top Left: The timeless elegance of classical posing will always have a prominent place in wedding photography. Here, master photographer Rick Ferro has created a beautiful and stately image that harnesses the curves and square lines of the architecture and the soft daylight that filters through the arches. **Bottom Left:** Elaine Hughes award-winning image, *And They Thought I Wouldn't Make It*, is a timeless photograph that captures the sweet sadness of the moment. **Right:** A new style of wedding photography seems to be emerging and it is one that incorporates the editorial look of the wedding magazines and the spontaneity of wedding photojournalism with a dash of formality. Award-winning wedding photographer Brian Shindle made this image.

bridal portrait taken by a journalist and the trained eye will observe hands posed poorly or not at all, head and shoulder axis confused, unflattering overhead lighting, and so on. Is the portrait spontaneous and the expression full of life? Perhaps, but there are traditions that also need preserving. These are the fundamentals of posing, composition and lighting that are literally timeless, dating back to Greek civilization.

■ EMERGING STYLES

You should not get the impression that roving groups of wedding photographers are warring with one another, but there are definitely two camps and two determined schools of thought. At this writing, things seem to be settling down and hostilities fading somewhat, in favor of a more evolved approach. The near elimination of formal group portraiture in photojournalistic wedding coverage is swinging back the other way. All types of wedding photographers are making

more group portraits. The main reason for this is that groups sell, and sales mean increased profits. Also, failing to offer such coverage limits the photographer in his or her professional approach. As a result, photographers are offering brides more options, including posed formals. And, because the choice is theirs, brides seem to be ordering them.

The nature of formal photos is changing, as well, adapting more informal posing and lighting techniques in an effort to preserve the same carefree, relaxed attitude found in the rest of the album. You will also see group portraits made with much more style and elegance than the traditional, straight on-camera flash you saw in wedding groups only twenty years ago. Again, brides are demanding ever more sophistication in their photographs.

Yes, the classic poses are fading in consideration of a more natural style. However, greater attention to posing fundamentals seems to be evident, as well. After all, these techniques represent time-honored ways of gracefully rendering the human form and revealing character.

Top: The nature of wedding groups is also changing. Informal groups with a premium on emotion are more in favor than the elegantly posed group shots of yesteryear. This image, made by nationally known photographer Ken Sklute, uses diffusion, very slight flash-fill and beautiful, out-of-focus highlights in the background to paint a group of affable brothers. Bottom: This is another interesting wedding group. Ken Sklute used diffused flash (positioned at about eleven o'clock) to softly light each beautiful face. While it may not be the most comfortable pose for the subjects, a good-natured photographer like Ken can pull it off. The effect is like a bouquet of bridesmaids. The secret to photographing groups is that each person has to look great!

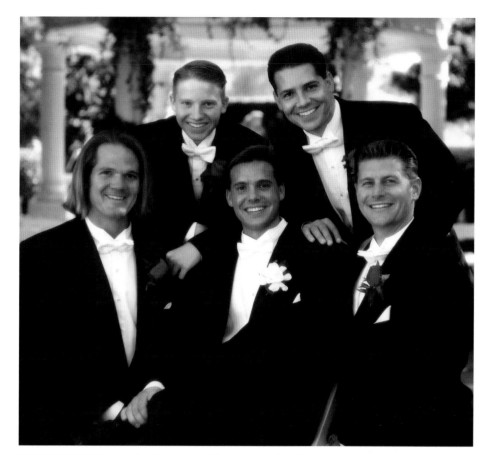

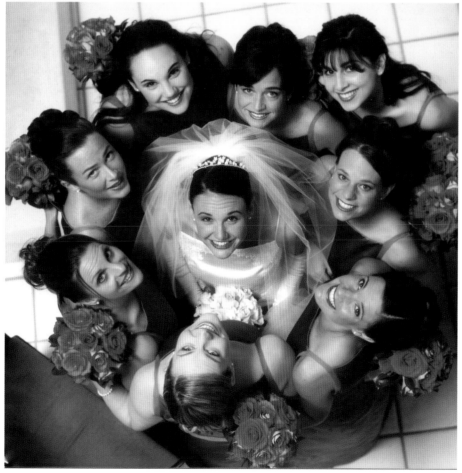

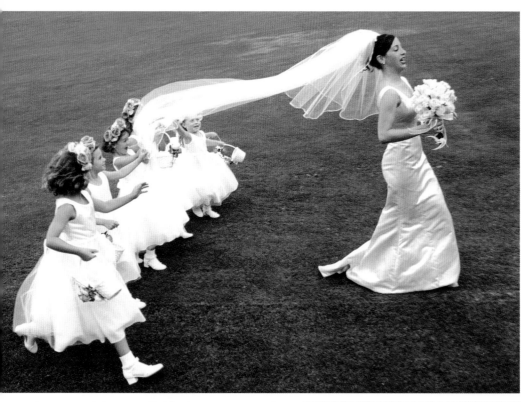

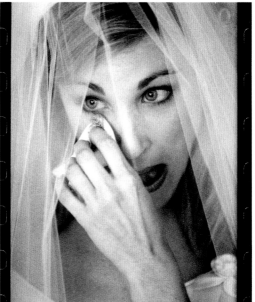

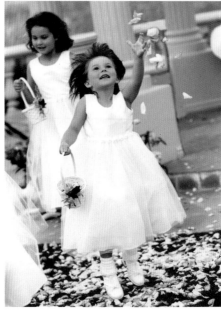

In the words of Monte Zucker, well known around the world for his traditional wedding portraits, "Photographers are well aware of this [divergence] . . . so they've combined a little of both. My particular style of wedding photography still comes from the fact that I'm more interested in faces and feelings than I am in backgrounds and trends." This combined approach opens up the best of both worlds for the bride and groom. Wedding photography is expanding its horizons. The quality and character of wedding coverage is better today than at any time in the past.

With an adherence to formal posing principles comes a type of classic elegance that is timeless. With the finely tuned skills of anticipation and observation, the photojournalistic coverage unearths more of the wedding day's wonderful moments, to be remembered for all time.

■ CAPTURING THE EMOTION
Photojournalism is all about capturing the emotion of a moment, which is extremely difficult. There is very little for margin for error. The shutter has to be released at the peak of the moment, much like a sports photographer shooting athletes at the peak of action.

The most obvious ability a photographer must possess is the ability to anticipate. Anticipation is a function of how adept the photographer is at observation. A photographer skilled at wedding photojournalism techniques is always watching and monitoring the events, and usually more than one event at a time. The camera, usually a motor-driven 35mm autofocus SLR, is always at the ready, set in an autoexposure mode so there is no guesswork or exposure settings to be made. Simply raise the camera, compose and shoot.

*Top: Joe Photo watched this scene developing and knew trouble was brewing as the flower girls kept reaching for the veil blowing in the wind. He realized that if he stayed with it, he'd get a great image, which happened when the bride's veil began to lift off her head. Notice the expression of the little girl in the middle. **Above Left:** Ken Sklute is a master at exposing those fleeting emotions at a wedding. Working quickly and from a distance away via telephoto lenses, he can isolate a moment like this without the bride ever knowing he made the image. **Above Right:** The best wedding photojournalists are nearly invisible, working unobserved and from a distance away so as not to inhibit people who may feel they have to act a certain way in front of the camera. Here Joe Photo has captured a precious moment, which he has entitled, Pure Joy. It took great timing to catch this flower girl off the ground.*

Each phase of the wedding day—the arrival at the ceremony, the ceremony itself, the receiving line, the cake cutting, etc.—presents its own set of opportunities. The reception is where most of these animated pictures will be made. People, usually after they've had a drink, begin to relax and with quiet observation, many wonderful moments and situations start to be revealed.

The experienced wedding photojournalist not only observes the scene, but is also receptive to feeling the emotion surrounding the event. It is a heightened state of excitement and the photographer attuned to it will have superb insights into the unfolding of the wedding story.

The best photojournalists are nearly invisible. They work unobserved, blending into the background as much as possible. When people are not aware they are being photographed they are most likely to act themselves. Moving quietly through the event, the photographer is alert and ready, but always listening and watching, sensitive to what is happening in one minute and always ready to react to the unexpected.

■ THE INNER EFFORT

One of the reasons for the photojournalist's perceived detachment is the concentration it takes to anticipate and observe the key action and the key elements of the story within all of the mayhem that is the wedding and reception. Like a good sports photographer, who may work quietly on the sideline for hours without speaking, wedding photojournalists must concentrate to see multiple picture opportunities emerging simultaneously, a task that is rigorous and demanding. As in sports photography, split-second timing and anticipation are absolute

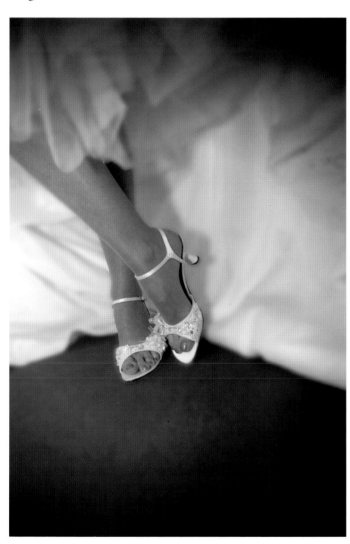
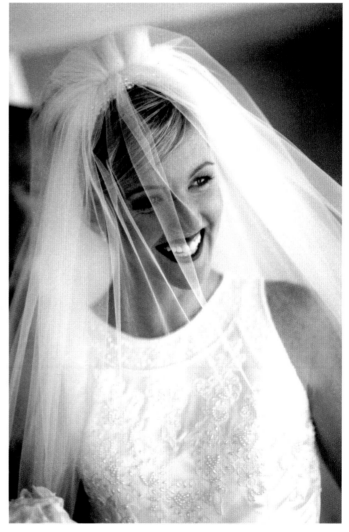

Left: A detail that would go unnoticed by most photographers but an image that the bride undoubtedly loved was a portrait of the bride's shoes that was made by Jeff Hawkins. Jeff softened the background considerably so that her feet seem to float off the ground and the folds of the wedding dress form a soft and fitting backdrop. Right: Joe Photo entitled this image, *Returning Daddy's Smile*. The diagonal tilt of the image heightens the feeling that the bride is looking at someone across the room. Her smile is pure happiness.

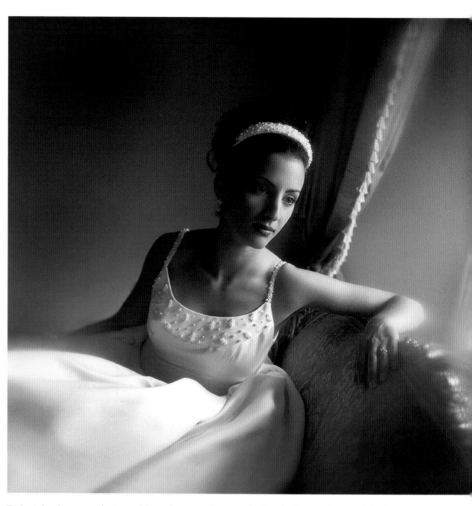

prerequisites, allowing the photojournalist to reveal the many subtleties and nuances of the story. Photojournalists talk about preparedness and technique being second nature—but there also has to be a basic instinct and an ability to sense the emotion around you. Another reason photojournalists seem detached is that it is human nature to fall prey to the emotion and literally join in the festivities. It's fun, why not? The photographer who indulges this impulse will most certainly lose his or her edge. There is a reason for the cordial aloofness of the wedding photojournalist—it is functional.

■ A SENSE OF STYLE

The most appreciated aspect of today's wedding photography, regardless of traditional or journalistic form, is a unique sense of style. Brides want distinctive images and they can only

Left: Today's brides want their wedding photos to have style. Bambi Cantrell, one of the best-known wedding photographers in the country, always tries to imbue her wedding images with style. Here, the line of the wedding dress and the layers of the veil form the "subject" of this picture. The use of grain and subtle highlights make this more a work of art than a "captured" image. **Right:** Anthony Cava is a master of the wedding portrait. In this window light portrait, entitled *Francesca*, he used a diffusion vignette to create a dreamlike atmospheric halo around the bride, and at the same time softened hard edges that would have distracted from the muted softness of the portrait. The image is also strong design-wise, incorporating strong diagonals that crisscross and lead your eye back to the beautiful bride's face.

come from a photographer exercising his or her individuality in the making and presentation of the photographs. Whether the coverage is primarily black & white or color, 35mm or medium format, classic or totally untraditional, the wedding pictures must be unique. The style may be natural or chic, high energy or laid-back, but uniqueness is the real product people are buying and it is the single defining standard for the photographs found in this book.

Equipment

Whether a traditionalist or a photojournalist, the equipment list for wedding coverage is exhaustive, including backup equipment and emergency supplies. Since so many different types of photography are required at a wedding, it's almost like outfitting oneself for safari.

■ MEDIUM FORMAT CAMERAS

The formals are usually made on a medium format camera, often a Hasselblad. The square format means never having to rotate the camera (and flash) for a vertical frame and unparalleled cropping flexibility. Short telephoto lenses and wide-angle lenses are both needed for portraits and groups, respectively. Photographers will generally bring whatever lenses they own, because the minute they don't bring any given lens, they'll need it at the wedding.

There is a wide assortment of lenses and accessories available for medium formats. Soft-focus lenses, diffusion and warming filters, a myriad of different focal lengths to choose from and a wide variety of special effects accessories—matte boxes, vignetters, and bellows lens-shades—are available, making this an ideal format for formals and romantic portraits.

■ PRO LENS SHADE OR MATTE BOX

Essential to any medium format wedding camera is a professional-type bellows lens shade, into which can be slipped all manner of corrective or special effects gels, filters and masks. The range of items that can be accommodated with a matte box is staggering—

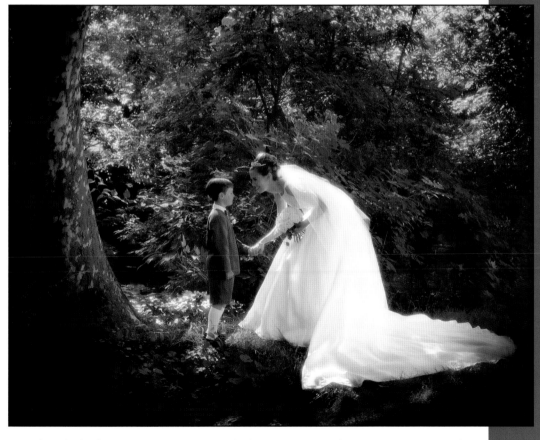

A pro lens shade allows one to use vignettes and other accessories at the same time. Here, award-winning wedding specialist Ferdinand Neubauer used a dark vignette to darken the very outer edges of three sides of the frame and a diffuser to soften the backlight. He also used a minimal amount of flash fill to open up the shadows.

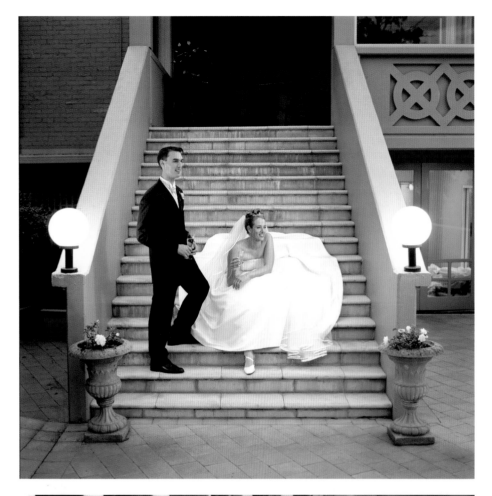

vignetters (high and low key) diffusers (homemade or commercially available ones), color-correction or color-compensating gels, acetate filters of all types, and the proverbial double-exposure masks (once a wedding staple, now a thing of the past).

■ FLASHMETER

A handheld incident flashmeter is essential for work indoors and out, but particularly crucial when mixing flash and daylight. It is also useful for determining lighting ratios. Flashmeters will prove invaluable when using multiple strobes and when trying to determine the overall evenness of lighting in a large room. Flashmeters are also ambient light meters of the incident type, meaning that they measure the light falling on them and not light reflected from a source or object.

■ REMOTE TRIGGERING DEVICE

If using multiple flash units (to light the dance floor, for instance), some type of remote triggering device will be needed to sync all the flashes at the instant of exposure. There are a variety of these devices available. Light-actuated slaves are sensitive to the light of a flash unit being fired and fire the flash they are attached to at the same instant they sense a flash going off.

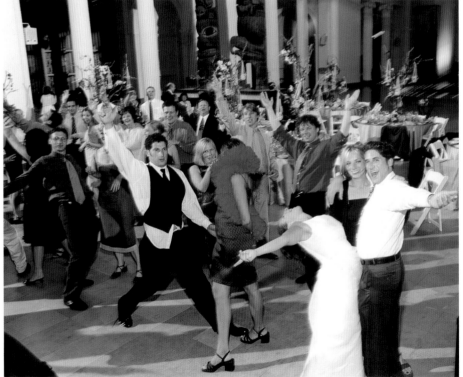

Top: David Anthony Williams created this casual wedding portrait using available light and the light from the street lamps. The tungsten lamps create warm highlights, especially on the groom. He balanced the exposure for both light sources so that even the room light from within the house looks normal. Good metering makes for precise exposures. Bottom: Highly decorated photographer Norman Phillips created this wild photo with strategically placed strobes that lit up the dance floor and most of the reception area. He used a slow shutter speed when photographing the dancers to give them a little movement.

Unfortunately, this can be your flash or someone else's—a real drawback to this type of remote flash trigger. Infrared remote flash triggers are a more reliable triggering device, and since many monolight-type flash units come equipped with an infrared sensor built in, it is a simple matter of syncing the flashes with the appropriate transmitter. A third type, the radio remote triggering device, uses a radio signal that is transmitted when you press the shutter release and then picked up by individual receivers mounted to each flash. These are reliable, but often require a plethora of cords. They are also not foolproof—a cordless microphone may trigger them accidentally. Radio remotes transmit signals in either digital or analog form. Digital systems, like the Pocket Wizard, are much more reliable and are not affected by local radio signals. Some photographers will use, as part of the standard equipment, a separate transmitter for as many cameras as are being used (for instance, an assistant's camera), as well as a separate transmitter for the handheld flashmeter, allowing the photographer to take remote flash readings from anywhere in the room.

■ FLASH

On-Camera Flash. On-camera flash is used sparingly at weddings because of the flat, harsh light it produces. As an alternative, many photographers use on-camera flash brackets, which position the flash over and away from the lens, thus minimizing flash red-eye and dropping the harsh shadows behind the subjects—a slightly more flattering light. On-camera flash is often used outdoors, especially with TTL-balanced flash exposure systems. With such systems, you can adjust the flash output for various fill-in ratios, thus producing consistent exposures. In these situations, the on-camera flash is most frequently used to fill in the shadows caused by the daylight, or to match the ambient light output, providing direction to the light.

Bounce-Flash Devices. Many photographers use their on-camera flash in bounce flash mode. A problem, however, with bounce flash is that it produces an overhead soft light. With high ceilings, the problem is even worse—the light is almost directly overhead. A number of devices on the market, like the Lumiquest ProMax system, offer a way to direct some of that bounce light directly toward the subject. They offer accessories that mount to the flash housing and transmit 10–20 percent of the light forward onto the subject, with the remainder of the light being aimed at the ceiling. This same company also offers devices like the Pocket Bouncer, which redirects light at a 90-degree angle from the flash to soften the quality of light and distribute it over a wider area. No exposure compensation is necessary with automatic and TTL flash exposure systems, although operating distances will be somewhat reduced.

Barebulb Flash. Perhaps the most frequently used handheld flash at weddings is the barebulb flash, such as the 50 watt-second Dynalite unit. These units are powerful and use, instead of a reflector, an upright mounted flash tube sealed in a plastic housing for protection. Since there is no housing or reflector, barebulb flash generates light in all directions. It acts more like a large point-source light than a small portable flash. Light falloff is less than with other handheld units, and they are ideal for flash-fill situations. These units are predominantly manual, meaning that you must adjust their intensity by changing the flash-to-subject distance or by adjusting the flash output. Many of the outdoor pictures

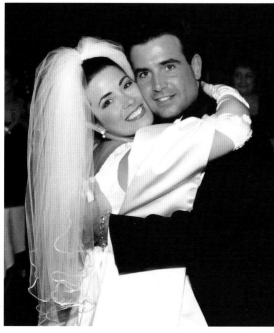

Top: With strobes positioned around the dance floor, Phil Kramer was able to photograph anything in the area, including these three little troublemakers. In such situations, you must know the difference between the exposure at floor level and at adult-head height, if there is a difference. Bottom: Sometimes on-camera flash is the only way to make an exposure. Stephen Maclone had his flash above the lens so as not to cause red-eye. Straight flash, because if falls off so quickly in intensity, creates a hopelessly dark background. Here, since the subjects are cropped tightly, the effect is minimized.

in this book were created using barebulb flash. Many photographers will mount a sequence of barebulb flash units on light stands at the reception for doing candids on the dance floor.

Studio Flash System. You may find it useful to have a number of studio flash heads with power packs and umbrellas. You can set these up for formals, or tape the light stands to the floor and use them to light the reception. Either way, you will need enough power (at least 50 watt-seconds per head) to light large areas or produce small apertures at close distances. The most popular of these type of lights is the monolight type, which has a self-contained power pack and usually has an on-board photo cell, which will trigger the unit to fire when it senses a flash burst. All you need is an electrical outlet and the flash can be positioned anywhere. Be sure to take along plenty of gaffers' tape and extension cords. Tape everything in position securely to prevent accidents.

Studio flash units can also be used with umbrellas for lighting large areas of a room. Be sure, however, to "focus" the umbrella—adjusting the cone of light that bounces into and out of the umbrella surface by moving the umbrella closer and farther away from the light source. The ideal position is when the light fills the umbrella, but does not exceed its perimeter. Focusing the umbrella also helps eliminate hot spots and maximize light output.

■ REFLECTORS
When photographing by window light or outdoors, it is a good idea to have a selection of white, silver, gold and

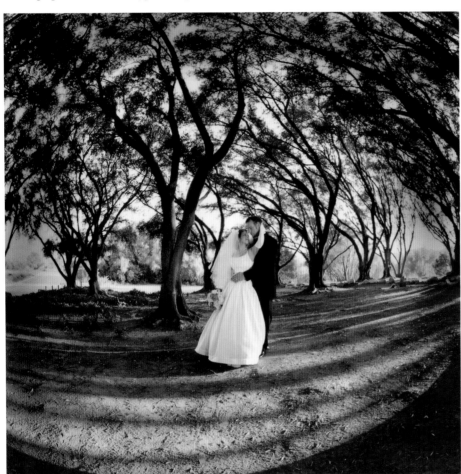

Left: When using a fisheye lens, such as is used here by photographer Jerry D, the subjects should be positioned close to the center of the frame to avoid distortion. Also, in order to use flash with such a wide lens, you need to use a barebulb flash, which has no housing and reflector, providing the widest possible flash coverage. In order to warm the light of the flash, Jerry used a warming filter over the flash tube. Below (Three Photos): Photographer Phil Kramer used umbrella-mounted strobes positioned around the dance floor to be able to photograph all of the activities there. Sequences such as this are ideal for panels in the wedding album. Notice how every image detail is sharp and clear in each frame as Phil moves around the couple to get the best angle.

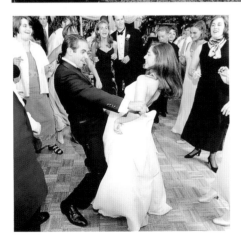
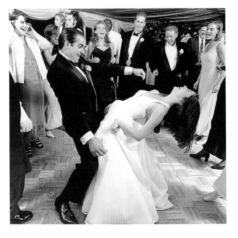
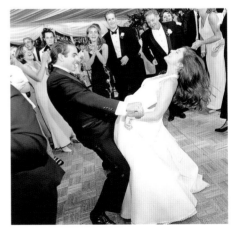

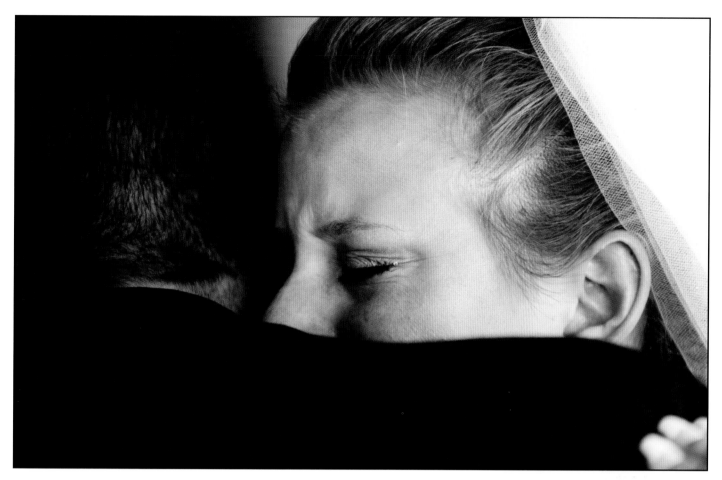

black reflectors. Most photographers opt for the circular disks, which unfold to produce a large reflector. They are particularly valuable when making portraits by available light.

■ 35MM AF SLR

The wedding photojournalist shoots with 35mm exclusively, although he or she may have medium-format cameras on hand for formals. Autofocus (AF), once unreliable and unpredictable, is now extremely advanced. Some cameras feature multiple-area autofocus so that you can, with a touch of a thumbwheel, change the AF sensing area to one of four or five areas of the viewfinder (the center and four outer quadrants). This allows you to "de-center" your images for more dynamic compositions. Once accustomed to quickly changing the AF area, this feature becomes an extension of the photographer's technique.

Autofocus and moving subjects used to be an almost insurmountable problem. While *you* could predict the rate of movement and focus accordingly, the earliest AF systems could not. Now, however, most AF systems use a form of predictive autofocus, meaning that the system senses the speed and direction of the movement

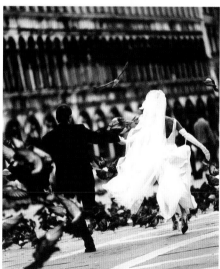

of the main subject and reacts by tracking the focus of the moving subject. This is an ideal feature for wedding photojournalism, which is anything but predictable.

■ LENSES

Another reason 35mm is the format of preference for photojournalists is the

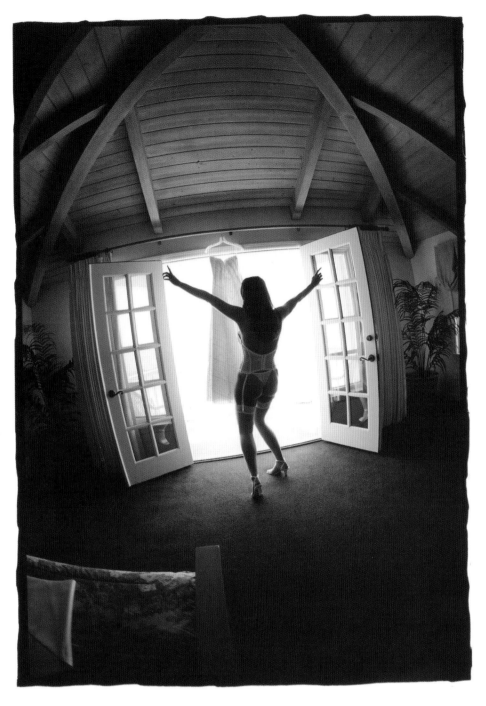

Fast lenses (f/2.8, f/2, f/1.8, f/1.4 etc.) will get lots of work on the wedding day, as they afford many more "available light" opportunities than slower speed lenses.

A lot of wedding photojournalists will take their 300mm f/2.8 or f/3.5 lenses to the wedding. These lenses are ideal for working unobserved and can isolate some wonderful moments. Even more than the 80–200mm lens, the 300mm throws the backgrounds beautifully out of focus and when used wide open, this lens provides a sumptuously thin band of focus, which is ideal for isolating image details.

Canadian photographer Vladimir Bekker uses a variety of focal lengths, including a fisheye lens and a panoramic camera. He believes that having great flexibility in viewpoint will pay big dividends when it comes time to design the album, which usually incorporates panoramas as two-page spreads, sometimes with inset photos of close-ups placed strategically.

■ FILMS

Ultrafast films in the ISO 1000–3200 range offer an ability to shoot in very low light and produce a larger than normal grain pattern and lower than normal contrast—ideal characteristics for photojournalistic coverage. Many photographers use these films in color and black & white for the bulk of their photojournalistic coverage. Usually, a slower, finer-grain film will be used for the formals and the groups. These ultrafast films used to be shunned for wedding usage because of excessive grain. But the newer films have vastly improved grain structure—and many

range of ultrafast zoom lenses available. The lens of choice seems to be the 80–200mm f/2.8 (Nikon) or the 70–200mm f/2.8 (Canon). These are very fast, lightweight lenses that offer a wide variety of useful focal lengths for both the ceremony and reception. They are internal focusing, meaning that autofocus is lightning fast and the lens does not change length as it is zoomed or focused. At the shortest range, 80mm, this lens is perfect for

full-length and ¾-length portraits. At the long end, 200mm is ideal for tightly-cropped candid coverage or head-and-shoulders portraits. Other popular lenses include the range of wide angles, both fixed focal length lenses and wide-angle zooms. Focal lengths from 17mm to 35mm are ideal for capturing the atmosphere as well as for photographing larger groups. These lenses are fast enough for use by available light with fast film.

brides and photographers have come to equate grain with mood, a positive aesthetic aspect to the pictures.

Color negative films in the ISO 100–400 range have amazing grain structure compared to films of only a few years ago. They possess mind-boggling exposure latitude, from –2 to +3 stops under or over normal exposure. Of course, optimum exposure is still (and will always be) recommended, but to say that these films are forgiving is an understatement.

Kodak and Fujifilm offer "families" of color negative films. Within these families are different speeds and either varying contrast or varying color saturation—but with the same color palette. Kodak's Portra films include speeds from ISO 160 to 800

Carrillo likes to work by available light. Here, very fast film and very low light combine to produce a very grainy image. However, the beauty of the image lies in its intimacy. In the background the big girls are getting ready. The little girls are no less intense in their preparations for the big day. There is absolutely no knowledge by the subjects that Carrillo is making a photo.

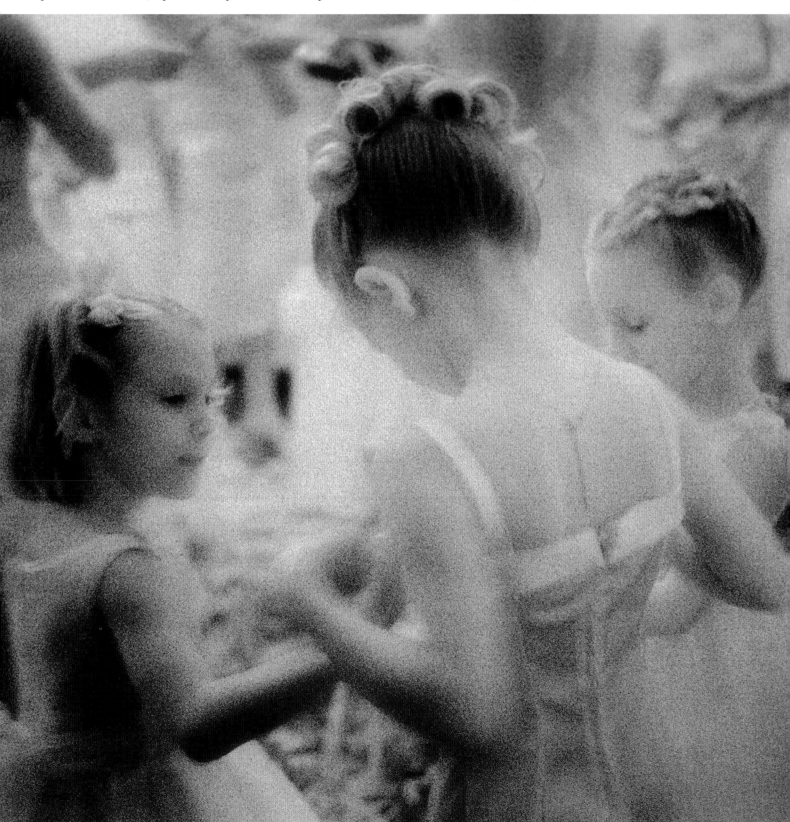

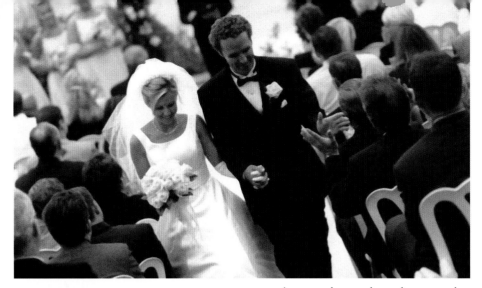

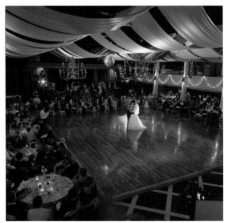

Top: Until a few months ago, Joe Photo shot everything on film. However, since he has acquired new digital cameras, all of his weddings are now captured digitally. Above: Brian Shindle created this marvelous image of the couple's first dance using tungsten-balanced film and a tripod-mounted medium format camera. The room, while fairly dark, has enough light sources to spread the light fairly evenly throughout. This is the type of image that all of the catering and hotel executives would love.

and are available in NC (natural color) or VC (vivid color) versions. Kodak even offers an ISO 100 tungsten-balanced Portra film. Fujicolor Portrait films, available in a similar range of speeds, offer similar skin-tone rendition among the different films as well as good performance under mixed lighting conditions, because of a fourth color layer added to the emulsion. These films are ideal for weddings because different speeds and for-

mat sizes can be used on the same day with minimal differences observed in the final prints.

Medium format color negative and black & white films have a "tooth," or slightly textured surface, on one side of the film. This makes retouching leads and dyes adhere to the film surface better. Since 35mm color negative films do not have such a surface, and since the negative is so small, retouching is not recommended with that format. Digital retouching is the way to go with 35mm images.

Black & White Films. Many wedding photojournalists like to shoot color film and convert it later to black & white. That way there is always a color original. With digital, this is a simple matter of changing the image mode in Photoshop. However, many photographers prefer the emulsions offered in black & white films, notably Kodak T-Max, which is available in a variety of speeds (ISO 100, 400 and 3200), is extremely sharp and offers fine grain even in its fastest version. Black & white coverage is almost a necessity for the wedding photojournalist. It provides a welcome relief from all-color coverage and offers a myriad of creative opportunities.

■ BACKUP AND EMERGENCY EQUIPMENT
Wedding photographers live by the expression, "If it can go wrong, it will

go wrong." That is why most seasoned pros carry backups—extra camera bodies and flash heads, transmitters, batteries and cords, twice the required amount of film, etc. If using AC-powered flash, extra extension cords, several rolls of duct tape (for taping cords to the floor), power strips, flash tubes and modeling lights also need to be on hand. Other items of note include the obligatory stepladder for making groups shots (Monte Zucker even has a black "formal" stepladder for use at weddings), lens cleaning solution and tissue, flashlights, a mini tool kit (for mini emergencies) and a quick-release plates for your tripods (these always seem to get left behind on a table or left attached to a camera).

■ DIGITAL CAMERA SYSTEMS
While most of the images in this book are digital, most were not captured digitally. This, however, is changing. There are now numerous full-fledged professional 35mm digital SLR systems available from Nikon, Canon, Kodak and Fuji with a full complement of lenses, flash units and accessories. In fact, these cameras take the system lenses that a photographer may already own. The focal length, however, is not quite the same, since the chip size is slightly smaller than a full 24mm x 36mm frame. Images can be stored on a variety of media and, for all intents and purposes, there is very little difference between film and digital capture. The same number of exposures can be made at a wedding as one would make traditionally, but the images are already in hand when the photographer leaves the wedding. Instead of scanning the images when they are returned from the lab, the original is already digital and ready to be brought into Photoshop for retouching or special effects and subsequent proofing and printing.

Posing Basics

There are a some formals that must be made at each wedding. These are posed portraits in which the subjects are aware of the camera, and the principles of good posing and composition are essential. For those times—and because any good wedding photographer who is not aware of the traditional rules of posing and composition is deficient in his or her education—the basics are included here.

The rules of posing are not formulas; like all good rules, they should be understood before they can be effectively broken. Posing standards offer ways to show people at their best—a flattering likeness.

No matter what style of photography is being used, there are certain posing essentials that need to be at work, otherwise your technique (or lack of it) will be obvious. The more you know about the rules of posing and composition, and particularly the subtleties, the more you can apply to your wedding images. And the more you practice these principles, the more they will become second nature and a part of your overall technique.

■ GIVING DIRECTIONS
There are a number of ways to give posing instructions. You can tell your subjects what you want them to do,

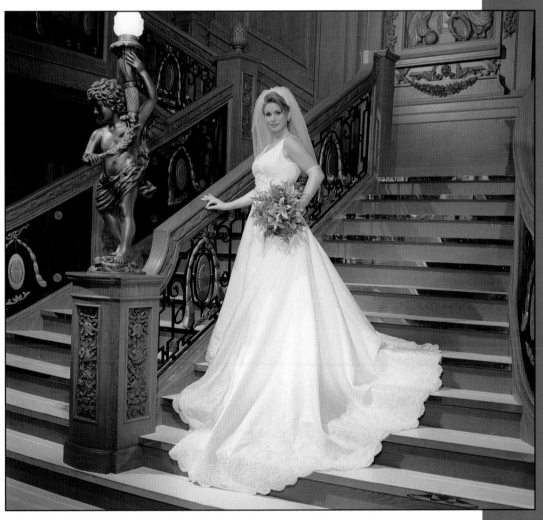

This elegant portrait is by Rick Ferro. Notice the statuesque posing that displays the dress. The hand on the banister is perfectly posed, forming a tight circle with the thumb and forefinger (drawing your eye to the hand). The left hand is placed on the hip to form an elegant bend in the elbow, positioning the bride's arm away from her body, and bringing the bouquet up to central position.

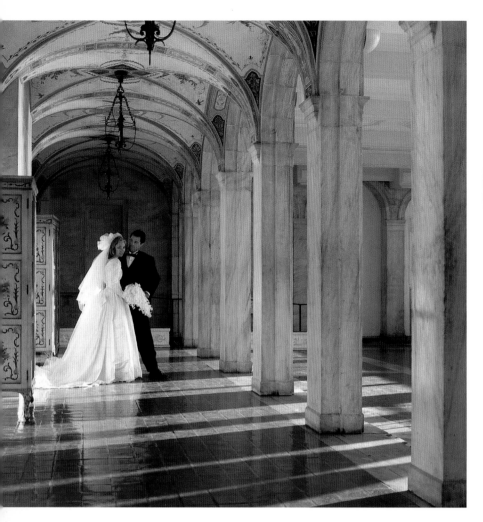

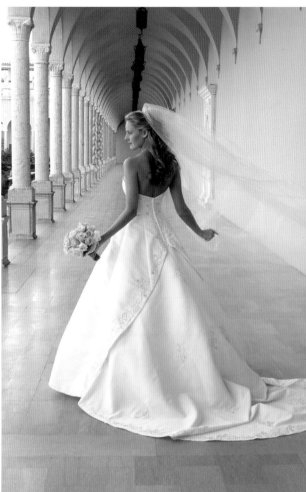

Left: Legendary photographer Monte Zucker uses a wealth of compositional and posing knowledge to create modern masterpieces. Here he employed an implied pyramid shape in the foreground that "aims" at the bride and groom. Their pose is working like a single pose—the bride leaning in and the groom leaning back to imply strength. Note the head and neck axis of each person is different; each head is turned and tilted at a slightly different angle than the shoulders. Right: Monte uses the pose to repeat the shape of the peach-colored arches in the composition. The arms are extended in an elegant pose with a slight "break" to the wrists. The pose itself gently mimics the arches above. The full flow of the dress and veil are visible and beautifully arranged, making this a memorable and very formal composition.

you can gently move them into position or you can demonstrate the pose you are describing. The latter is perhaps the most effective, as it breaks down barriers of self-consciousness on both sides of the camera.

■ SUBJECT COMFORT

The person must be made to be comfortable. A subject who *is* uncomfortable will most likely *look* uncomfortable in the photos. After all, these are normal people, not models who make their living posing. Use a pose that feels good to the subject. If the person is to look natural and relaxed, then the pose must be not only natural to them, but also typical—something they do all the time. Refinements are your job—the turn of a wrist, weight on the back foot, the angling of the body away from the camera—but the pose itself must be representative of the person posing.

■ THE HEAD-AND-SHOULDERS AXIS

One of the basics of good portraiture—capturing a flattering likeness of a person—is that the subject's shoulders should be turned at an angle to the camera. With the shoulders facing the camera straight on to the lens, the person looks wider than he or she really is. Simultaneously, the head should be turned a different direction than the shoulders. This provides an opposing or complementary line within the photograph that, when seen together with the line of the body, creates a sense of tension and balance. With men, the head is often turned the same general direction as the shoulders (but not exactly the same angle), but with women, the head is usually at an opposing angle to the line of the body. With women, when the head is turned and tilted to the higher shoul-

der a beautiful "S" curve is created, from head to toe.

THE ARMS

Subjects' arms should not be allowed to fall to their sides, but should project outward to provide gently sloping lines and a "base" to the composition. This is achieved by asking subjects to move their arms away from their torsos. Remind them that there should be a slight space between their upper arms and their torsos. This triangular base in the composition visually attracts the viewer's eye upward, toward the face.

WEIGHT ON THE BACK FOOT . . . ALWAYS

The basic rule of thumb is that no one should be standing at attention, both feet together. Instead, the shoulders should be at a slight angle to the camera, as previously described, and the front foot should be brought forward slightly. The subject's weight should always be on the back leg/foot. This has the effect of creating a bend in the front knee and dropping the rear shoulder to a position lower than the forward one. When used in full-length bridal portraits, a bent forward knee will give an elegant shape to the dress. With one statement, "Weight on your back foot," you have introduced a series of dynamic lines into an otherwise average composition.

JOINTS

Never break the portrait at a joint—an elbow, knee or ankle, for example. This sometimes happens when a portrait is cropped. Instead, crop between joints if you have to—at mid-thigh or mid-calf, for example. When you break the composition at a joint, it produces a disquieting feeling to the photograph.

FACE POSITIONS

As mentioned above, the head should be at a different angle than the shoulders. There are three basic head positions (relative to the camera) found in portraiture.

The ⅞ View. If you consider the full face as a head-on "mug shot," then the ⅞ view is when the subject's face is turned just slightly away from the camera. In other words, you will see a little more of one side of the subject's face. You will still see the subject's far ear in a ⅞ view.

The ¾ View. This is when the far ear is hidden from camera and more of one side of the face is visible. With this pose, the far eye will appear smaller because it is farther away from the camera than the near eye. It is important when posing subjects in a ¾ view to position them so that the smallest eye (people usually have one eye that is slightly smaller than the other) is closest to the camera. This way both eyes appear, perspective-wise, to be the same size in the photograph. It is important to note that you do not

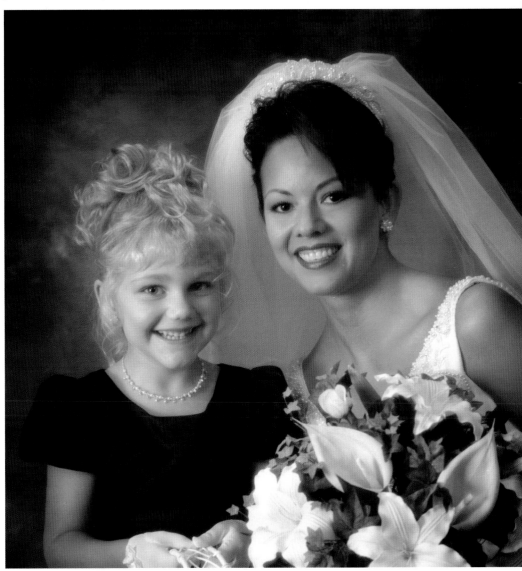

In this beautiful portrait by highly decorated photographer Michael Ayers you can see two ⅞ face positions. Actually, the bride is positioned closer to a ¾ view. With the bride leaning in and the faces positioned toward each other, you see the beautiful roundness and modeling that the lighting creates, sculpting each face beautifully.

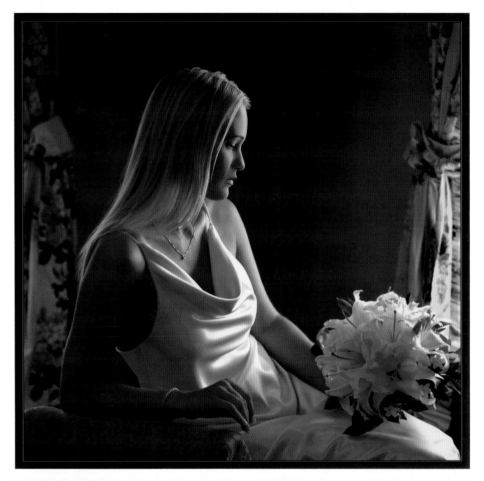

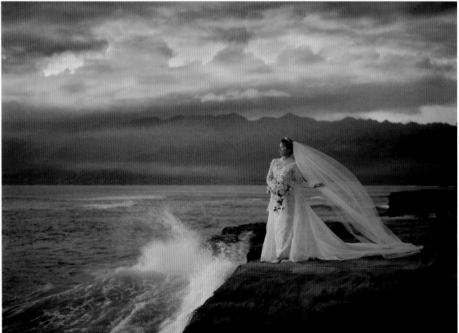

have the luxury of time in posing groups of people at a wedding, but when photographing the bride and groom, care should be taken to notice the subtleties.

Profile. In the profile the head is turned almost 90 degrees to the camera. Only one eye is visible. In posing your subjects in profile, have them turn their heads gradually away from the camera position just until the far eye and eyelashes disappear.

Knowing the different head positions will help you provide variety and flow to your images, and you can incorporate the different head positions within group portraits. You may, at times, end up using all three head positions in a single group pose. The more people in the group, the more likely that becomes.

■ THE EYES

The best way to keep your subjects' eyes active and alive is to engage them in conversation. Look at the person while you are setting up and try to find a common frame of interest. Inquire about the other person, the single subject that above all will interest him or her. If the person does not look at you when you are talking, he or she is either uncomfortable or shy. In either case, you have to work to

relax the person. Try a variety of conversational topics until you find one he or she warms to and then pursue it. As you gain their interest, you will take the subject's mind off of the session.

The direction the person is looking is important. Start the formal session by having the person look at you. Using a cable release with the camera tripod-mounted forces you to become the host and allows you to physically hold the subject's gaze. It is a good idea to shoot a few frames of the person looking directly into the camera, but most people will appreciate some variety.

One of the best ways to enliven your subject's eyes is to tell an amusing story. If they enjoy it, their eyes will smile—one of the most endearing expressions a human being can make.

◻ THE SMILE
One of the easiest ways to produce a natural smile is to praise your subject. Tell her how good she looks and how much you like a certain feature of hers—her eyes, her hairstyle, etc. To

simply say "Smile!" will produce that familiar lifeless expression. By sincere confidence building and flattery, you will get the person to smile naturally and sincerely and their eyes will be engaged by what you are saying.

Remind the subject to moisten her lips periodically. This makes the lips sparkle in the finished portrait, as the moisture produces tiny specular highlights on the lips.

Pay close attention to your subject's mouth, making sure there is no

tension in the muscles around it, since this will give the portrait an unnatural, posed look. Again, an air of relaxation best relieves tension, so talk to the person to take his or her mind off the session.

One of the best photographers I've ever seen at "enlivening" total strangers is Ken Sklute. I have looked at literally hundreds of his wedding images and in almost every image, the people are happy and relaxed in a natural, typical way. Nothing ever looks

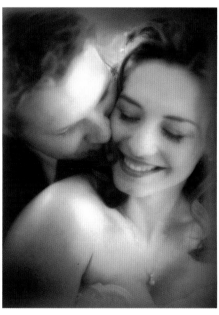

Top Left: In this beautiful pose Don Emmerich sets up two strong diagonal lines—the bride's shoulders and the line of her eyes—solely to rivet attention on her smoldering dark eyes. No matter where you look within this portrait, your gaze is drawn back to the bride's eyes. *Top Right:* Carrillo, who moved in close to concentrate on the connection between the bride and groom, created this intimate and charming pose. The smile on the bride's face is so real and genuine that you get the sense that the couple was oblivious to the photographer's presence. *Bottom:* Alisha and Brook Todd are experts at capturing the real emotion of the wedding day. In this close-up of the groom, the joy of the day is mirrored in the young man's eyes, which seem to be smiling, as well.

posed in his photography—it's almost as if he happened by this beautiful picture and snapped the shutter. One of the ways he gets people "under his spell" is his enthusiasm for the people and for the excitement of the day. His enthusiasm is contagious and his affability translates into attentive subjects.

▪ HANDS

Hands can be strong indicators of character, just as the mouth and eyes are. Posing hands properly can be very difficult because in most portraits they are closer to the camera than the subject's head, and thus appear larger. One thing that will give hands a more

natural perspective is to use a longer lens than normal. Although holding the focus of both hands and face is more difficult with a longer lens, the size relationship between them will appear more natural. If the hands are slightly out of focus, this is not as crucial as when the eyes or face are soft.

One basic rule is never to photograph a subject's hands pointing straight into the camera lens. This distorts the size and shape of the hands. Always have the hands at an angle to the lens.

Another basic is to photograph the outer edge of the hand when possible. This gives a natural, flowing line to the hand and wrist and eliminates distortion that occurs when the hand is photographed from the top or head-on. Try to "break" the wrist, meaning to raise the wrist slightly so there is a smooth bend and gently curving line where the wrist and hand join. And always try to photograph the fingers with a slight separation in between.

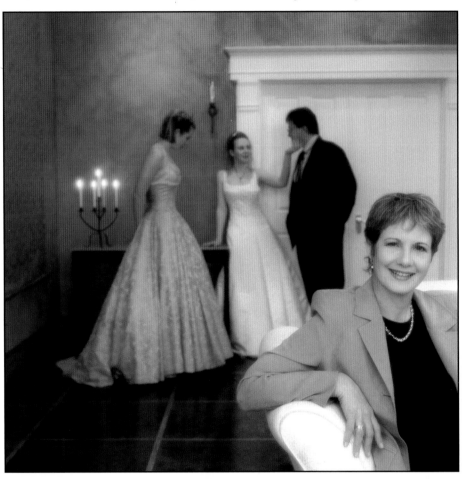

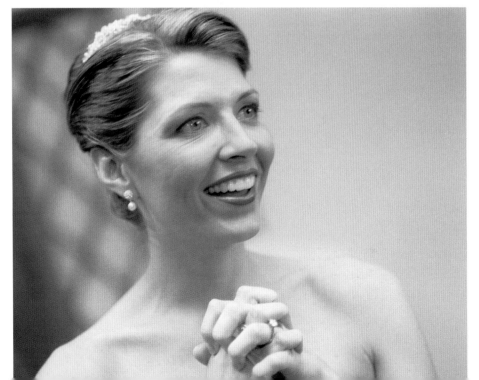

Top: This is a wonderful portrait of the mother of the bride by David Anthony Williams. One of its charms is the way certain posing guidelines are ignored while others are adhered to with certainty. The mother's hand is posed to perfection, fingers spread delicately, an arch at the wrist and the edge of the hand facing the camera. Yet, Williams decided to crop into her left side for impact—usually a no-no. The secondary posing in the background is also expert, yet casual. Bottom: This is excellent—albeit untraditional—posing of hands. In fact, the image is so spontaneous, it probably wasn't posed at all. But the photographer, Robert Hughes, had the foresight to position himself appropriately to capture not only the expression, but also the "church steeple" pose of the hands, which also shows off the wedding ring.

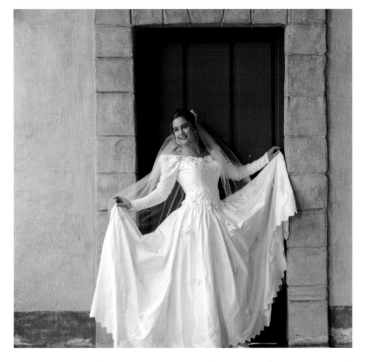

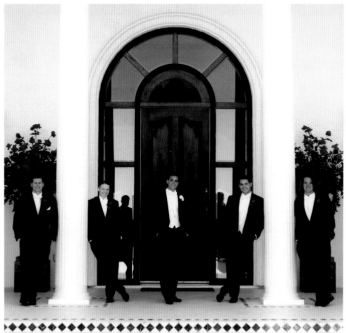

This gives the fingers form and definition. When the fingers are closed together, they appear as a blob.

As generalizations go, it is important that the hands of a woman have grace, and the hands of a man have strength.

Hands in Groups. Hands can be a problem in groups. Despite their small size, they attract visual attention, particularly against dark clothing. They can be especially troublesome in seated groups, where at first glance you might think there are more hands than there should be.

A general rule of thumb is to either show all of the hand or show none of it. Don't allow a thumb or half a hand or only a few fingers to show. Hide as many hands as you can behind flowers, hats or other people. Be aware of these potentially distracting elements and look for them as part of your visual inspection of the frame before you make the exposure.

Hands with Standing Subjects. When some of your subjects are standing, hands can become a real problem. If you are photographing a man, folding the arms across his chest is a good

Left: The beauty of an elegantly posed portrait can be unsurpassed. Award-winning photographer Heidi Mauracher produced this lovely portrait in open shade, which is blocked from above. One of Heidi's strengths as a photographer is her wealth of posing knowledge. Notice the delicate hand posing and "feminine" tilt to the bride's head. **Right:** Award winner Ken Sklute created this handsome portrait of the bridal party by spacing the men equidistant from the pillars. Of particular interest is how Ken posed the hands—all thrust in pockets but with the cuffs of their shirts showing so that there is a slight tonal break.

strong pose. Remember, however, to have the man turn his hands slightly, so the edge of the hand is more prominent than the top of the hand. In such a pose, have him lightly grasp his biceps, but not too hard or it will look like he's cold. Also, remember to instruct the man to bring his folded arms out from his body a little bit. This slims down the arms, which would otherwise be flattened against his body, making them (and him) appear larger. Separate the fingers slightly.

With a standing woman, one hand on a hip and the other at her side is a good standard pose. Don't let the free hand dangle, but rather have her twist the hand so that the outer edge shows to the camera. Always create a break in the wrist for a more dynamic line.

CAMERA HEIGHT

When photographing people with average features, there are a few general rules that govern camera height in relation to the subject. These rules will produce normal (not exaggerated) perspective.

For head-and-shoulders portraits, the rule of thumb is that camera height should be the same height as the tip of the subject's nose. For 3/4-length portraits, the camera should be at a height midway between the subject's waist and neck. In full-length portraits, the camera should be the same height as the subject's waist. In each case, the camera is at a height that divides the subject into two equal halves in the viewfinder. This is so that the features above and below the lens/subject axis will be the same distance from the lens, and thus recede

equally for "normal" perspective. When the camera is raised or lowered, the perspective (the size relationship between parts of the photo) changes. This is particularly exaggerated with wide-angle lenses. By controlling perspective, you can alter the physical traits of your subject.

By raising the camera height in a ¾- or full-length portrait, you enlarge the head-and-shoulder region of the subject, but slim the hips and legs. Conversely, if you lower the camera, you reduce the size of the head, and enlarge the size of the legs and thighs. Tilting the camera down when raising the camera and up when lowering the camera increases these effects. The closer the camera is to the subject, the more pronounced the changes are. If you find that after you make an adjustment of camera height for a desired effect there is no change, move the camera in closer to the subject and observe the effect again.

When you raise or lower the camera in a head-and-shoulders portrait, the effects are even more dramatic. Raising or lowering the camera above or below nose height is a prime means of correcting facial irregularities. Raising the camera height lengthens the nose, narrows the chin and jawline and broadens the forehead. Lowering camera height shortens the nose, de-emphasizes the forehead and widens the jawline while accentuating the chin.

While there is little time for many such corrections on the wedding day, knowing these rules and introducing them into the way you photograph people will help make many of these techniques second nature.

■ EYEGLASSES
Eyeglasses can present major problems on the wedding day, especially in group pictures. When working with

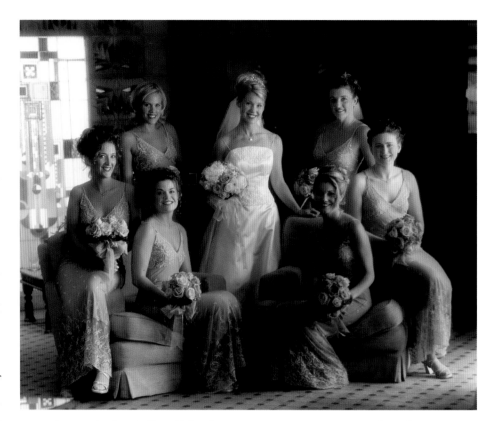

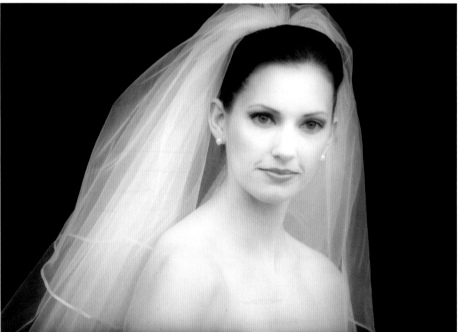

Top: In this window-lit portrait of the bride and her bridesmaids there are multiple posing challenges, specifically, fourteen hands. The photographer, a master of photographing groups, Ken Sklute, hid all the hands behind bouquets and in laps. One of the problems is that it takes a long time to pose so many hands, so the best practice is to hide them. The only visible hand is the bride's, gently resting on the back of the stuffed chair. Bottom: Alisha and Brook Todd make formal portraits when the opportunities arise. Here, a lovely bride is photographed in soft shade against a dark background. As a head and shoulders portrait, this image has great dynamic quality. Note too that the camera height is midway between the top of the bride's head and the bottom of the frame to avoid distortion of any kind, despite the wider than normal focal length.

bounce flash or when using flash-fill outdoors, you can pick up specular reflections on eyeglasses and not even notice the problem until you see the film. The best bet is to ask the person to remove their glasses, but don't be surprised if they decline. Many people wear glasses all the time and feel self-conscious without them.

David Anthony Williams created this beautiful ¾-length portrait. Although it is not generally recommended to photograph a person with their shoulders square to the camera, it is effective here since the bride is slim enough to carry it off. Notice the way the hands are posed both in a curved upward position to lead the viewer's eye back up to the bride's face. The composition is delicately balanced so that the eye bounces back and forth between the foreground and background and across to the non-descript branches opposite the bride. In portraits that incorporate environment, it is essential that those secondary elements add to the design and meaning of the portrait.

One rule of light to remember when you encounter eyeglasses is this: the angle of incidence equals the angle of reflection. Light directed head-on toward a group will more than likely produce an unwanted eyeglass reflection. Move the main light to the side and raise it so that the angle of reflection is directed away from the camera lens. Any fill light should be adjusted laterally away from the camera until its reflection disappears. If you cannot eliminate the fill light's reflection, try bouncing the fill light off the ceiling

Another trick is to ask the person to tilt their glasses downward on his or her nose slightly. This should solve most problems with reflections.

When your subject is wearing thick glasses, it is not unusual for the eyes to record darker than the rest of the face. If this happens, there is nothing you can do about it during the photography, but the eyeglasses can be dodged during printing or in Photoshop to restore the same print density as in the rest of the face.

Any type of "photo-gray" or self-adjusting lenses should be avoided. Outdoors, they will photograph like sunglasses. Indoors, under normal room light, they won't present much of a problem. A trick is to have the person, usually a man, keep his glasses in his pocket until you are ready to shoot. This will keep the lenses from getting dark prematurely from the ambient or shooting lights.

■ THREE-QUARTER AND FULL-LENGTH POSES
When you use a three-quarter or full-length pose, you have arms, legs, feet and the total length of the body to contend with. A three-quarter-length portrait is one that shows the subject from the head down to a region below the waist. Usually a three-quarter-length portrait is best composed by having the bottom of the picture be mid-thigh or mid-calf.

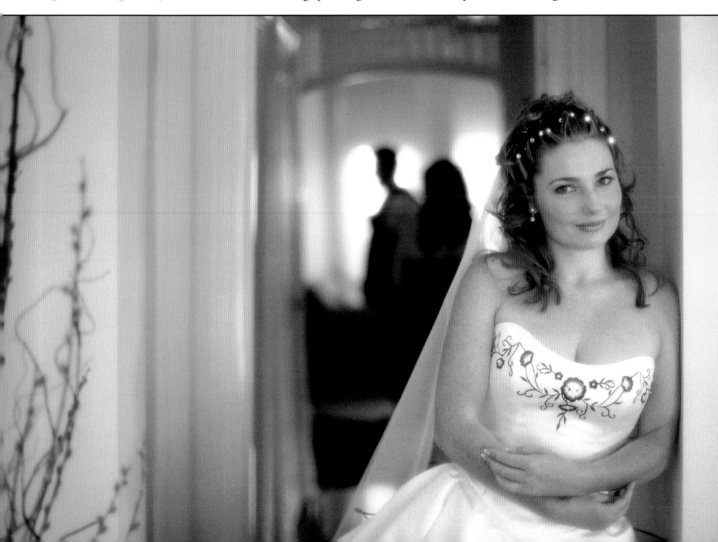

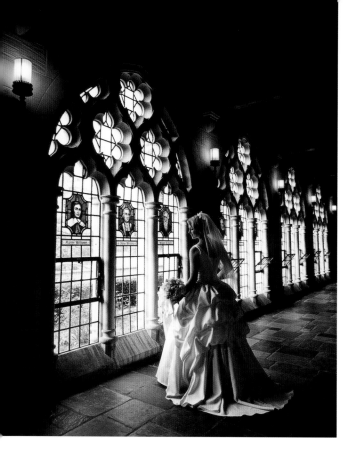

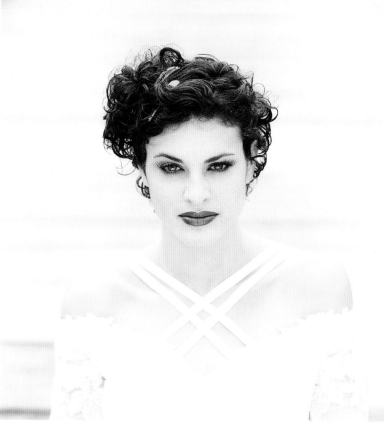

Left: In this classically posed portrait, Heidi Mauracher reveals not only the beauty of the bride and her dress, but captures her in a timeless fashion. Notice the elbows separated from the body so that space and shape are visible. This is particularly effective on the left side, where the highlight visible on the bride's waist helps define her figure. The bend of the left arm produces a graceful line that connects the implied diagonal line between the bouquet and the bride's eyes. **Right:** Phil Kramer broke all the rules of portrait posing to produce this elegant fashion portrait of a beautiful young woman. With head and shoulders square to the camera and on the same axis, the viewer is focused on the eyes and lips and other subtle details not erased in the high-key treatment. While it breaks some of the rules of effective portraiture, this image is a timeless testament to this woman's beauty.

A full-length portrait shows the subject from head to toe. Whether the person is standing or sitting, it is important to angle the person to the lens. Never photograph the person head-on, as this adds mass to the body. Angle the person, usually at a 30–45-degree angle to the camera. Your subject's weight should be on the back foot rather than distributed evenly on both feet—or worse yet, on the front foot. There should be a slight bend in the front knee if the person is standing. This helps break up the static line of a straight leg and with women, helps show off the line of the dress.

Have the feet at an angle to the camera. Just as it is undesirable to have the hands facing the lens straight-on, so it is with feet, but more so. Feet look stumpy when shot straight-on.

When the subject is sitting, a cross-legged pose is effective. Have the top leg facing at an angle and not directly into the lens. When posing a woman who is seated, have her tuck the calf of the leg closest to the camera in behind the leg farthest from the camera. This reduces the size of the calves, since the leg that is farther from the camera becomes more prominent. Whenever possible, have a slight space between the subject's leg and the chair, as this will slim down thighs and calves.

It should be noted that in any discussion of subject posing the two most important points are that the pose appear natural (one that the person would typically fall into), and that the person's features be undistorted.

■ HEAD-AND-SHOULDER PORTRAITS

With close-up portraits of one or more people, it is important to tilt the head and retain good head-and-shoulder axis positioning. Shoulders should be at an angle to the camera lens and the angle of the person's head should be at a slightly different angle. Often head-and-shoulders portraits are of only the face—as in a beauty shot. It is important to have a dynamic element, such as a diagonal line, which will create visual interest.

In a head-and-shoulders portrait, all of your camera technique will be evident, so focus is critical (start with the eyes) and lighting must be flawless. Use changes in camera height to correct various irregularities (see page 37–38). Don't be afraid to fill the frame with the bride or bride and groom's faces. They will never look as good as they do on their wedding day!

Noted group portrait specialist Robert Love has a simple concept for photographing groups—each person must look great, as if the portrait were being made solely of that individual. Achieving this ideal means calling on both compositional and posing skills.

Form, Line and Direction. Designing groups of people successfully depends on your ability to manage the intangible—implied and inferred lines and shapes within a composition. Line is an artistic element used to create visual motion within the image. It may be implied by the arrangement of the group, or inferred, by grouping various elements within the scene. It might also be literal, as well; like a fallen tree used as a posing bench that runs diagonally through the composition.

Shapes are groupings of like elements: diamond shapes, circles, pyramids, etc. These shapes are usually a collection of faces that form the pattern. They are used to produce pleasing shapes that guide the eye through the composition. The more you learn to recognize these elements, the more they will become an integral part of your compositions.

These are the keys to making a dynamic portrait. The goal is to move the viewer's eye playfully and rhythmically through the photograph. The opposite of a dynamic image is a static one, where no motion or direction is

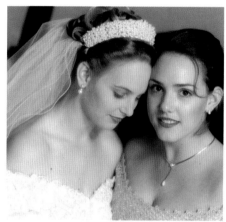

Right: David Anthony Williams connects the poses to form a beautiful and intimate image of two best friends. Note how the two are turned toward each other with differing head/neck axes. The bridesmaid on the right is posed with her head slightly tilted back for the bride to "lean into." He effectively connected two very different poses for a splendid portrait. Below: Good composition is quiet but effective. Here, David Anthony Williams creates a wonderful group portrait using subtle curved lines and triangle shapes. Notice how the four adult faces form a gentle curved line and how a triangle shape is formed between the bride, the bridesmaid to her left and the little girl. Connecting the little girl, the bouquet and the same bridesmaid forms another triangle shape. There is also a lovely jagged line following the bouquets (including the child's face). Williams wrapped the bridesmaids around the bride on her right and let the one on her left (also the tallest girl) stand more independently. All of the design factors add increased visual interest to the portrait.

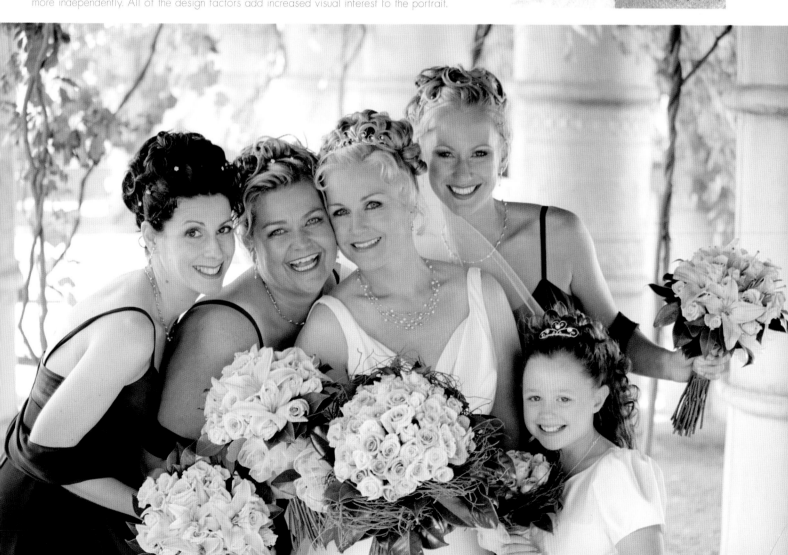

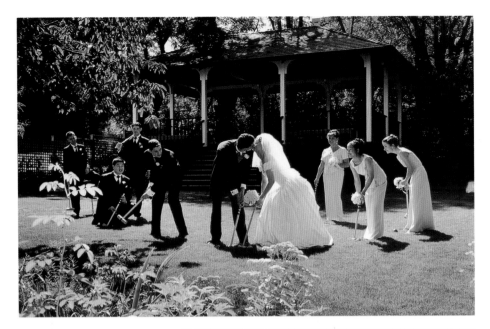

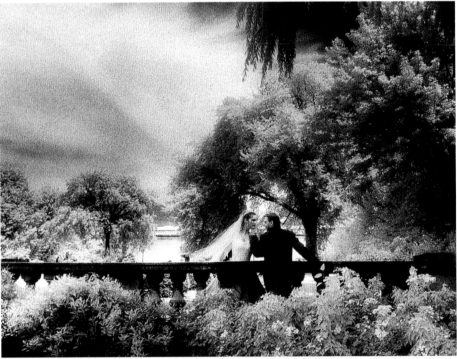

Top: Award-winning Canadian photographer Frances Litman created this humorous portrait of a bride and groom who can't keep their minds on the game at hand. In order to focus your eye on the bride and groom, she created a wedge-shaped composition of groomsmen and bridesmaids that leads your eye to the bride and groom. Use of a wide-angle lens also forced the main subjects to be larger in the image (because of their proximity to the lens). Flash fill was used to open up the shadows caused by the midday sun. Bottom: Well known wedding photographer Barbara Rice incorporated a long horizontal line into this composition to act as a compositional base. She contrasted this shape by forming a small triangle of the groom and bride. The image is recorded on infrared film, a popular film choice of today's brides.

found, and the viewer simply "recognizes" rather than enjoys all of the elements in the photograph.

Enter the Armchair. An armchair is the perfect posing device for photographing from three to eight people. The chair is best positioned at about 30–45 degrees to the camera. Regardless of who will occupy the seat, he and/or she should be seated laterally across the cushion. They should be seated on the edge of the chair, so that all of their weight does not rest on the chair back. This promotes good sitting posture and narrows the lines of the waist and hips, for both men and women.

Using an armchair allows you to seat one person, usually the man, and position the other person close and on the arm of the chair, leaning on the far armrest. This puts their faces in close proximity but at different heights. A variation of this is to have the woman seated and the man standing. If their heads are far apart, you should pull back and make the portrait full-length.

The seated woman should have her hands in her lap, elbows extended slightly. This slims the body—waist, thighs and hips. She should be seated at an angle and the leg closest to the camera should have that foot "hooked" behind the leg farthest from the camera—a pose which women seem to fall into naturally. While dated, this pose is still effective in rendering the woman's shape flatteringly.

Couples. The simplest of groups is two people. Whether it's a bride and groom, mom and dad or the best man and the maid of honor, the basic building blocks call for one person slightly higher than the other. A good starting point is to position the mouth of the lower person parallel to the forehead of the higher person. Many photographers recommend mouth to eyes as the ideal starting point.

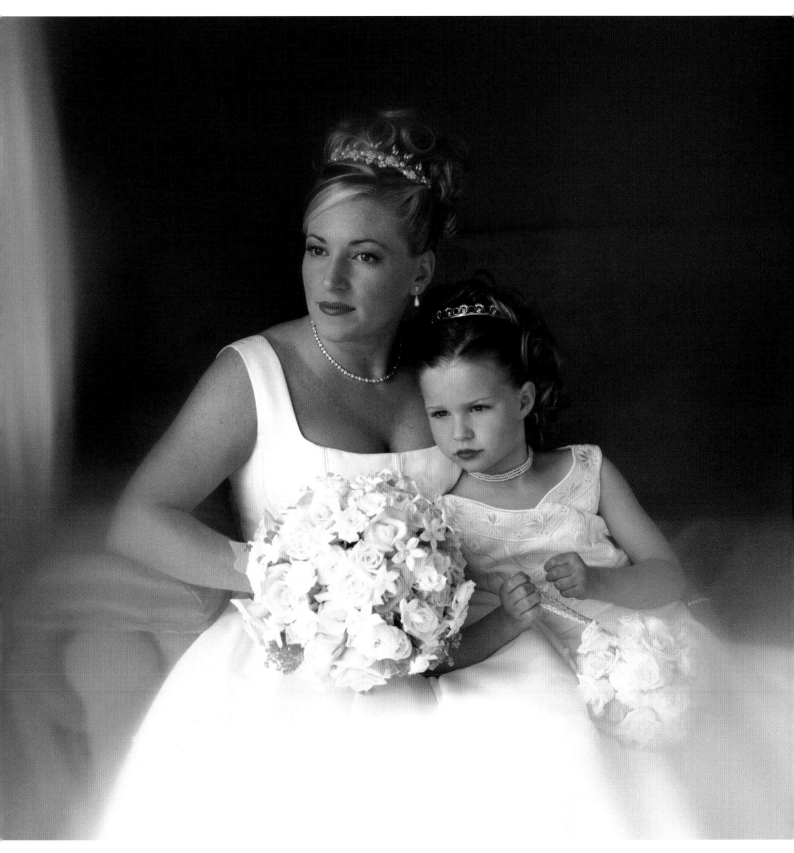

Award-winning photographer Anthony Cava created this elegant portrait by incorporating a basic pyramid shape formed by the line of the bride's and flower girl's dresses and by having the flower girl lean in to the bride. The line of the elbows also forms a secondary triangle shape, which complements the larger one. Anthony also minimized distracting elements by using a soft-focus vignette to soften edges around the perimeter of the image.

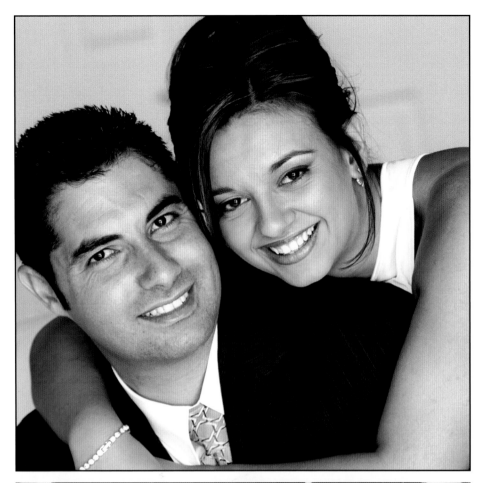

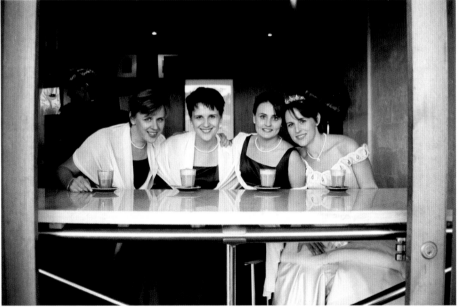

Although they can be posed in parallel position, a more interesting dynamic with two people can be achieved by having them pose at 45-degree angles to each other, so their shoulders face in toward one another. With this pose you can create a number of variations by moving them closer or farther apart.

Another intimate pose for two is to have two profiles facing each other. One should still be higher than the other, as this allows you to create an implied diagonal between their eyes, which also gives the portrait direction.

Since this type of image is fairly close up, make sure that the frontal planes of the subjects' faces are roughly parallel so that you can hold focus on both faces.

Adding and Third Person. A group portrait of three is still small and intimate. It lends itself to a pyramid or diamond-shaped composition, or an inverted triangle, all of which are pleasing to the eye. Don't simply adjust the height of the faces so that each is at a different level. Use the turn of the shoulders of those at either end of the group as a means of looping the group together.

Once you add a third person, you will begin to notice the interplay of lines and shapes inherent in good group design. As an exercise, plot the implied line that goes through the shoulders or faces of the three people in the group. If the line is sharp or jagged, try adjusting the composition so that the line is more flowing, with gentler edges. Try a simple maneuver like turning the last or lowest person in the group inward toward the group and see what effect it has.

Try different configurations. For example, create a single diagonal line with the faces at different heights and all the people in the group touching. It's a simple yet pleasing design. The

Top: David Anthony Williams created a strong diagonal that follows the line of both sets of eyes to help connect this intimate portrait. Notice how each face is angled toward the other so that there is less of a straight-in view, showing more of each face. Notice too the slight space between the heads that preserves the girl's delicate hairstyle. **Bottom:** Here, Williams contrasted the very straight lines in this group portrait by including the dynamic inverse triangle shape of the table supports. The pose is lovely and symmetrical and all of the faces are in the same plane of focus. Williams often incorporates compelling background elements in his portraits and in this case it is the young man.

graphic power of a well defined diagonal line in a composition will compel the viewer to keep looking at the image. Adjust the group by having those at the ends of the diagonal tilt their heads slightly in toward the center of the composition.

Try a bird's-eye view. Cluster the group together, grab a stepladder or other high vantage point and you've got a lovely variation on the three-person group. It's what photographer Norman Phillips calls "a bouquet." For a variation, have the people turn their backs to each other, so they are all facing out of the triangle.

Adding a Fourth and Fifth Person. This is when things *really* get interesting. You will find that as you photograph more group portraits, even numbers of people are harder to pose than odd. Three, five, seven or nine people seem much easier to photograph than similarly sized groups of an even number. The reason is that the eye and brain tend to accept the disorder of odd-numbered objects more readily than even-numbered objects.

As you add more people to a group, remember to do everything you can to keep the film plane parallel to the plane of the group to ensure everyone in the photograph is sharply focused.

With four people, you can simply add a person to the existing poses of three described above—with the following advice. Be sure to keep the eye height of the fourth person different from any of the others in the group. Also, be aware that you are now forming shapes within your composition. Think in terms of pyramids, extended triangles, diamonds and curved lines. Be aware of both line and shape and direction as you build your groups.

An excellent pose for four people is the sweeping curve of three people with the fourth person added below

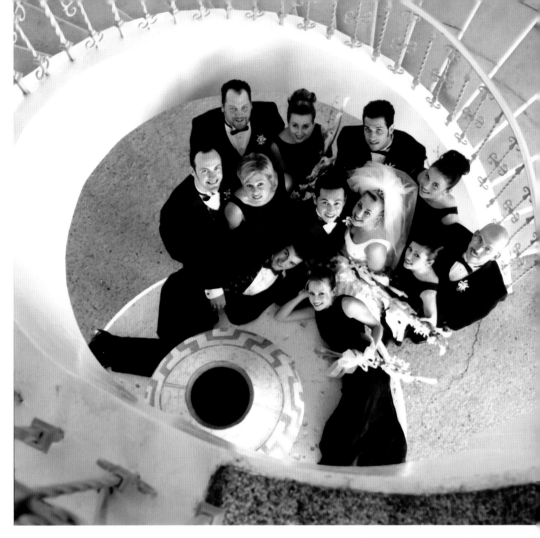

Ken Sklute enjoys coming up with interesting ways to photograph groups. Here, he had the bridal party pose at the base of this circular staircase. In order to give the pose some dimension, he had two people lie down, giving the image a more dynamic shape to contrast all of the circles.

and between the first and second person in the group.

The fourth person can also be positioned slightly outside the group for accent, without necessarily disrupting the harmony of the rest of the group.

When Monte Zucker has to pose four people, he sometimes prefers to play off of the symmetry of the even number of people. He'll break the rules and he'll seat two and stand two and, with heads close together, making the line of the eyes parallel with both the top two and bottom two. Strangely, this seems to work, without the monotony one would expect.

Bigger Groups. Compositions will always look better if the base is

wider than the top, so the final person in a large group should elongate the bottom of the group.

Each implied line and shape in the photograph should be designed by you and should be intentional. If the arrangement isn't logical (i.e., the line or shape doesn't make sense visually), then move people around and start again.

Try to coax "S" shapes and "Z" shapes out of your compositions. They form the most pleasing shapes to the eye and will hold a viewer's eye within the borders of the print. Remember that the diagonal line also has a great deal of visual power in an image and is one of the most potent design tools at your disposal.

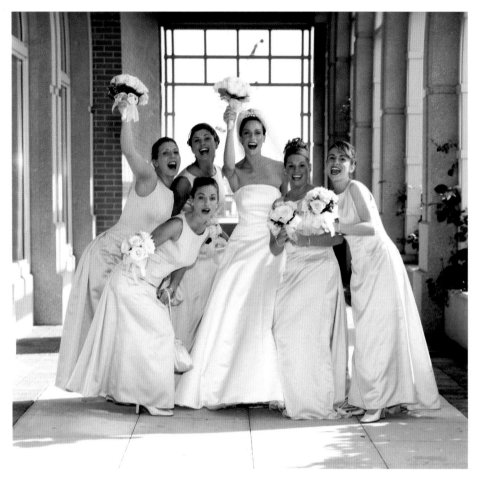

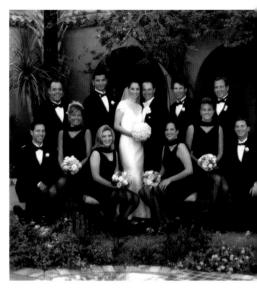

The use of different levels creates a sense of visual interest and lets the viewer's eye bounce from one face to another (as long as there is a logical and pleasing flow to the arrangement). The placement of faces, not bodies, dictates how pleasing and effective a composition will be.

When adding a sixth or an eighth person to the group, the group should still retain an asymmetrical look for best effect. This is best accomplished by creating elongated sweeping lines and using the increased space to slot in extra people. Keep in mind that while a triangle shape normally calls for three people, you *can* add a fourth and still keep the shape intact.

As your groups get bigger, keep your depth of field under control. The stepladder is an invaluable tool for larger groups, because it lets you elevate the camera position and keep the camera back (film plane) parallel to the group for most efficient focus. Another trick is to have the last row in a group lean in while having the first row lean back, thus creating a shallower subject plane, which makes it easier to hold the focus across the entire group.

As your grouping exceeds six people, you should start to base the composition on linked shapes—like linked circles or triangles. What makes combined shapes work well is to turn them toward center. Such subtleties unify a composition and make combining visually appealing design shapes more orderly.

Camera Technique

■ FOCAL LENGTH AND ITS EFFECT ON PERSPECTIVE

The general rule for photographing portraits is to use a lens that is twice the diagonal of the film you are using. With 35mm film, a 75–85mm lens is a good choice; for the 6cm x 6cm square format, 100–120mm lenses are good, and for 6cm x 7cm format, 110–150mm lenses are acceptable.

Such short- to medium-length telephotos provide normal perspective without subject distortion. If you used a "normal" focal-length lens (50mm in 35mm format, 75–90mm in the medium formats), you would need to move in too close to the subject to attain an adequate image size. Because it alters the perspective, such proximity to the subject exaggerates subject features—noses appear elongated, chins jut out and the backs of heads may appear smaller than normal. This phenomenon is known as foreshortening. The short telephoto provides a better working distance between

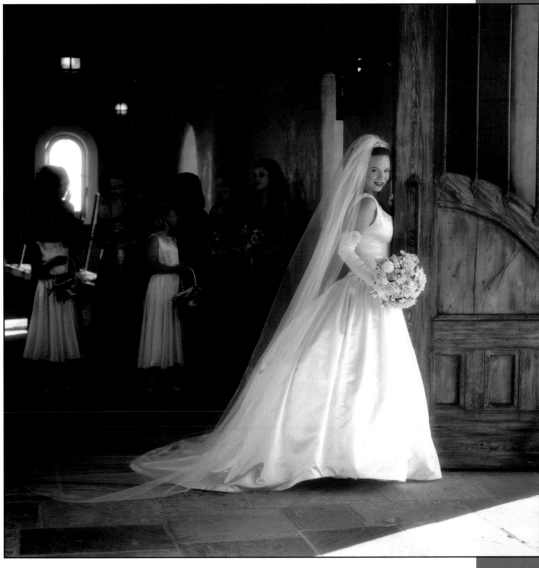

Ken Sklute masterfully arranged a group and bridal portrait in a single image. The perspective had to appear normal, so a normal lens was employed on a medium format camera. The camera height is midway between the bride's head and feet and he used a smaller-than-normal taking aperture to pull the background elements into focus, although not completely. Ken did not light the bridesmaids in order to have them appear several zones darker, making the group a secondary element.

camera and subject, while increasing the image size to ensure normal perspective.

When photographing groups, some photographers prefer long lenses; for example, a 150mm lens on a 6cm x 6cm camera. The longer lens keeps people in the back of the group the same relative size as those in the front of the group.

When space doesn't permit the use of a longer lens, short lenses must be used, but you should be aware that the subjects in the front row of a large group will appear larger than those in the back of the group, particularly if you get too close. Extreme wide-angle lenses will distort the subjects' appearance, particularly those closest to the frame edges. Raising the camera height, thus placing all subjects at the same relative distance from the lens, can minimize some of this effect. Also, the closer to the center of the frame the people are, the less distorted they will be rendered.

Conversely, you can use a much longer lens if you have the working room. A 200mm lens, for instance, is a beautiful portrait lens for the 35mm format because it provides very shallow depth of field and throws the background completely out of focus, providing a backdrop that won't distract from and will enhance the subjects. When used at wider apertures, this focal length provides a very shallow band of focus that can be used to accentuate just the eyes, for instance, or just the frontal planes of the faces. Very long lenses (300mm and longer for 35mm) can sometimes distort perspective—subjects' features appear compressed, depending on the working distance—the nose often appears pasted onto the subject's face, and the ears appear parallel to the eyes. While lenses this long normally prohibit communication in a posed portrait, they are ideal for working unobserved as a wedding photojournalist often does. You can make head-and-shoulders images from a long distance away.

When making three-quarter-length or full-length group portraits, it is best to use the normal focal-length lens for your camera. This lens will provide normal perspective because you will be at a greater working distance from your subject than you would be when making a close-up portrait. It is tricky sometimes to blur

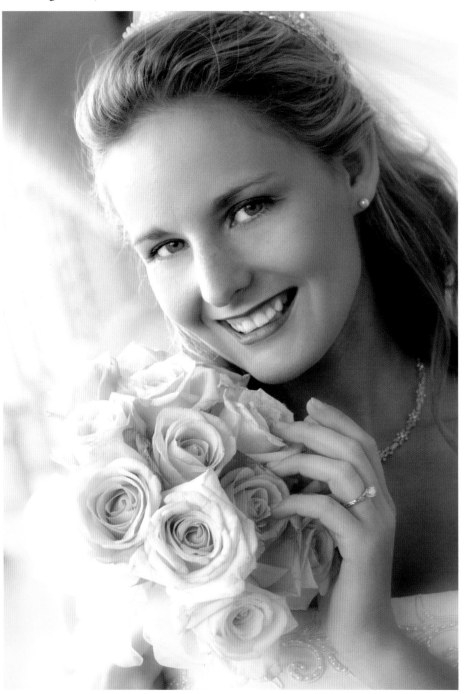

Monte Zucker created this lovely bridal portrait by using a long lens and controlling the plane of focus. Monte wanted just the face, most of the bouquet and just a hint of the archway to be in focus so the repeating shape would be visible. By adjusting the focus, his region of sharpness became the distance from the perfectly posed hand to the bride's eyes; a distance of only a few inches. The image was created digitally with a Canon D30.

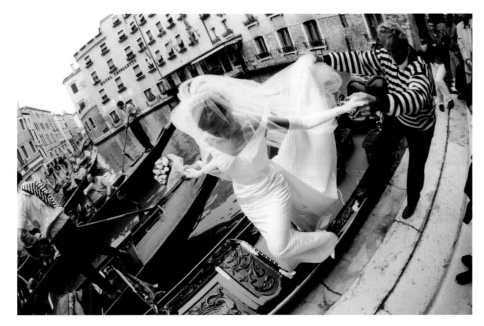

Top Right: A wild cockeyed camera angle and a rectilinear fisheye lens are not exactly the makings of a great bridal portrait, but Joe Photo knows what he's doing. Because he positioned the bride in the center of the frame, there is minimal distortion. Yet everything around her seems distorted. His timing is also impeccable, waiting until just the right moment when her foot is raised for her departure. He titled this image "Grand Exit." **Bottom Right:** Wide-angle lenses are often used to introduce design elements such as the receding diagonal of the break wall. David Anthony Williams combined an unlikely location with beautiful twilight colors to produce a memorable portrait. The unusual tint of the wedding gown is augmented by the color of the twilight and a warm-toned flash used as fill. **Below:** Longer lenses make for delicately narrow bands of focus. The region of sharpness in this Stephen Maclone portrait stretches from the tip of the bride's nose to her hairline.

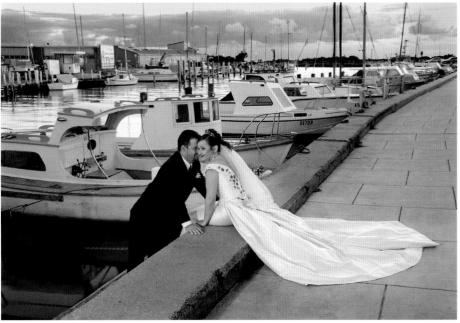

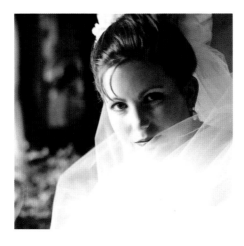

the background with a normal focal length lens, since the background is in close proximity to the subjects. With longer lenses you can isolate your subjects from the background because of the working distance and image size.

When making group portraits, you are often forced to use a wide-angle lens. The background problems discussed above can be even more pronounced, but a wide angle is often the only way you can fit the entire group into the shot and still maintain a decent working distance. For this rea-son, many expert group photographers carry a stepladder or scope out the location in advance to find a high vantage point, if called for.

■ DEPTH OF FIELD

Wide-angle lenses have greater inherent depth of field than telephoto ones. This is why you must focus telephoto lenses so precisely in portraiture. Also, the closer you are to your subjects with *any* lens, the less depth of field you will have, at any given aperture. When you are shooting a tight image of faces, be sure that you have enough depth of field at your working lens aperture to hold the focus on all the faces.

Remember is that medium-format lenses have less depth of field than lenses for the 35mm format. A 50mm lens on a 35mm camera will yield more depth of field than a 75mm lens on a medium-format camera—even if the lens apertures and subject distances are the same. This is important because many photographers think that if they go to a larger format, they

will improve the quality of their images. This is true in that the image will appear improved simply by the increase in film size; however, focusing and depth of field become much more critical with the larger format.

Learn to use your lens' depth-of-field scale. The viewfinder screen is often too dim when the lens is stopped down with the depth-of-field preview to gauge overall image sharpness accurately. Learn to read the scale quickly and practice gauging distances. With the camera away from your eye, guess how far away your subject is. Focus and then check the lens focus ring to confirm the distance. With practice, you can become amazingly accurate.

Learn the characteristics of your lenses. You should know what to expect in the way of depth of field, at your most frequently used lens apertures, which for most group shots will be f/5.6, f/8 and f/11. Some photographers develop a tendency to use only one or two favorite apertures when they shoot. Norman Phillips, for instance, prefers f/8 over f/11 (for shooting group portraits), even though f/11 affords substantially more depth of field than f/8. He prefers the relationship between the sharply-focused subject and the background at f/8, saying that the subjects at f/11 look "chiseled out of stone."

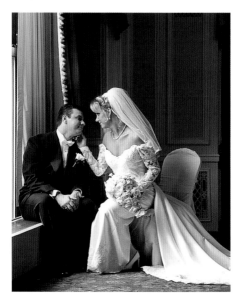

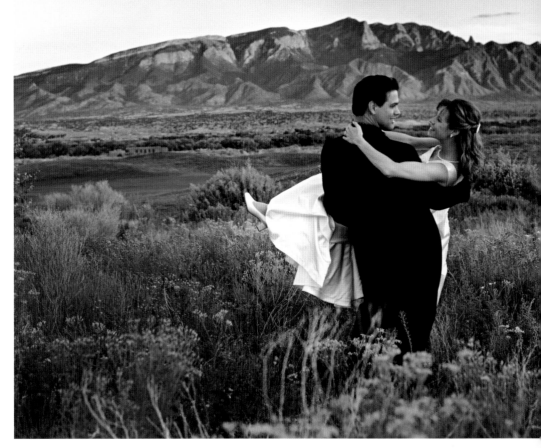

■ DEPTH OF FOCUS

When working up close at wide lens apertures where depth of field is reduced, you must focus carefully to hold the eyes, lips and tip of the nose in focus. This is where a good working knowledge of your lenses is essential. Some lenses will have the majority (two thirds) of their depth of field behind the point of focus; others will have the majority (two thirds) of their depth of field in front of the point of focus. In most cases, depth of field is split 50/50, half in front of and half behind the point of focus. It is important that you know how your different lenses operate and to check the depth of field with the lens stopped down to your taking aperture, using your camera's depth-of-field preview control.

With most lenses, if you focus one third of the way into the group or scene, you will ensure optimum depth of focus at all but the widest apertures. Assuming that your depth of field lies half in front and half behind the point of focus, it is best to focus on the eyes in a group close-up. The eyes are the region of greatest contrast in the face, and thus make focusing easier. This is particularly true for autofocus cameras that often seek areas of highest contrast on which to focus.

Focusing a ¾- or full-length portrait is a little easier because you are farther from the subjects, where depth of field is greater. With small groups, it is essential that the faces fall in the same focusing plane. This is accomplished with posing and careful maneuvering of your subjects or camera position.

■ MAKING THE FILM PLANE PARALLEL TO THE SUBJECT

Suppose your wedding group is large and you have no more room in which to make the portrait. One solution is to raise the camera height, angling the camera downward so that the film plane is more parallel to the plane of the group. You have not changed the amount of depth of field that exists at that distance and lens aperture, but you have optimized the plane of focus to accommodate depth of the group. By raising the camera height, you are effectively shrinking the depth of the group, making it possible to get front and back rows in focus at the same time.

■ SHIFTING THE FOCUS FIELD

Lenses characteristically focus objects in a more or less straight line—but not completely straight. If you line your subjects up in a straight line and back up so that you are a distance away from the group, all subjects will be rendered sharply at almost any aperture. At a distance, however, image size is small. As a result, you must move closer to the group, making those at the ends of the group proportionately farther away from the lens than those in the middle of the lineup.

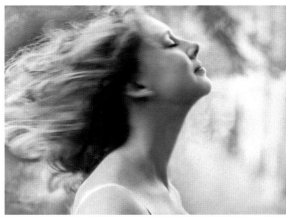

Top: Fading twilight and no fill-in source of light meant that Frank Frost had to precisely define the band of focus. He made this image on a Hasselblad with an 80mm lens and allowed the foreground and background to drift out of focus. He arranged the pose so the plane of necessary focus was parallel to the film plane. **Above:** This elegant portrait made by Elaine Hughes uses a slight focus shift to attain its elegant softness. The image is slightly front-focused, keeping the near shoulder in focus, but the woman's face is slightly soft. A very thin zone of focus helps make this an effective stylized portrait. The use of motion in her hair helps to heighten its dreamlike illusion.

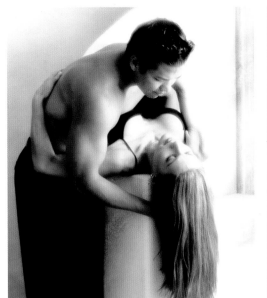

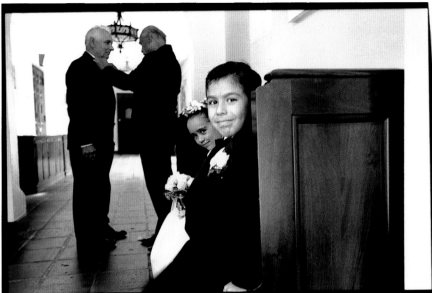

Left: This lovely engagement portrait made by Ira Ellis uses a very narrow plane of focus to soften its edges. The zone of focus is really the frontal planes of the two faces, which are positioned directly in line with each other to better facilitate focusing. Right: Using a wide-angle lens, with more inherent depth of field than a normal or telephoto lens, photojournalist Scott Streble focused on the little girl, a point ⅓ of the way into the composition. Even though the light was dim, he was able to hold acceptable focus on the little boy and the two gentlemen in the background. Knowing your lenses' depth of field and depth of focus parameters makes capturing this kind of image decision-free.

Those farthest from the lens will be difficult to keep in focus. The solution, simply, is to bend the group, making the middle of the group step back and the ends of the group step forward so that all of the group are the same relative distance from the camera. To the camera, the group looks like a straight line, but you have actually distorted the plane of sharpness to accommodate the group.

■ CHOOSING THE RIGHT SHUTTER SPEED

You must choose a shutter speed that stills both camera and subject movement. If using a tripod, $\frac{1}{15}$ to $\frac{1}{60}$ second should be adequate to stop average subject movement. If you are using electronic flash, you are locked into the flash sync speed your camera calls for—unless you are "dragging" the shutter. Dragging the shutter means working at a slower than X-sync speed to bring up the level of the

ambient light. This effectively creates a balanced flash exposure with the ambient-light exposure.

It should be noted that 35mm SLRs have a different shutter type than medium and large format cameras. 35mm SLRs use a focal plane shutter, which produces an X-sync speed for electronic flash use of anywhere from $\frac{1}{60}$ to $\frac{1}{400}$ of a second. The X sync speed is always marked in a different color on the shutter speed dial. Many medium format cameras use lens-shutters, which allow you to synchronize with electronic flash at any shutter speed. Using the technique of "dragging the shutter" you can shoot at any shutter speed slower than the X-sync speed with a SLR camera and still maintain flash synchronization. If you shoot at a shutter speed faster than the X-sync speed with an SLR, the flash will only partially expose the film frame.

When working outdoors, you should normally choose a shutter speed faster than $\frac{1}{60}$ second, because even a slight breeze will cause the subjects' hair to flutter, producing motion during the moment of exposure.

When handholding the camera, you should use the reciprocal of the focal length of the lens you are using for a shutter speed. For example, if using a 100mm lens, use $\frac{1}{100}$ second (or the next highest equivalent shutter speed, like $\frac{1}{125}$) under average conditions. If you are very close to the subjects, as you might be when making a portrait of a couple, you will need to use an even faster shutter speed because of the increased image magnification. When farther away from the subject, you can revert to the shutter speed that is the reciprocal of your lens's focal length.

One great technical improvement is the development of image stabilization lenses. These lenses correct for camera movement and allow you to shoot handheld with long lenses and relatively slow shutter speeds. Canon and Nikon, two companies that currently offer this feature in some of their lenses, offer a wide variety of zooms and long focal length lenses with image stabilization. If using a

zoom, for instance, which has a maximum aperture of f/4, you can still shoot handheld wide open in subdued light at ¹/₁₀ or ¹/₁₅ of a second and get dramatically sharp results. The benefit is that you can use the light longer in the day and still shoot with fine grain ISO 100 and 400 films. Subject movement will not be quelled with these lenses, only camera movement.

When shooting groups in motion, use a faster shutter speed and a wider lens aperture. It's more important to freeze subject movement than it is to have great depth of field for this kind

of shot. If you have any question as to which speed to use, always use the next fastest speed to ensure sharpness.

Some photographers are able to use impossibly long exposures, like ¼ or ½ second, handheld. They practice good breathing and shooting techniques to accomplish this. With the handheld camera laid flat in the palm of your hand and your elbows in against your body, take a deep breath and hold it. Do not exhale until you've "squeezed off" the exposure. Use your spread feet like a tripod and if you are near a doorway, lean against

it for additional support. Wait until the action is at its peak (all subjects except still lifes are in some state of motion) or at least subdued to make your exposure. I have seen the work of photographers who shoot in impossible low-light conditions come back with available-light wonders by practicing these techniques.

■ EXPOSURE TECHNIQUES

Film companies are somewhat notorious for overrating the film speed of their products. For that reason, most pros are skeptical and will automatically underrate their film to produce slightly more exposure detail in the shadows.

The wedding day presents the ultimate in extremes—a black tuxedo and a white wedding dress. Both extremes require the photographer to hold the detail in them, but neither is as important as proper exposure of skin tones. Although this will be discussed later in the section on lighting, most pros will opt for a minimal lighting ratio of about 3:1 so that there is detail in

Top: This expertly crafted image by Brian Shindle required a very wide-angle lens and a relatively small aperture to hold the focus from the top of the banister to the lighted area where the bride and groom were dancing. Brian used a single blue-gelled flash discretely positioned behind the bride and groom to produce a rim-light effect. He then "dragged the shutter" to properly expose for all the incandescent lights in this beautiful room. In addition, he had to split focus, focusing probably on the chandelier, to get all regions of the image sharp. Bottom: Ferdinand Neubauer describes the making of this image: "Jamie and Yasmin came to my studio for their engagement 'Love Story' portrait session. I noticed they brought along casual outfits as well as formal attire for their portrait. Although we had planned to do the session indoors, I suggested after we do some studio formals, we go to one of my favorite parks in my area to photograph them in their casual outfits, since Jamie's shirt complemented the fall foliage beautifully. Jamie was a musician, so I brought along my guitar to be used in one of the photographs. I set them up in a romantic setting and had him sing to Yasmin to get the feeling I was after. This photograph was made in the late afternoon with my 100mm lens on my Hasselblad, natural light with no artificial lights or reflectors. Kodak Portra 400NC film rated at ISO 320 was used. A Leon Vignetter was placed in my Lindahl lens shade."

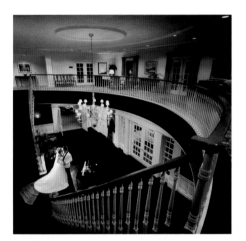

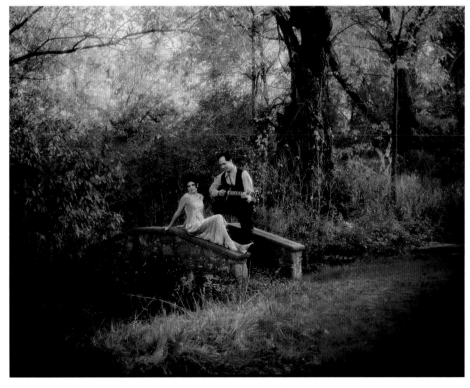

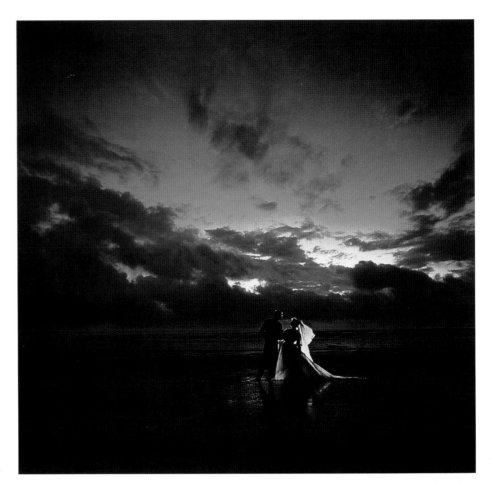

both facial shadows and highlights. They will fill the available light with flash or reflectors in order to attain that medium lighting ratio and this frees them to concentrate on exposures that are adequate for the skin tones.

Metering. The preferred type of meter for portraiture is the handheld incident light meter. This does not measure the reflectance of the subjects, but measures the amount of light falling on the scene. Simply stand where you want your subjects to be, point the hemisphere (dome) of the meter directly at the camera lens and take a reading. This type of meter yields extremely consistent results, because it measures the light falling on the subjects rather than the light reflected from them. It is less likely to be influenced by highly reflective or light-absorbing surfaces.

It is advisable to run periodic checks on your meter if you base the majority of your exposures on its data. You should do the same with any in-camera meters you use frequently. If your incident meter is also a flashmeter, you should check it against a second meter to verify its accuracy. Like all mechanical instruments, meters can be temporarily out of whack and need periodic adjustment.

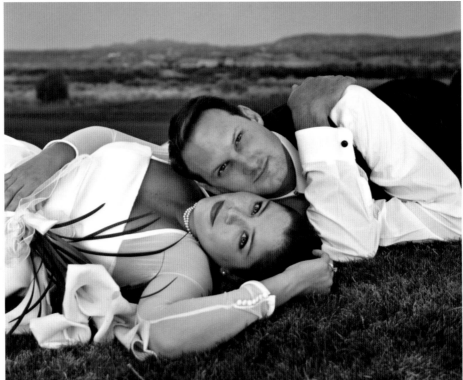

Because the contemporary wedding encompasses so many different types of photography, it is essential for the wedding photographer to be well versed in all these disciplines. No pictures are more important to the bride and groom than the engagement photo and formal portraits. The engagement portrait is often used in newspapers and local magazines to announce the couple's wedding day, and it is a portrait that can enrich the wedding photographer's profits significantly. These portrait may be (and usually are) made in advance of the wedding day, providing the much needed time to get something really spectacular. According to talented wedding photographer Kelly Greer, "I try to shoot an engagement portrait of every couple before the wedding so that we've worked together before and are familiar with each other's styles and personalities. I also find out what they want and expect from me." By the wedding day, the couple and the photographer are familiar with each other, making the photography go much easier.

The formal portraits of the bride and groom together and of each alone are also significant images that demand special time allotted to them and an understanding of classical pos-

Studio Lighting

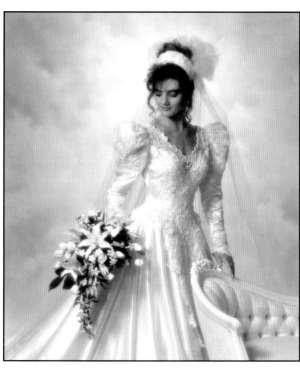 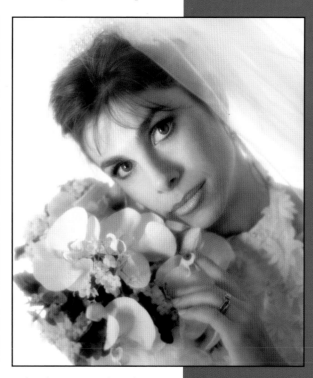

Left: This image by photographer Rita Loy has won numerous national and state awards and is a beautiful example of a high-key bridal portrait. Masterful control of light is the hallmark of this image. There is ample highlight detail and tonal separation of all of the white tones in the image. The key to this image's success is the relatively strong lighting ratio and the strength of the lighting pattern coming from a dominant key light. The lighting pattern is a modified "loop" lighting with excellent facial contouring. **Right:** Monte Zucker, who used his Hasselblad with a 150mm lens, originally created this delicate high-key portrait for a *Rangefinder* magazine cover. The image is made using only daylight. The background is a Westcott translucent panel with direct light coming through it. Two Monte Illuminators (reflectors) were used, one in main light position and the second reflector positioned to camera-right, forward of her face to open up the shadows created with the first main-light reflector. Notice the delicate "S" curve of the hand, which leads the eye up to the bride's eyes, the focal point of the composition.

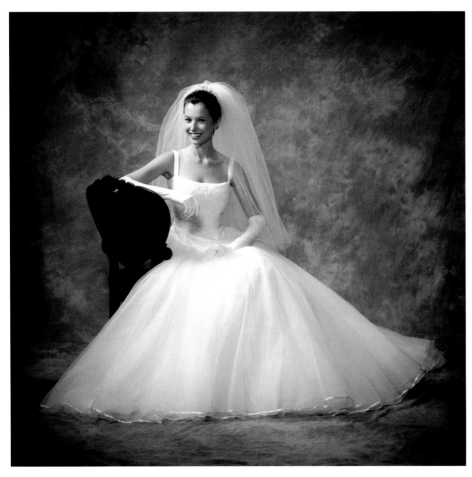

ing and lighting techniques. Often the photographer will arrange to make the formal portraits on the day of the wedding, but several hours before the day's schedule commences. Couples relish the alone time and it is the perfect opportunity for the photographer to break the ice with the couple.

Because of the importance of these images, it is essential that the accomplished wedding photographer be skilled in studio portraiture, which is quite different but related to the techniques he or she normally employs on the wedding day. The key to understanding good lighting and creating it in your photographs is to understand the concept of "single-light" lighting. The sun is the primary light source in all of nature, and all lighting emanates from the sun. While there may be secondary light sources in nature, they are all subservient to the sun. So it is in the studio.

■ THE FIVE LIGHTS

Basic portrait lighting techniques can be done with as few as two lights, but to get the full effect of elegant portrait lighting, a full set of five lights with stands and parabolic reflectors is recommended. Most photographers opt for studio strobes; either self-contained monolight-type strobes, or those systems using a single power pack into which all lights are plugged. Some use a combination of the two types. A full system of reflectors and diffusers is required with any lighting system. The five lights are the key light, the fill light, the hair light, the background light, and the optional kicker, a backlight used for shoulder or torso separation.

Key and Fill Lights. The key and fill lights should be high-intensity lights in parabolic reflectors. Reflectors should be silver-coated on the inside to reflect the maximum amount

of light. Most photographers don't use parabolic reflectors anymore, opting for diffused key and fill-light sources. If using diffusion, umbrellas or soft boxes, the entire light assembly should be supported on a sturdy light stand.

The key light, if undiffused, should have barn doors affixed. These are black, metallic, adjustable flaps that can be opened or closed to control the width of the beam of the light. Barn doors ensure that you light only the parts of the portrait you want lighted. They also keep stray light off the camera lens, which can cause flare.

The fill light, if in a reflector, should have its own diffuser, which is nothing more than a piece of frosted plastic or acetate in a screen that mounts over the reflector. The fill light should also have barn doors attached. If using a diffused light source, such as an umbrella or soft box for a fill light, be sure that you do not "spill" light into unwanted areas of the scene, such as the background or onto the taking lens. All lights, whether in reflectors of diffusers, should be "feathered" by aiming the core of light slightly away from the subject, employing the edge of the beam of light.

Hair Light. The hair light is a small light. Usually it takes a scaled-down reflector with barn doors for control, and a reduced power setting,

because hair lights are almost always used undiffused. Barn doors are a necessity, since this light is placed behind the subject to illuminate the hair; without barn doors, the light will cause lens flare.

Background Light. The background light is also a low output light. It is used to illuminate the background so that the subject and background will separate tonally. The background light is usually used on a small stand placed directly behind the subject, out of view of the camera lens. It can also be placed on a higher stand or boom and directed onto the background from either side of the set.

Kicker. Kickers are optional lights used similarly to hair lights. These add highlights to the sides of the face or body to increase the feeling of depth and richness in a portrait. Because they are used behind the subject, they produce highlights with great brilliance, as the light just glances off the skin or clothing. Since kickers are set behind the subject, barn doors should be used.

■ BROAD AND SHORT LIGHTING
There are two basic types of portrait lighting. Broad lighting means that the key light is illuminating the side of the face turned toward the camera. Broad lighting is used less frequently than short lighting because it flattens and de-emphasizes facial contours. It is often used to widen a thin or long face.

Short lighting means that the key light is illuminating the side of the face turned away from the camera. Short lighting emphasizes facial contours, and can be used as a corrective lighting technique to narrow a round or wide face. When used with a weak fill light, short lighting produces a dramatic lighting with bold highlights and deep shadows.

■ THE FIVE BASIC
PORTRAIT LIGHTING SETUPS
Paramount Lighting. Paramount lighting, sometimes called butterfly lighting or glamour lighting, is a lighting pattern that produces a symmetrical, butterfly-shaped shadow directly beneath the subject's nose. It emphasizes cheekbones and good skin. It is generally not used on men because it tends to hollow out cheeks and eye sockets too much.

For this style, the key light is placed high and directly in front of the subject's face, parallel to the vertical line of the subject's nose. Since the light must be high and close to the subject to produce the wanted butterfly shadow, it should not be used on women with deep eye sockets, or very little light will illuminate the eyes. The fill light is placed at the subject's head height directly under the key light. Since both the key and fill lights are on the same side of the camera, a reflector must be used opposite these lights and in close to the subject to fill in the deep shadows on the neck and shaded cheek.

The hair light, which is always used opposite the key light, should light the hair only and not skim onto the face of the subject. The background light, used low and behind the subject, should form a semi-circle of illumination on the seamless background (if using one) so that the tone of the background grows gradually darker toward the frame edges.

Loop Lighting. Loop lighting is a minor variation of paramount lighting. The key light is lowered and moved more to the side of the subject so that the shadow under the nose becomes a small loop on the shadow side of the face. This is one of the more commonly used lighting setups and is ideal for people with average, oval-shaped faces.

The fill light is moved to the opposite side of the camera from the key light in loop lighting. It is used close to the camera lens. It is important that the fill light not cast a shadow of its own in order to maintain the one-light character of the portrait. The only place you can really observe if the fill light is doing its job is at the camera position. Judge to see if the fill light is casting a shadow of its own by looking through the viewfinder.

The hair light and background lights are used the same way they are in paramount lighting.

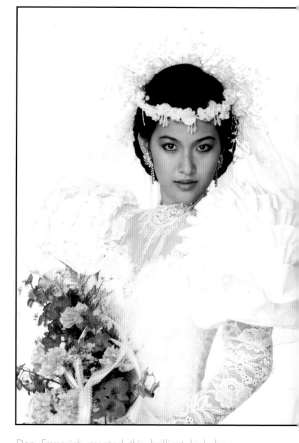

Don Emmerich created this brilliant high key bride. The background is the whitest portion of the image. All other significant tones of the dress are slightly darker, creating uniform separation throughout. The image is just barely broad lighting, although the bride's face is almost directly facing the lens. Of particular note here are the dual catchlights, top and bottom. The eye is drawn to the dark area between the two highlights.

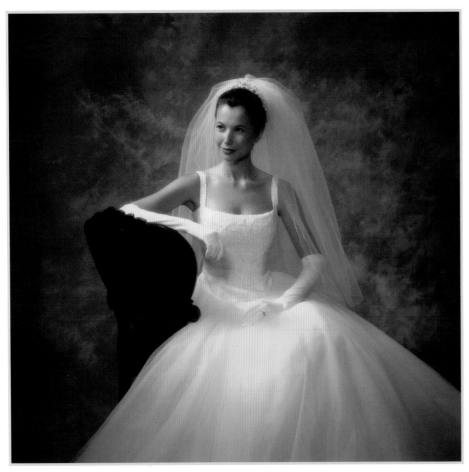

Rembrandt lighting produces a diamond shaped highlight on the shadow side of the subject's face. A good lighting ratio of 3:1 or even a little more helps to clearly define the lighting pattern. Photograph by Michael Ayers.

Rembrandt Lighting. Rembrandt or 45-degree lighting is characterized by a small, triangular highlight on the shadowed cheek of the subject. The lighting takes its name from the famous Dutch painter who used a skylight to illuminate his subjects. This type of lighting is dramatic and more often a masculine lighting and is used commonly with a weak fill light to accentuate the shadow-side highlight.

The key light is moved lower and farther to the side than in loop and paramount lighting. In fact, the key light almost comes from the subject's side, depending on how far his or her head is turned away from the camera.

The fill light is used in the same manner as it is for loop lighting. The hair light, however, is often used a little closer to the subject for more brilliant highlights in the hair. The background light is in the standard position.

With Rembrandt lighting, kickers are often used to delineate the sides of the face. As with all front-facing lights, avoid shining them directly into the lens. The best way to check is to place your hand between the subject and the camera on the axis of the kicker, and see if your hand casts a shadow on the lens. If so, then the kicker is shining directly into the lens and should be adjusted.

Split Lighting. Split lighting is when the key light illuminates only half the face. It is an ideal slimming light. It can also be used with a weak fill to hide facial irregularities. Split lighting can be used with no fill light for dramatic effect.

In split lighting, the key light is moved farther to the side of the subject and lower. In some cases, the key light may be slightly behind the subject, depending on how far the subject is turned from the camera. The fill light, hair light, and background light are used normally for split lighting.

Profile or Rim Lighting. Profile or rim lighting is used when the subject's head is turned facing 90 degrees from the camera lens. It is a dramatic style of lighting used to accent elegant features. It is used less frequently now than in the past, but it is still stylish portrait lighting, even today.

In rim lighting, the key light is placed behind the subject so that it illuminates the profile of the subject and leaves a polished highlight along the edge of the face. The key light will also highlight the hair and neck of the subject. Care should be taken so that the accent of the light is centered on the face and not so much on the hair or neck.

The fill light is moved to the same side of the camera as the key light and a reflector is used to fill in the shadows. An optional hair light can be used on the opposite side of the key light for better tonal separation of the hair from the background. The background light is used normally.

■ OVERLIGHTING
In setting the lights, it is important that you position the lights gradually, studying their effect as you use more and more light aimed at the subject. If you merely point the light directly at the subject, you will probably overlight the person, producing pasty highlights with no detail.

Adjust the lights carefully, and observe the effects from the camera position. Instead of aiming the light so

that the core of light strikes the subject, feather the light so that you employ the edge of the light to light the subject. The trick is to add brilliance to your highlights. This is achieved by careful lighting. The highlights, when brilliant, have minute specular (pure white) highlights within the main highlight. This further enhances the illusion of great depth in a portrait.

Sometimes feathering won't make the skin "pop" (show highlight brilliance) and you'll have to make a lateral adjustment to the light or move it back from its current position. A good starting position for your key light is 8–12 feet.

◼ DOUBLE SHADOWS AND CATCHLIGHTS
The fill light can pose its own set of problems. If too close to the subject, the fill light will produce its own set of specular highlights that show up in the shadow area of the face, making the skin appear excessively oily. To solve the problem, move the camera and light back slightly or move the fill light laterally away from the camera slightly. You might also feather the light into the camera a bit. This method of limiting the fill light is preferable to closing down the barn doors to lower the intensity of the fill light.

The fill light often creates multiple catchlights in the subject's eyes. These

Rita Loy created this elegant portrait of an Oriental bride in her wedding dress. Notice the sophisticated posing of the hand and the delicate control of lighting. The key light in this profile pose is behind and above the bride, creating a cross between a loop and 45-degree lighting pattern. The image uses soft focus, so the highlights glow. The highlight that runs the length of the hand-carved wood of the love seat provides a beautiful compositional base. The fill light is ample but about a stop less than the key light. Kickers are used to produce elegant edge highlights on the hair and the left hand. This photo is also a major award winner.

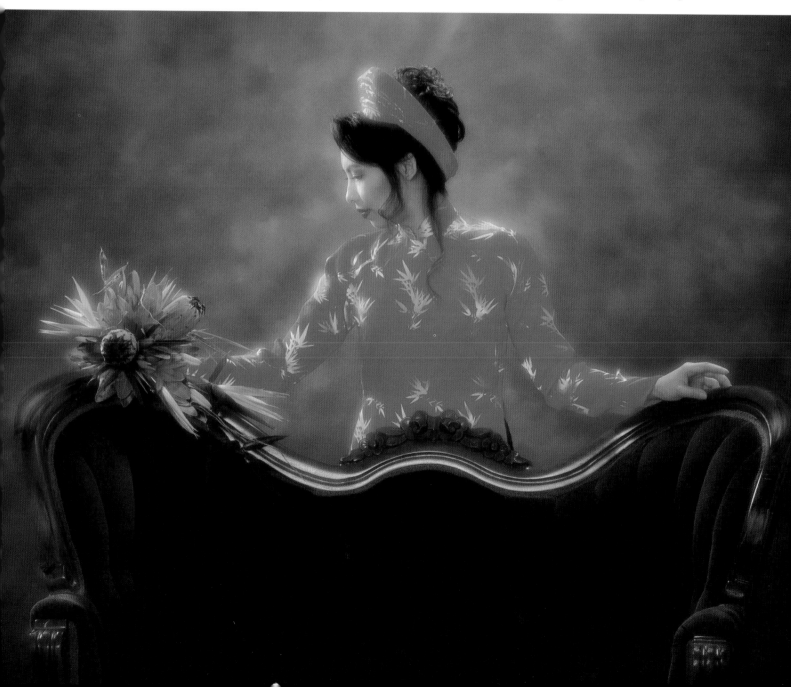

are small specular highlights (pure white) on the iris. With fill light you will get a set of catchlights from the fill as well as the primary set from the key light. The effect of two catchlights is to give the subject a directionless gaze. This second set of catchlights is usually removed later in retouching. When using a large diffused fill light, there is usually not a problem with dual catchlights. Instead, the fill produces a large milky highlight that is much less objectionable.

▣ LIGHTING RATIOS

The term "lighting ratio" describes the difference in intensity between the shadow and highlight sides of the face and is expressed as a ratio—3:1, for example, meaning that the highlight side of the face is three times brighter than the shadow side. Ratios are useful because they determine how much overall contrast there will be in the portrait. They do not determine scene contrast (the subject's clothing, the background and the tone of the face determine that), but rather, lighting ratios determine the lighting contrast measured at the subject.

Lighting ratios indicate how much shadow detail you will have in the final portrait. Since the fill light controls the degree to which the shadows are illuminated, it is important to keep the lighting ratio fairly constant. A desirable ratio for color film is 3:1, because of the limited tonal range of color printing papers. Black & white films can stand a greater ratio—up to 8:1—although at this point it takes a near-perfect exposure to hold detail in both highlights and shadows.

Ratios are determined by measuring the intensity of the fill light on both sides of the face with a light meter, and then measuring the intensity of the key-light side of the face only. If the fill light is next to the camera, it will cast one unit of light on each side (shadow and highlight sides) of the face. The key light, however, only illuminates the highlight side of the face.

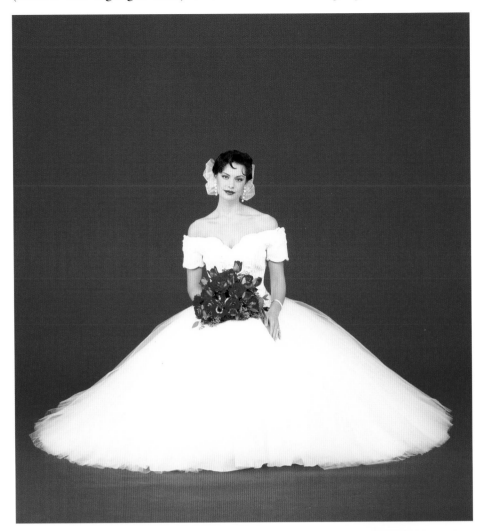

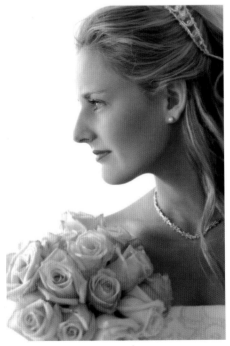

Above: Phil Kramer produced this gorgeous and uncharacteristic bridal portrait. Almost editorial in personality, this portrait uses a bank of three diffused frontal lights to wash the set in soft light. The main soft box is to the left of the model. The other two light sources are smaller but also diffused. There is no lighting pattern and although it is a very high lighting ratio, there is beautiful facial modeling. There are no backlights used. **Right:** Monte Zucker is the master of using daylight like studio light. Here he diffuses direct sunlight that is coming from behind the bride and fills that light with a reflector beneath the camera. Notice the elegant wraparound effect. Monte softened the near cheek in Photoshop so that only the bride's eyes are sharply focused.

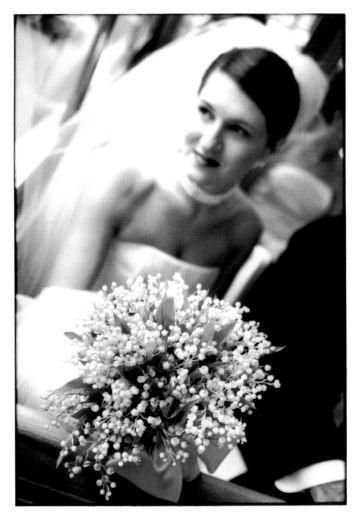

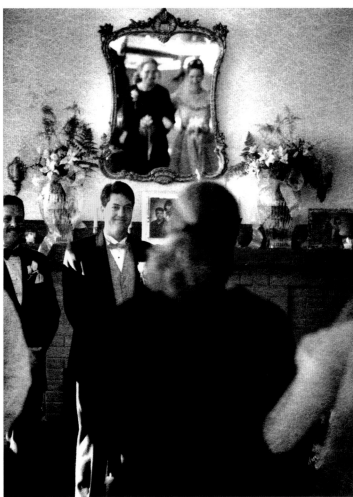

If the key is the same intensity as the fill light, then you have a 2:1 ratio. A 2:1 ratio shows minimal roundness in the face and is desirable for high key effects. High key portraits are those with low lighting ratios, light tones, and usually a white or light-toned background.

A 3:1 ratio occurs when the key light is one stop greater in intensity than the fill light. This yields an exposure with excellent shadow and highlight detail. It shows good roundness and is ideal for rendering most faces.

A 4:1 ratio is used when a slimming or dramatic effect is desired. In a 4:1 ratio, the shadow side of the face loses its glow and the accent becomes the highlights. Ratios of 4:1 and higher are considered low key portraits, which are characterized by dark tones and a dark background.

A 5:1 ratio and beyond is considered almost a high-contrast rendition. Shadow detail is minimal at the higher ratios and as a result, they are not recommended for color films unless your only concern is highlight detail. The higher the lighting ratio the thinner the subject's face will appear.

■ METERING

If using an incident meter, hold it at the subject's nose and point it directly back toward the camera lens position. If any of the backlights (like the hair lights or the kickers) are shining on the meter's light-sensitive hemisphere, shield the meter from them, as they will adversely affect exposure. You are only interested in the intensity of the frontal lights when determining exposure.

■ CLASSICAL LIGHTING AT THE WEDDING

While the basic lighting patterns do not have to be used with absolute precision, it is essential to know what they are and how to achieve them. If, for instance, you are photographing your

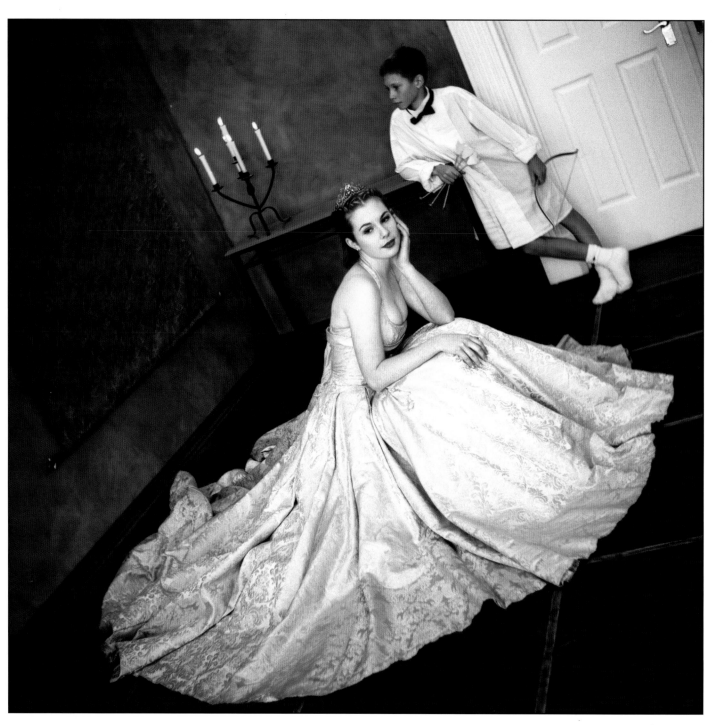

David Anthony Williams created this fascinating wedding portrait using tungsten-balanced film with a combination of daylight and tungsten lighting. The main light, behind the camera, bathes the bride in very soft light, almost like a fashion type of lighting. The secondary subject, young Cupid, is exposed partially by the daylight and the candlelight and whatever room light is turned on. Due to mixing light sources, there is an intentional off-coloration to the image that adds to its dreamlike quality.

bride and groom outdoors, you can position a single key light to produce the desired lighting pattern and ratio, and use the ambient light (shade, or sun as backlighting) as the fill light. No other lights are needed to produce every one of the five basic portrait lightings. Use of reflectors, instead of an independent fill light or kickers, may accomplish much the same thing in terms of controlling light.

You can also create an elegant profile of the bride with a single flash used as a backlight, outlining the edges of her face, neck and the wedding veil. Use the daylight as fill, and only one light is required to produce an elegant, classically lit portrait.

Another aspect of classical portrait lighting is the use of lighting ratios, which are just as effectively employed outdoors as they are in the studio.

Weddings are photographed in almost every kind of light you can imagine—open shade, bright sun, dusk, dim room light, and every combination in between. Savvy wedding photographers must feel at home in all these different situations and know how to get great pictures in them. Subjects may be backlit, sidelit, toplit or frontlit. Good outdoor lighting is really what separates the good wedding photographers from the great ones. Learning to control, predict and alter these various types of light will allow the photographer to create great wedding pictures all day long.

■ DIRECT SUNLIGHT

Sometimes you are forced to photograph your wedding groups in bright sunlight. While not the best scenario, it is still possible. Turn your group so the direct sunlight is backlighting or rimlighting the group. Backlighting negates the harshness of the light and prevents your subjects from squinting. Of course, you need to fill in the backlight with strobe or reflectors and you also need to be careful not to underexpose in backlit situations. It is best to give your exposure another ⅓ to ½ stop of exposure in backlit portraits in order to "open up" the skin tones.

Don't trust your in-camera meter in backlit situations. It will read the bright background and highlights on the hair instead of the exposure on the face. If you expose for the background light intensity, you will silhouette the subject. As usual, it is best to use the handheld incident meter in these situations. Shield the meter from any backlight, so you are only reading the light on the faces.

If the sun is low in the sky, you can use cross lighting to get good modeling on your subjects. You must be careful to position the subjects so that

Outdoor and Mixed Lighting

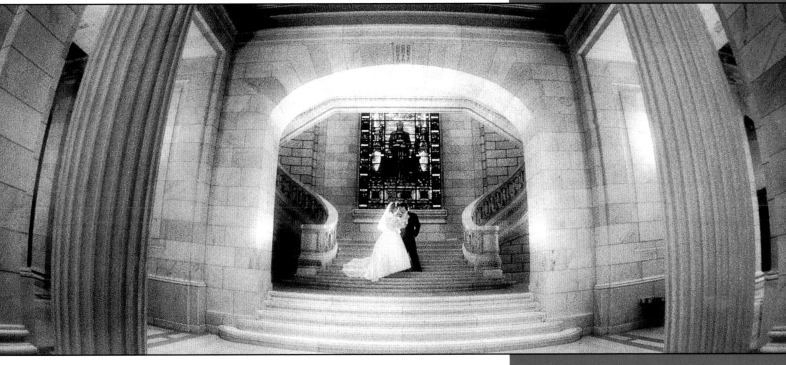

Travis Hill, the son of Barbara and Patrick Rice, created this interesting bridal portrait using a panoramic format and several flash units, hidden from camera view by the walls and pillars. A flash is also hidden behind the bride and groom to illuminate her veil. Using a flashmeter simplifies exposure calculation, allowing you to adjust the output of each flash being used until just the right effect is achieved.

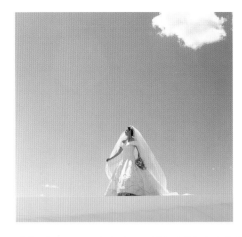

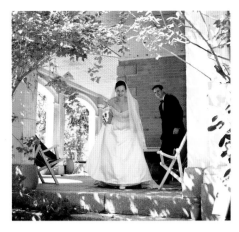

Top Left: Few wedding photographers would attempt a formal bridal portrait in the desert in bright sunlight. Enter Heidi Mauracher, who makes it work. Heidi positioned the bride so the sun was behind the bride. The dress and sand filled in the shadows well. The bonus in this composition is the big fluffy cloud that happened by, creating a beautiful balance between itself and the bride. **Top Right:** David Anthony Williams is a master at finding great light. Here, with direct sunlight lighting the exterior of the building, the porch is nestled in bright directional shade. No fill source was used, only the light bouncing around on the porch. Notice the direction of the light—on the bride, the main light seems to come from the right, while the main light on the groom seems to be coming from the opposite direction. **Bottom:** Minutes before this photo, Ferdinand Neubauer was photographing Carrie with her parents. He had the camera on a tripod, which was adjusted with two legs on one step and the other leg on another. According to Ferdy, "I had to move in closer, but instead of readjusting the tripod I figured I would hold onto it for just one shot. Wrong thing to do! I walked over to fix Carrie's veil and forgot my camera wasn't too steady—I heard moans as my tripod tipped over. I saw pieces go flying. Still, I had to remain calm and reassure the bride. I put my flash back together, changed shades and tested my flash and lens. The only damage was to the lens shade and my soft focus filters, which cushioned the impact on the 100mm lens I was using which was in fine working order. The photograph was made in the bride's yard where the lighting was beautiful. A natural backlight came in from behind, highlighting the gown and veil. I positioned the flower girls to add to the storytelling appeal and softened it with my Stephen Rudd warm soft filter. A week fill was added (with flash) to the shadow area. The image was taken on my Hasselblad with a 100mm lens. The film was Portra 400NC. It was made into black & white and then a hint of brown tone was added in Photoshop. A short time following the wedding, Carrie sent me a thank-you card and said she was sorry for breaking my camera."

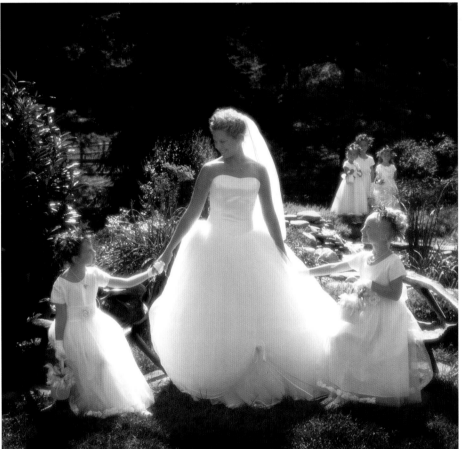

the sun's side lighting does not hollow out eye sockets on the highlight side of the face. Subtle repositioning will usually correct this. You'll need fill-in on the shadow side to preserve detail. Try to keep your fill-in flash output about ½ to one stop less than your main light exposure.

■ CONTRAST CONTROL IN BRIGHT SUN
Images made in bright sunlight are unusually contrasty. To lessen that

contrast try using telephoto lenses or zooms, which have less inherent contrast than shorter lenses. You can noticeably soften the image contrast by using a telephoto lens.

■ OPEN SHADE
By far the best place to make outdoor portraits is in the shade, away from direct sunlight. Shade is nothing more than diffused sunlight. Contrary to popular belief, shade is not direction-

less. Particularly out in the open, shade has a definite overhead cast, creating deep shadows in the eye sockets and under the noses and chins of the subjects. The best shade is found in or near a clearing or an overhang or around buildings, where diffused shade filters in from the sides, canceling out the overhead nature of the light. Such light produces excellent modeling on the faces.

Open shade is soft light that is reflected from the sky on overcast days. It is different than shade created by direct sunlight being blocked by obstructions, such as trees or buildings. This light has sideways direction, which is a more pleasing light for portraiture. Open shade can be particularly harsh, especially at midday when the sun is directly overhead. The open shade takes on the same characteristics as overhead sunlight. Open shade can be tamed and made useful by finding an overhang, like tree branches or a porch, which blocks the overhead light, but allows soft shade light to filter in from the sides, producing direction and contouring on the subject.

If forced by circumstance to shoot your subjects out in open shade, you must fill in the shade with a frontal flash or reflector. If shooting the bride

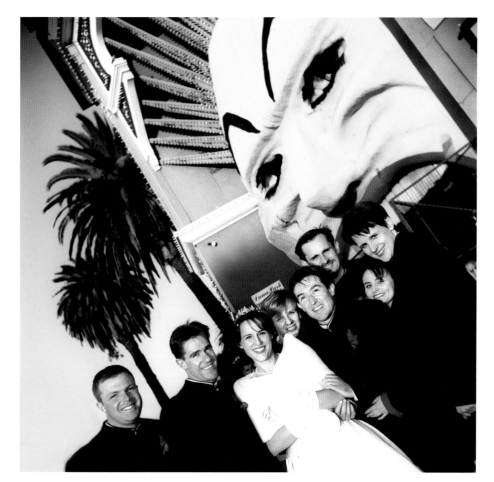

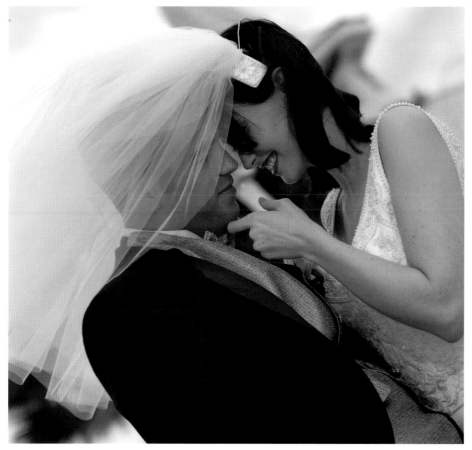

Top: This is another example of an effective group portrait made in direct sunlight with no fill-in. David Anthony Williams utilized the late afternoon sun, low in the sky. As the direct sun starts to become diffused twilight, the light loses its harshness and this is when the portrait was made. Bottom: Rick Ferro made this image in what appears to be open shade, however, he used a weak flash to fill in the shadows and get the beadwork on the dress to sparkle. The flash was set to the same output as the daylight exposure.

or the bride and groom, a reflector held close to and beneath your subjects should suffice for filling in the shadows created by open shade. If photographing more than two people, then fill-flash is called for. The intensity of the light should be about equal to the daylight exposure.

Even experienced photographers sometimes can't tell the direction of the light in open shade, particularly in mid-morning or mid-afternoon. A simple trick is to use a piece of gray or white folded card—an index card works well. Crease the card in the middle but don't fold it, let the two sides waggle. Held vertically and pointed toward the camera, the card

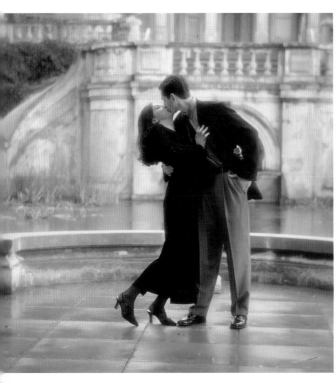

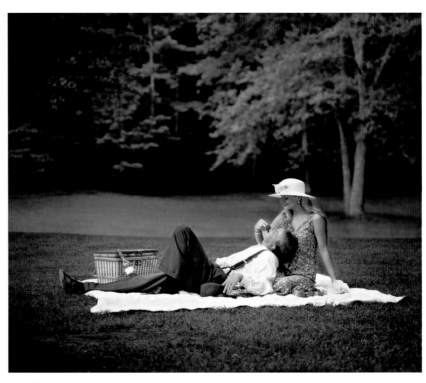

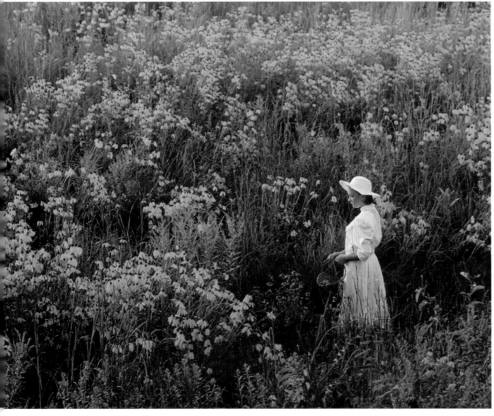

Top Left: Open shade in an enclosed area with buildings nearby has the effect of producing directional shade. Here, noted wedding photographer Jerry D found a location that was surrounded with buildings and alternating open spaces. While in shade, the couple is lit from the right by a column of diffused sunlight. The bride is highlighted by soft indirect sunlight from behind. Seeing good lighting in nature is a refined skill. Top Right: In open shade, which is overhead in nature, unless you use a means of filling the shadows, the lighting will not be flattering. Here photographer Rita Loy harnessed the open shade in two ways: first, the bride's hat softens the shade on her face and second, the groom is looking up into the sky, so the overhead light is now bathing the frontal planes of his face. Left: Using available sunlight is a risky proposition except late in the day when it is diffuse. Gary Fagan created this memorable portrait of a summer bride in a field of black-eyed Susans. The sunlight, low on the horizon, shines through the flowers, making them translucent, and skims across the face of the bride. Her white dress does the job of a reflector and fills in the shadows.

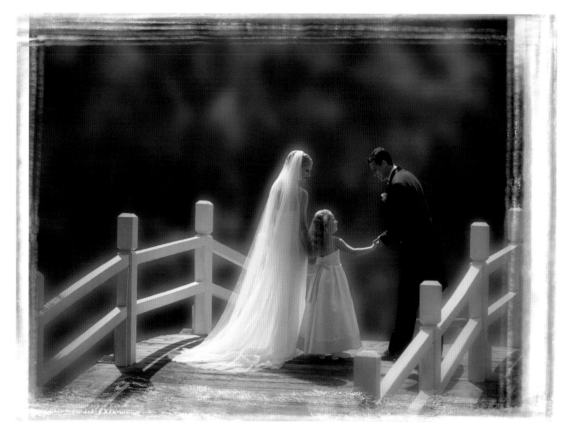

will tell you if the light is coming from the right or left and how intense the ratio between highlight and shadow is. Held with the fold horizontal and pointed toward the camera, the card will tell you if the light is vertical in nature, coming from above. Sometimes, using this handy tool, you can gauge when a slight adjustment in subject or camera position will salvage an otherwise good background.

■ TWILIGHT, THE BEST LIGHT

The best time of day for making great pictures is just after the sun has set. The sky becomes a huge softbox and the effect of the lighting on your subjects is soft and even, with no harsh shadows.

There are three problems with working with this great light. First, it's dim. You will need to use medium to fast films combined with slow shutter speeds, which can be problematic. Working in subdued light also restricts your depth of field, as you have to choose wide apertures. The second problem in working with this light is that twilight does not produce catch-lights, white specular highlights in the eyes of the subjects. For this reason, most photographers augment the twilight with some type of flash, either barebulb flash or softbox-mounted flash that provides a twinkle in the eyes. Thirdly, twilight is difficult to work with because it changes so rapidly. The minutes after sunset or before sunrise produce changing light levels. Meter often and adjust flash output, if using fill-flash, to compensate.

■ A SINGLE MAIN LIGHT, ALWAYS

It is important to have only one main light in your images. This is fundamental. Other lights can modify the main light, but there should always be a single defining light source. Most photographers who shoot a lot of outdoor portraits subscribe to the use of a single main light for groups, indoors or out, and filling the shadows of the main light with one or more flash units.

■ REFLECTORS

Like the stepladder, it is a good idea to take along a selection of portable light reflectors to every wedding. Reflectors should be fairly large for maximum versatility. Light discs, which are reflectors made of fabric mounted on flexible and collapsible circular frames, come in a variety of diameters and are a very effective means of fill-in illumination. They are available from a number of manufacturers and come in silver (for maximum fill output), white, gold foil (for a warming fill light) and black (for blocking light from hitting a portion of the subject). In most instances, an assistant is required to position and hold the reflector for maximum effect.

When the shadows produced by diffused light are harsh and deep—or even when you just want to add a little sparkle to the eyes of your sub-

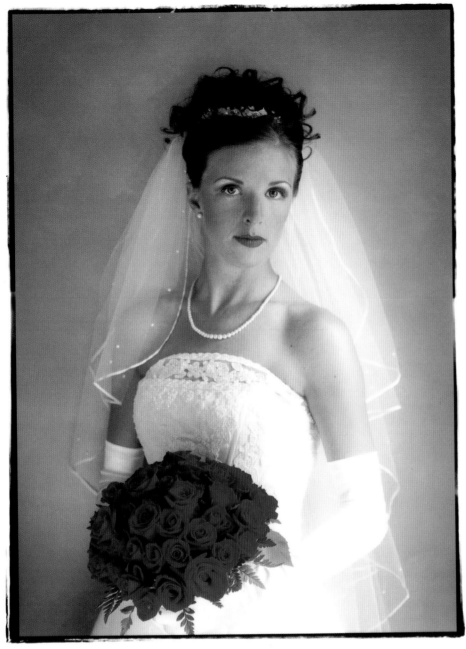

jects—use a large reflector or several reflectors. As mentioned, it really helps to have an assistant so that you can precisely set the reflectors and see their effect from the viewfinder. Be sure to position reflectors outside the frame. With foil-type reflectors used close to the subject, you can sometimes overpower the daylight, creating pleasing and flattering fill-in.

Be careful about bouncing light in from beneath your subjects. Lighting coming from under the eye/nose axis is generally unflattering. Try to

"focus" your reflectors (this really does require an assistant), so that you are only filling the shadows that need filling in.

■ FLASH-FILL
A more predictable form of shadow fill-in is electronic flash. As mentioned, many photographers shooting weddings use barebulb flash, a portable flash unit with a vertical flash tube, like a beacon, that fires the flash a full 360 degrees. You can use as wide a lens as you own and you won't get

flash falloff with barebulb flash. Barebulb flash produces a sharp, sparkly light, which is too harsh for almost every type of photography except outdoor fill. The trick is not to overpower the daylight. It is most desirable to let the daylight or twilight backlight your subjects, capitalizing on a colorful sky background if one exists, and using barebulb flash to fill the frontal planes of your subjects.

Some photographers like to soften their fill-flash, using a soft box instead of a barebulb flash. In this type of situation it is best to trigger the strobe cordlessly, using a radio remote trigger. This allows you to move the diffused flash out to a 30- to 45-degree angle to the subjects for a dynamic fill-in. For this application, it is wise to equal or overpower the daylight exposure slightly so that the off-angle flash acts more like a key light. For larger groups, it may be necessary to use several softboxes or to use a single one close to the camera for more even coverage.

Metering and Exposure. Here's how you determine accurate fill-flash exposures every time. First, meter the scene with an incident flashmeter. Say, for example, that the metered exposure is $^1/_{30}$ at f/8. Next, meter the flash only. It is desirable for the flash output to be one stop less than the ambient exposure. Adjust the flash output or flash distance until your flash reading is f/5.6. Set the camera to $^1/_{30}$ at f/8. That's it. You can set the flash output from f/8 to f/5.6 and you will not overpower the daylight, you will only fill in the shadows created by the daylight and add sparkle to the eyes.

If the light is fading or the sky is brilliant and you want to shoot for optimal color saturation in the background, overpower the daylight with the flash. Returning to the situation above, where the daylight exposure

was $^1/_{30}$ at f/8, adjust your flash output so your flashmeter reading is f/11, a stop more powerful than the daylight. Set your camera to $^1/_{30}$ at f/11. The flash is now the key light and the soft twilight is the fill light. The problem with this technique is that you will get a separate set of shadows from the flash. This can be acceptable, however, since there aren't really any shadows coming from the twilight. As described above, this technique works best when the flash is diffused and at

an angle to the subjects so there is some discernable lighting pattern.

Remember that electronic flash falls off in intensity rather quickly, so be sure to take your meter readings from the center of your group and then from either end to be sure the illumination is even. With a small group of three or four, you can get away with moving the strobe away from the camera to get better modeling—but not with larger groups, where the light falloff is too great. You

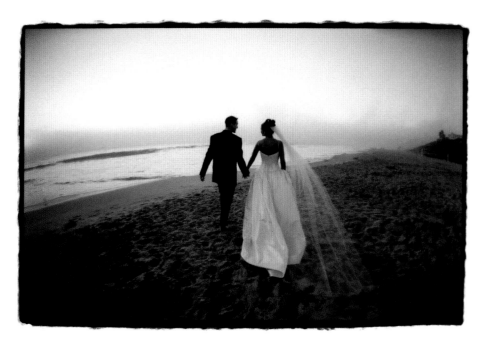

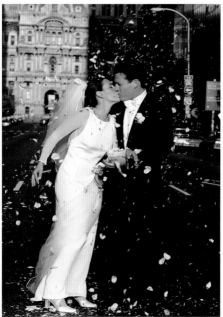

Above: Sometimes, no auxiliary light is needed—available light works just fine as in this wide-angle portrait of the bride and groom by Joe Photo. The ultrashort focal length produces a bend to the horizon line as if the bride and groom inhabit their own world. Left: Direct flash and bright sunlight, if the exposures are matched, create an interesting effect. Here, Phil Kramer used flash to illuminate the individual pieces of confetti as they fell.

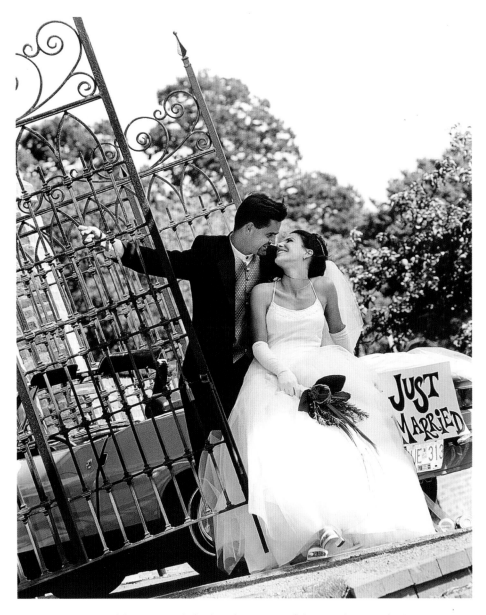

can, however, add a second flash of equal intensity and distance to help widen the light.

It is also important to remember that you are balancing two light sources in one scene. The ambient light exposure will dictate the exposure on the background and the subjects. The flash exposure only affects the subjects. When you hear of photographers "dragging the shutter" it refers to using a shutter speed slower than X-sync speed in order to expose the background properly.

Flash-Fill Variation. Backlighted subjects allow you to work in bright light as long as you fill the shadows.

One of the outdoor techniques master photographer Monte Zucker uses is to position his single flash on a light stand as if it were a studio light, raised and to the right or left of the subjects, usually at a 30- to 45-degree angle. He uses his single flash at the same output as his daylight exposure, which may be as bright as f/16. The effect is to fill the shadows with dynamic light that rounds and sculpts each face. The effect is similar to the studio lighting involving a strong backlight and single key light. Ambient daylight provides the fill-in.

He uses a similar technique for formal groups where a single flash would

fall off too rapidly, leaving one half of the group unlighted. He will add a second light at the same angle as the first, but spaced so that it will light the half of the group farthest away. He feathers both lights so they don't overlight the middle of the group. Without modeling lights outdoors, the best way to see the lighting is a Polaroid check, which Monte recommends. This technique allows you to create big wide groups—even use wide-angle lenses—and still attain elegant lighting.

■ FLASH-KEY ON OVERCAST DAYS
When the flash exposure and the daylight exposure are identical, the effect is like creating your own sunlight. This technique works particularly well on overcast days when using barebulb flash, which is a point light source like the sun. Position the flash to the right or left of the subject(s) and raise it up for better modeling. If you want to accentuate the lighting pattern and darken the background and shadows, increase the flash output to ½ to one stop greater than the daylight exposure and expose for the flash exposure. Do not underexpose your background by more than a stop, however, or you will produce an unnatural nighttime effect.

Many times this effect will allow you to shoot out in open shade without fear of hollow eye sockets. The overhead nature of the diffused daylight will be overridden by the directional flash, which creates a distinct lighting pattern.

■ FLASH SYNC SPEEDS

If using a focal plane shutter as found in 35mm SLRs, you have an X-sync shutter speed setting. You cannot use flash and employ a shutter speed faster than the X-sync speed. Otherwise, your negatives will look as if they were half exposed, and that would actually be the case. You can, however, use any shutter speed slower than the X-sync speed. Your strobe will fire in synchronization with the shutter, and the longer shutter speed will build up the ambient light exposure.

With in-lens blade-type shutters, flash sync occurs at any shutter speed, because there is no focal plane shutter curtain to cross the film plane.

■ "STRAIGHT" FLASH

On-camera flash should be avoided altogether for making wedding portraits—except as a fill-in source. Straight flash is too harsh and flat and it produces no roundness or contouring. Since light falloff is extreme, it produces cavernous black backgrounds—unless the shutter is left open for a longer time to expose the ambient room light.

When you diffuse on-camera flash, you get a reasonably soft frontal lighting. While diffused flash is still a flat lighting and frontal in nature, the softness of the light produces much better contouring than direct, undiffused flash. Lumiquest offers devices like the Pocket Bouncer, which redirects light

Top: Rick Ferro uses available light from the huge window to light the bride. The fill from the bride's wedding dress lights the face of the flower girl and the light from the mini chandeliers around the room provides warm-toned fill in the shadow side of the gown. Bottom: Jerry D photographed this scene with a mix of tungsten light from the porch and available daylight. The tungsten light gives the scene its warmth. The daylight adds to the overall fill-in.

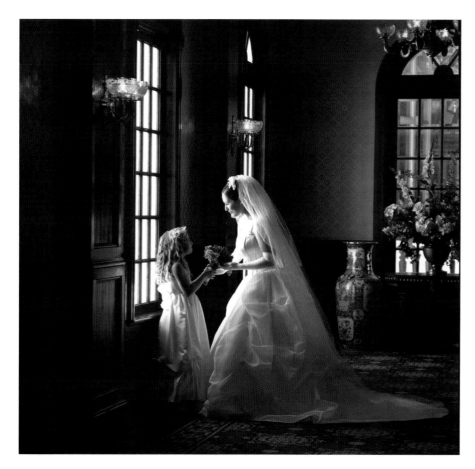

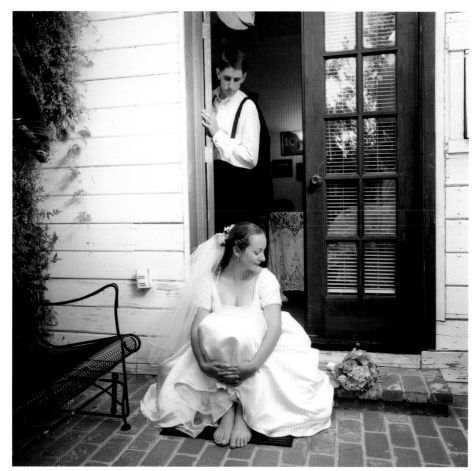

at a 90-degree angle from the flash to soften the quality of light and distribute it over a wider area. There are also frosted acetate caps that fit over the flash reflector to soften the direct flash and these can be effective as well. Most of these accessories can be used with your flash in auto or TTL mode, making exposure calculation effortless.

Many photographers, especially those shooting 35mm systems, prefer on-camera TTL flash, which features a mode for TTL fill-in flash that will balance the flash output to the ambient-light exposure for balanced fill-flash. Most of these TTL flash systems are adjustable so that you can vary the flash output in fractional increments, thus providing the means to dial in the precise ratio of ambient-to-fill illumination. They are marvelous systems and, of more importance, they are reliable and predictable. The drawback to these systems is that they are camera-mounted—although many such systems also allow you to remove the flash from the camera via a TTL remote cord.

▪ UMBRELLAS

Oftentimes you will need to light an area, such as the dance floor or dais at a reception. Stationary umbrellas that are "slaved" to your camera or on-camera flash are the ideal way to accomplish even lighting over a large area. It is important to securely tape all cords and stands to the floor in as inconspicuous a manner as possible to prevent anyone from tripping over them. Once positioned, you can adjust the umbrellas so that you get even illumination across the area. The way to do that is to focus the umbrellas.

Umbrellas fit inside a tubular housing inside most studio electronic flash units. The umbrella slides toward and away from the flash head, and is anchored with a set-screw or similar device. The reason the umbrella-to-light-source distance is variable is because there is a set distance at which the full amount of strobe light hits the full surface of the umbrella, depending on the diameter of the umbrella and type of reflector "housing" used on the flash head. This is optimal. If the umbrella is too close to the strobe, much of the beam of light is focused in the center portion of the umbrella, producing light with a "hot-spot"

center. If the strobe is too far away from the umbrella surface, the beam of light is focused past the umbrella surface, wasting a good amount of light. When setting up, use the modeling light of the strobe to focus the distance correctly, so the outer edges of the light core strike the outer edges of the umbrella for maximum output.

Umbrellas also need to be "feathered" to maximize the coverage of the umbrella's beam of light. If you aim a light source directly at the area you want illuminated then meter the light, you'll find that it is falling off at the ends of the area—despite the fact that the strobe's modeling light might trick

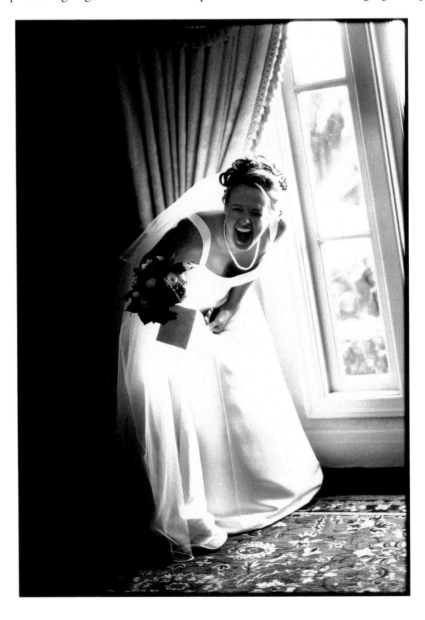

Joe Photo captured this wonderful image, entitled *A Case of the Giggles*, with window light as the only light source.

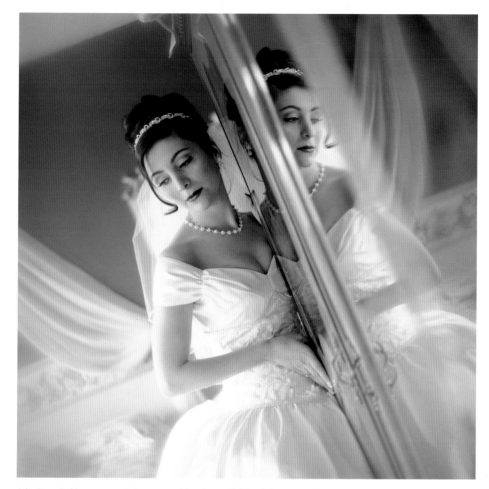

Vladimir Bekker created this unusual but beautiful bridal portrait by using window light and a dressing mirror in the room. The bride's image is reflected twice in the mirror and the reflective surface also adds to the fill on the shadow side of her face. The image is slanted to produce a dynamic diagonal line running through the image.

you into thinking it is even throughout. Feathering the light past the area you want illuminated will help more evenly light your scene because you are using the edge of the light. Another trick is to move the light source back so that is less intense overall but covers a wider area. The light will be harsher and less diffuse the farther back you move it. Triggering is best accomplished with a radio transmitter set to fire only those strobes.

BOUNCE FLASH

Portable flash units do not have modeling lights, so it is impossible to see beforehand the lighting effect produced. However, there are certain ways to use a camera-mounted flash in

a predictable way to get excellent lighting—especially at the reception.

Bounce flash is an ideal type of portrait light. It is soft and directional. By bouncing the flash off the ceiling, you can achieve an elegant type of soft light that fully illuminates your subjects. You must learn to gauge angles and distances when using bounce flash. Aim the flash unit at a point on the ceiling that will produce the widest beam of light reflecting back onto your subjects. You should never use color film when bouncing flash off colored ceilings or walls—the light reflected back onto your subjects will be the same color as the walls.

TTL flashmetering systems and auto-flash systems will read bounce

flash situations fairly accurately, but factors such as ceiling distance, color and absorption qualities can affect proper exposure. Although no exposure compensation is necessary with these systems, operating distances will be reduced.

There are a number of accessory devices available for bounce flash, like the Lumiquest ProMax system, which offers a way to direct some of that bounce light directly toward a subject. These devices mount to the extended flash housing and transmit either 10 or 20 percent of the light forward, directly onto your subject. The remainder of the light is bounced onto the ceiling.

You don't necessarily have to use your flash-sync speed when making bounce flash exposures. If the room light exposure is within a stop or two of your bounce flash exposure ($\frac{1}{125}$ at f/4, for example), simply use a slower shutter speed to record more of the ambient room light. If the room light exposure is $\frac{1}{30}$ at f/4, for example, expose the bounce flash photos at $\frac{1}{30}$ at f/4 for a balanced flash and room light exposure. Be wary of shutter speeds longer than $\frac{1}{15}$ second, as you might incur camera movement or subject movement in the background (the flash will freeze the nearer subject although the longish shutter speed might produce "ghosting" if your subject is moving).

AVAILABLE LIGHT

Throughout this chapter various means of augmenting available and existing light have been discussed. There are many occasions when the available light cannot really be improved. Such situations might arise from window light or open shade or sometimes the incandescent light found in the room. It is a matter of seeing light that is important. Learn to

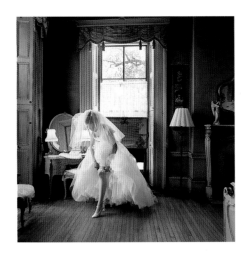

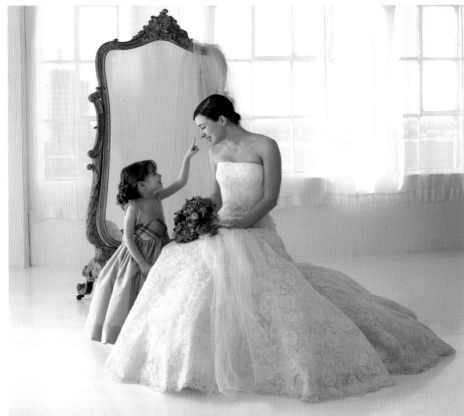

evaluate light levels as well as lighting patterns, both inside and out. The better you can see light, the more advanced and refined your photographs will be.

■ WINDOW LIGHT

One of the most flattering types of lighting you can use for wedding por-

traits is window lighting. It is a soft light that minimizes facial imperfections, yet it is also a highly directional light that yields good facial modeling with low to moderate contrast. Window light is usually a fairly bright light and it is infinitely variable, changing almost by the minute. This allows a great variety of moods, depending

on how far you position your subjects from the light.

Since daylight falls off rapidly once it enters a window, and is much weaker several feet from the window than it is closer to the window, great care must be taken in determining exposure, particularly with groups of three or four people. You will undoubtedly

need reflectors to balance the light overall when photographing that many people in the group. Other problems are that you will sometimes have to work with distracting backgrounds and uncomfortably close shooting distances.

The best quality of window light is the soft light of mid-morning or mid-afternoon. Direct sunlight is difficult to work with because of its intensity and because it will often create shadows of the individual windowpanes on the subject.

Diffusing Window Light. If you find a nice location for a portrait but the light coming through the windows is direct sunlight, you can diffuse the window light with some acetate diffusing material taped to the window frame. It produces a warm golden window light. Light diffused in this manner has the warm feeling of sunlight but without the harsh shadows. If the light is still too harsh, try doubling the thickness of the acetate for more diffusion. Since the light is so scattered by the diffusers, you may not need a fill source, unless working with a larger group. In that case, use reflectors to kick light back into the faces of those farthest from the window.

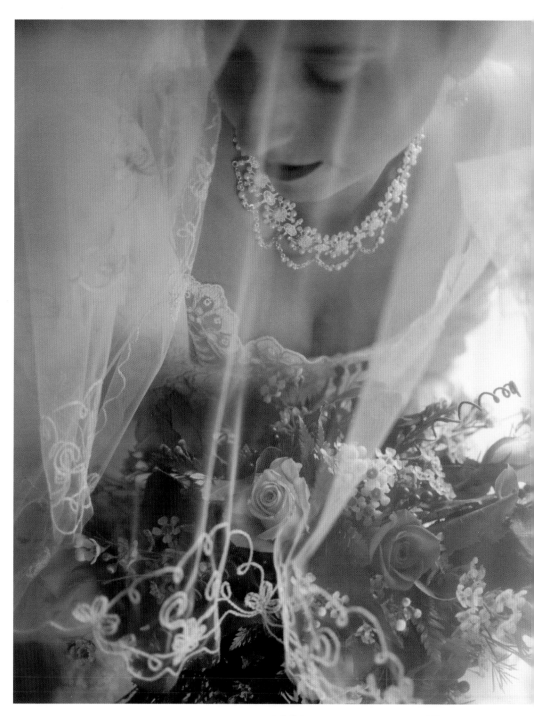

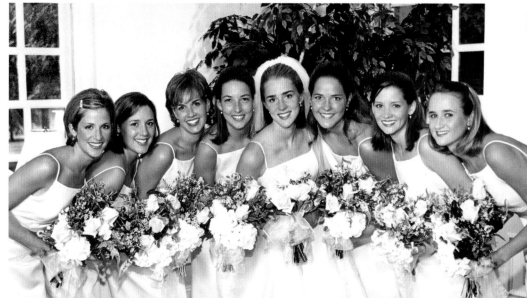

Top: Window light was the only light source for this elegant close-up bridal portrait by Kimarie Richardson. Kim had the bride turn her head slightly to add more dynamics to the composition. Shooting through the veil is a clever technique that seems to add intimacy to the portrait. Right: This is a more conventional group showing all of the bridesmaids. David used three lights and posed the girls close together, overlapping shoulders to get faces tightly grouped. About this photo the photographer quips, "Three lights to get eight smiles."

Preparation and Planning

■ PRE-WEDDING PREPARATIONS

Arrange a meeting with the couple at least one month before the wedding. Use this time to take notes, formulate detailed plans and get to know the couple in a relaxed setting. It will be time well spent and allows you a month after the meeting to check out the locations, introduce yourself to the people at the various venues as well as the minister, priest or rabbi, and go back to the couple if there are any problems or difficulties. This initial meeting also gives the bride and groom a chance to ask any questions of you that they may have.

Tell the couple what you plan to photograph and show them examples. Ask if they have any special requests or special guests who may be coming from far away. Avoid creating a list of required photographs, as it may not be possible to adhere to. Make a note of the names of the parents and also of all the bridesmaids, groomsmen, the best man and maid of honor so that you can address each by name. Also make notes on the color scheme, the supplier of the flowers, the caterer, the band and so on. You should contact all of these people in advance, just to touch base. You may find out interesting details that will affect your timetable or how you make certain photos.

At many religious ceremonies you can move about and even use flash—but it should really be avoided, in favor of a more discreet, available-light approach. Besides, available light will provide a more intimate feeling to the images. At some churches you may only be able to take photographs from the back, in others you may be offered the chance to go into a gallery or the balcony. You should also be prepared for the possibility that you may not be able to make pictures at all during the ceremony.

Armed with information from the briefing meeting, you need to visit the

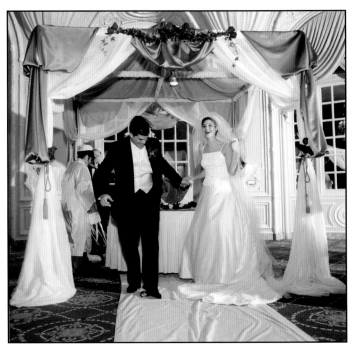

Left: By making contact with the caterers, wedding planner and decorator, you will be apprised of any special preparations for the wedding day. Here, Phil Kramer captured this beautiful treatment of tying a bouquet to the chair before anyone arrived at the reception. **Right:** Knowing the details of the ceremony will help you prepare to make important pictures during the ceremony and reception. Photography by Stephen Maclone.

couple's wedding venues if you have not been there before. Try to visit at the same times of day as the wedding and reception, so that you can check lighting, make notes of special locations, and catalog any potential problems. Also, you should make note of the walls and types of ceilings, particularly at the reception—this will affect your ability to use bounce flash. It is useful to produce an "A" list and a "B" list of locations—alternate locations in case your "A" selection doesn't work out on the wedding day.

■ CREATING A MASTER SCHEDULE

You must plan your schedule in advance. This is essential to smooth

Robert Hughes created this ornate vision of the bride and groom at the hotel during a quite moment.

sailing on the wedding day. The couple should know that if there are delays, adjustments or deletions will have to be made to the requested pictures. Good planning and an understanding of exactly what the bride and groom want will help prevent any problems.

You should know how long it will take for you to drive from the bride's home to the ceremony. Inform the bride that you will arrive at least a 45 minutes to an hour before she leaves. You should arrive at church at about the same time as or a little before the groom, who should arrive about a half

hour before the ceremony. At that time you can make portraits of the groom and his groomsmen and his best man. Bridesmaids will arrive at about the same time. You need to determine approximately how long the ceremony will last. One formula is to plan to spend up to twenty minutes on groups at the church, and about the same amount of time on portraits of the couple at the reception.

If the ceremony is to take place at a church or synagogue where you do not know the customs, make sure you visit the minister beforehand. If you are unfamiliar with the customs, ask to

This very creative and cool image of an alto sax being played at the reception is a photograph the bandleader would cherish and might also get you a referral down the line. Photograph by Jeff Hawkins.

attend another wedding as an observer. Such experiences will give you invaluable insight into how you will photograph the wedding.

■ YOU AND THE TEAM

As the photographer, you are part of the group of wedding specialists who will ensure that the bride and groom have a great day. Be friendly and helpful to all of the people on the team— the minister, the limo driver, the wedding coordinator, the banquet manager, the band, the florist and other vendors involved in the wedding. They are great sources of referrals. Get the addresses of their companies so that you can send them a print of their specialty after the wedding.

■ ASSISTANTS

An assistant is invaluable at the wedding. He or she can run interference for you, change film magazines so one is always ready, organize guests for a big group shot, help you by taking flash readings and predetermining exposure, tape light stands and cords securely with duct tape and a thousand other chores. Your assistant can survey your backgrounds looking for unwanted elements, and become a moveable light stand by holding your secondary flash or reflectors.

An assistant must be trained in your posing and lighting techniques. The wedding day is not the time to find out that the assistant either doesn't understand or, worse yet, *approve* of your techniques. You should both be on the same page—and a good assistant will even be able to anticipate your next need and keep you on track for upcoming shots.

Most assistants go on to become full-fledged wedding photographers. After you've developed confidence in an assistant, he or she can help you photograph the wedding, particularly at the reception when there are too many things going on at once for one person to cover. Most assistants will try to work for several different wedding photographers to broaden their experience. It's not a bad idea to employ more than one assistant so that, if you get a really big job, you can use both of them—or if one is unavailable, you have a backup assistant.

Assistants also make good security guards. I have heard too many stories of photographers' gear "disappearing" at weddings. An assistant is another set of eyes whose priority it should be to safeguard the equipment.

The following is a collection of tips and advice that come from accomplished wedding pros.

◼ BIG GROUPS

You'll need help to persuade all the guests to pose for a photo. Make it sound fun—which it should be. The best man and ushers, as well as your assistant, can usually be persuaded to do the organizing. Have the guests put their drinks down before they enter the staging area. Try to coordinate the group so that everyone's face can be seen and the bride and groom are the center of interest. Tell the group that they need to be able to see you with both eyes to be seen in the photo. Look for a high vantage point, such as a balcony or second-story window, from which you can make the portrait. Or you can use the trusty step ladder, but be sure someone holds it steady, particularly if you're at the very top. Use a wide-angle lens and focus about a third of the way into the group, using a moderate taking aperture to keep everyone sharply focused.

◼ THE BOUQUET

Make sure a large bouquet does not overpower your composition, particularly in your formal portrait of the bride. Make sure the bride looks com-

Helpful Tips

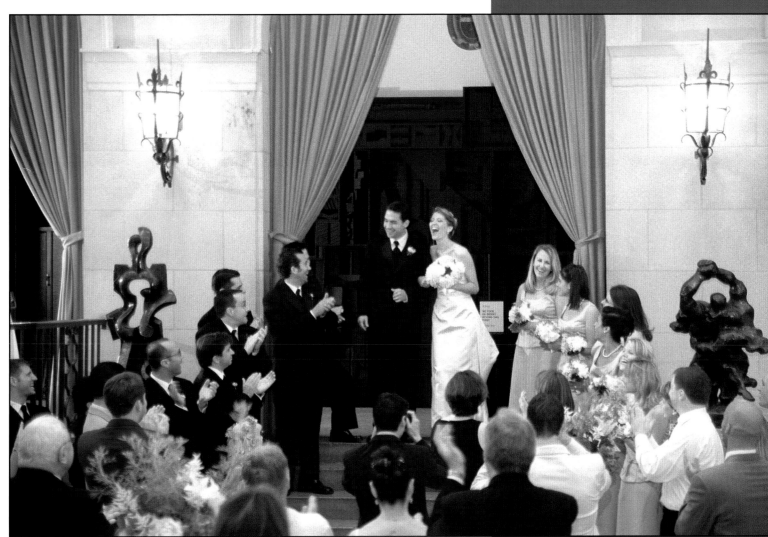

Be sure to include as part of your equipment a stepladder that will allow you to get higher than the floor for those once-in-a-wedding images. Here, Robert Hughes has ascended over the heads of the crowd to get this wonderful shot of the bride and groom arriving at the reception.

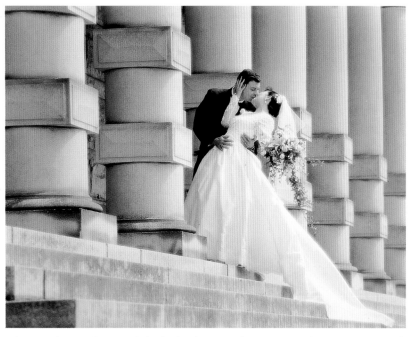

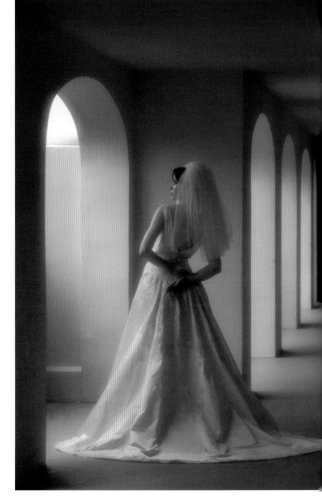

Above: Always photograph the bride closest to the camera and get as many good shots of the couple embracing and kissing as you can. Some couples don't even make contact on the wedding day, as hard as that is to believe. Photograph by Frances Litman.
Right: The wedding dress is usually the most expensive dress a woman ever owns, and her wedding day is probably the day when the bride will be more beautiful than she's ever been. For these reasons it is important to make as many images of the dress as possible—and don't forget the back of the dress! Photograph by Rick Ferro.

fortable holding it. A small bouquet should be an important and colorful element in the composition. Give the bride some guidance as to how she should hold her bouquet for the best effect. It should be placed in front with her hands behind it, making sure it is held high enough to put a slight bend in her elbows to keep her arms slightly separated from her body.

◼ THE BRIDE SHOULD BE CLOSEST
When you have a choice—and the photographer *always* has a choice—position the bride closest to the camera. This keeps the (usually) smaller bride in proper perspective and allows her dress to be better seen.

◼ A CASE OF NERVES
The wedding day is usually a tense time. There is a surplus of emotion

and people tend to wear those emotions on their sleeves. Your demeanor and professionalism should be a calming and reassuring presence, especially to the bride. Be calm and positive, be funny and lighthearted and above all, don't force the situation. If you can see that demanding to make a picture is going to really upset people, have the willpower to hold off until later. Remember that positive energy is contagious, and can usually save a sticky situation.

◼ THE DRESS
Most brides will spend more money on their wedding dress and more time on their appearance than for any other occasion in their entire lives. They will often look more beautiful than on any other day. The photographs you make will be a permanent record of how

beautiful she looked on her wedding day. Do not ignore the back of the dress—dress designers incorporate as much style and elegance in the back of the dress as the front. Be sure to get the bridesmaid's gowns as well.

◼ DRESS LIKE A GUEST
This is award-winning photographer Ken Sklute's advice. A suit or slacks and a sports jacket are fine for men; and for women, business attire works well—but remember that you have to lug equipment and move freely, so don't wear restrictive clothing. Many wedding photographers (both men and women) own a tux and wear it for every formal wedding.

◼ FLASH SYNCH CHECK
Check and recheck that your shutter speed is set to the desired shutter

speed for flash sync. This is particularly important with focal plane shutters because if you set a speed faster than your X-sync, you will get half-frame images—a true nightmare. It has happened to everyone who's ever shot a wedding, but it's certainly preventable with a little vigilance. Check the shutter speed every time you change film. If you're like most photographers, you'll check it more often—every couple of frames. Of course, if you're using a lens shutter camera, the flash syncs at every shutter speed, but it's still a good idea to make sure the shutter speed dial is where you set it.

GETTING THE BRIDE INTO A CAR

This tip is from Monte Zucker, who says "One of the things that I learned a long time ago was how to help the bride sit in a car without wrinkling her gown. What I do is have her lift up the back of her gown and put it around her shoulders. This forms a sort of cape. But what it also does is pick up the back side of the gown, so that when the bride sits down she's not sitting on her dress and wrinkling it. Here's the final trick. She has to back into the car. Now, even if she were to pick up some dirt as she enters the car, it would be on the underside and never show."

FLOWERS

While waiting around to go upstairs to photograph the bride getting ready, don't cool your heels. Arrange for the flowers to be delivered early and use the time to set up an attractive still life for the album while you wait.

The kiss is a shot you should always be on the lookout for. Photograph by Jeff Hawkins. In this image the photographer had the bride extend the bouquet and her left foot for a more stylish pose.

HANDS-FREE

Hands are troublesome, especially with groups. They usually don't add up—there are seemingly more or less hands than people. If the hands are particularly poorly arranged, no one knows whose hands belong to whom. Eliminate as many hands as possible.

Generally, men photographed in groups or photographed individually should put their hands in their pockets. A variation of this is to have them put a hand in a pocket, but hitch their thumb over the outside of the pocket. Preventing the hand from going all the way into the pocket puts a space between the elbow and the torso. This creates a flattering line and helps to prevent your subject(s) from looking overly "thick."

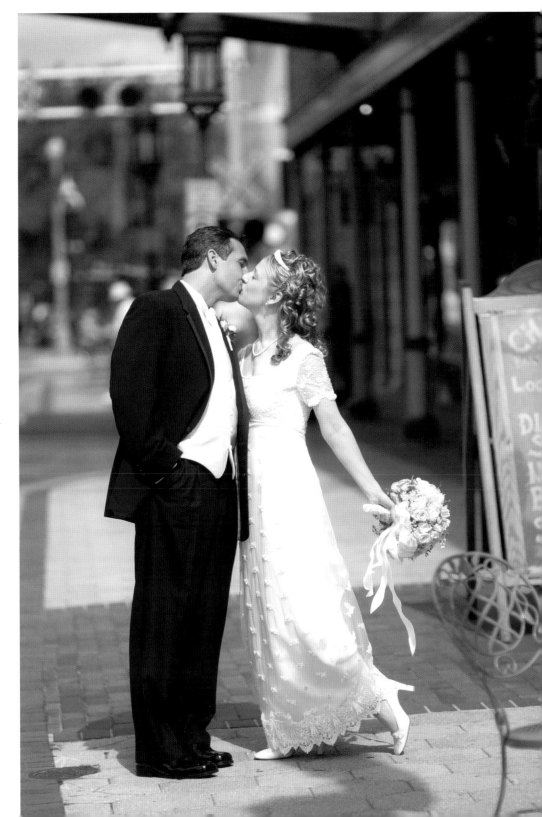

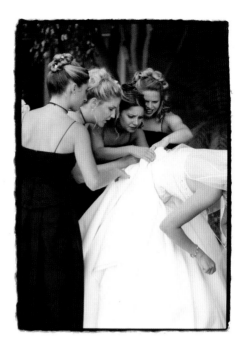

Above: By being on hand as the bride gets ready you won't miss a priceless moment like Joe Photo has captured here. The expressions on the faces of the bridesmaids are priceless.
Right: When photographing the rice or confetti throwing or, as in this case, the dove release, you will only have one chance to get a great shot. Don't leave it up to chance. Choreograph the event and have it begin on your cue. Kimarie Richardson had her flash on and ready, set her camera to ⅟₆₀₀ at f/8, waited until the birds were aloft and got the great shot.

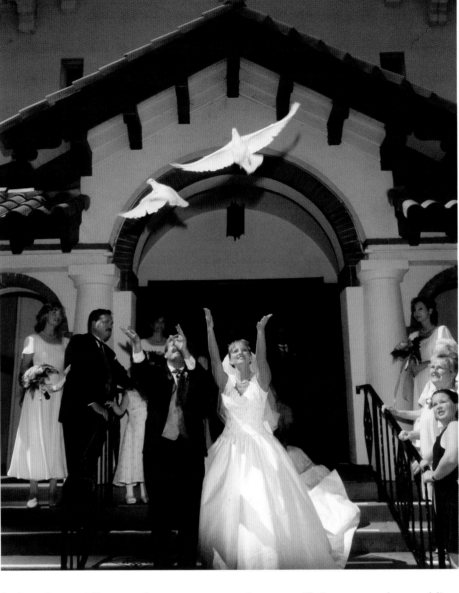

With women, try to hide their hands in their laps or behind other people in the group.

LATE BRIDES

If the bride is late (as brides usually are), do not hold things up further. Simply make a series of photojournalistic images of her arrival and plan to make the previously arranged shots later in the day.

INVEST THE TIME

Almost every successful wedding photographer makes it a point to get to know the couple and their families before the wedding, so that everyone is accustomed to him or her and knows what to expect. This can involve a prearranged engagement portrait, in which the photographer and couple actually work together, or it can be a handwritten note or a phone call. Two successful wedding photojournalists in the San Francisco Bay area, Alisha and Brook Todd, send out a bottle of Dom Perignon and a hand-written note the day after the contract goes out, and follow it up with monthly phone calls to "check in." The more familiar the couple is with the photographer, the better the pictures will be come the wedding day!

THE KISS

Be sure to get the bride and groom kissing at least once in your photographs; preferably, in several different shots. These are favorites and you will find many uses for these shots in the album. Whether you set it up, which you may have to do, or you are on the lookout for this shot, make sure you get several. Get a good vantage point and make sure you adjust your camera angle so neither person obscures the other.

To save money, many hotels use coiled fluorescent bulbs instead of tungsten-filament bulbs in the room lamps. Be on the lookout for them because these fluorescents will not have the same warming quality as tungsten bulbs and could turn things a bit green.

Wedding and environmental specialist Frank Frost uses a system not unlike the Dale Carnegie system to remember people's names. Frost believes that

photographers should master the names of their clients. Photography is not just about the work, but it involves human relations and people skills, as well. He says, "There can be

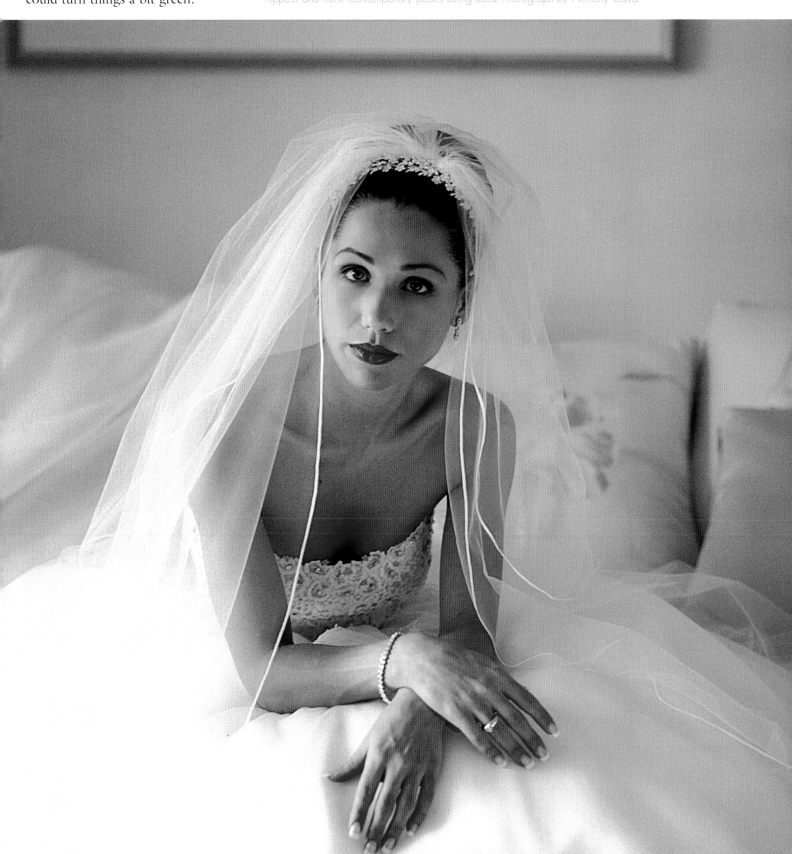

By studying the bridal magazines and other fashionable publications, you will get an idea of the hippest and most contemporary poses being used. Photograph by Anthony Cava.

twenty people in the wedding party and I'm able to call everybody by name. It makes a big impression and by the end of the evening, everybody is my friend."

■ SEATED MEN

Whenever a man is seated it's a good idea to check his clothes. He should have his jacket unbuttoned to prevent it from looking tight. If wearing a tux

with tails he should also avoid sitting on the them as this will also alter the shape of the coat. If he has shirt cuffs, they should be pulled down to be visible. And if sitting cross-legged, make

Studying gentlemen's magazines like *GQ* and *Esquire* can help you expand your repertoire of poses for men and stay on top of the latest trends—styles your clients will be looking for. Photograph by Anthony Cava.

sure his socks are pulled up high enough so that you don't see any bare leg.

■ SPEEDING UP YOUR GROUPS

One solution for making your formal groups is to make them at the church door as the couple and bridal party emerge. Everyone in the wedding party is present and the parents are nearby. If you don't have a lot of time to make these groups, this is a great way to get them all at once—in under five minutes.

■ STUDY THE WEDDING MAGAZINES

Top wedding photographers constantly review the editorial photography found in bridal magazines, both national and regional publications. Every bride is looking at these same magazines, dreaming that her wedding will look just like what she sees in these magazines. Styles, techniques, new trends and the "coolest" poses are all there to review.

A good source of poses for men are the gentlemen's magazines: *GQ* or *Esquire*. The range of poses runs from intellectual to macho and you'll pick up some good ideas, particularly for the groom's portrait and the groom and groomsmen group.

■ THE TRAIN

Formal wedding dresses often include long flowing trains. It is important to get several full-length portraits of the full train, draped out in front in a circular fashion, or flowing behind. Include all of the train, as these may be the only photographs of her full wedding gown. If making a formal group, this might also be an appropriate time to reveal the full train pulled to the front. One way to make the train look natural is to pick it up and let it gently fall to the ground.

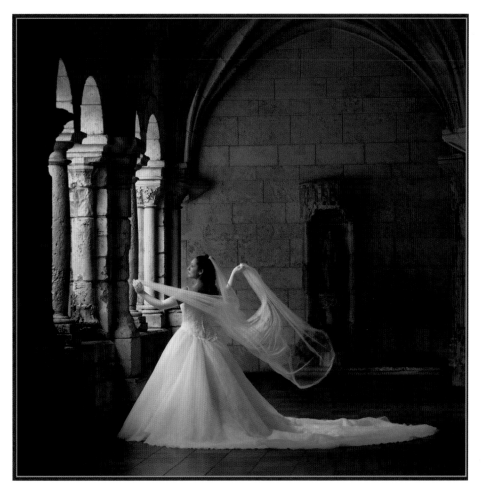

In making your formals, don't ignore the veil or the train, both integral parts of the wedding dress. Photograph by Rick Ferro. Note the elegance of this pose, which gives the veil motion and fullness.

■ THE VEIL

Make sure you get some close-up portraits of the bride through her veil. It acts like a diffuser and produces romantic, beautiful results. Lighting should be from the side rather than head-on to avoid shadows on the bride's face caused by the patterned mesh.

Monte Zucker will often use the veil as a compositional element in portraits. Lightly stretch the veil so that the corners slant down toward the lower corners of the portrait, forming a loose triangle that leads the viewer's eyes up to the bride's eyes.

■ WHEN GUESTS ASK YOU TO MAKE THEIR PICTURE

This tip is from Monte Zucker: "What I do is to discuss this with the bride and groom prior to the wedding. I explain to them that it happens all the time, but I'd usually get stuck with the pictures afterwards, because the guest would never see it to place their order. What I finally began doing is to either make the bride and groom responsible for paying for "special-request" pictures, or I'd make financial arrangements directly with the guests before I would take the picture. Usually, they'd select the latter option."

Proofing and Sales

■ PAPER PROOFS

Paper proofs have been the preferred method for reviewing a client's work—at least until recently. With paper proofs, you are offering a representation of the final image to the customer, but without the benefits of color correction, retouching and print finishing. Paper proofs not only fail to reflect the quality of the final image, they are a liability in an age when everyone seems to own a scanner.

Regardless of the mode of presentation, editing is essential. Present only those proofs from the wedding that are good, high quality images. Concise editing will guarantee that the couple will be delighted with how great the pictures

are. Because you're the pro, the couple will look to you for advice on those difficult picture decisions. Because you know the difference between a good pose and bad, good lighting and bad and so on, your opinion will be important to them.

■ SLIDES

Instead of showing paper proofs, award-winning photographer Frank Frost uses a proofless system for ordering. He tells couples that he'll call them four weeks after the wedding to schedule an appointment to come into the studio, view the wedding pictures and place their order. In the meantime, he makes slides from the negatives and hires a caterer to bring in a tray of food and sparkling apple cider.

Everybody sits down together to enjoy the slide show. Couples bring their parents and everybody orders on the spot. Usually, this presentation lasts about two-and-a-half hours. Frost likes to tell the story of the wedding using a variety of sizes and poses. As he walks them through the presentation he gently guides them toward the combinations that look best, and provides advice on page layout. There is no high-pressure approach, he merely offers opinions and suggestions. Clients are always free to make their own choices.

■ MULTIMEDIA

Some photographers take it a step further, producing a multimedia show of the wedding proofs. Brian and Judith Shindle have a very low-pressure,

When customers come to visit your studio and see beautifully framed wedding images, it instantly offers options that they may not have considered as yet. Photograph by Vladimir Bekker.

understated sales technique. After the wedding, the Shindles put on an elegant multimedia "premier night" party with catered food and fresh flowers and they invite guests from the wedding party. The event is held in the studio's elaborately decorated viewing room. This elegant event produces great sales success, because it doesn't resemble a sales session at all.

Other photographers use commercial software, such as the Montage® system, which produces projected images in a "suggested" album. First the album images are digitized and then brought into templates of any configuration, much like a page-layout program. The images are projected onto a large LCD screen already conceived as an album. Most couples, when they see the finished presentation, will want the album with only minimal changes.

■ DIGITAL PROOFS

Charles Maring accepts the fact that clients copying proofs is a reality. Maring has his digital images printed by the family lab, Rlab. Each photograph is numbered with the file number in the bottom right corner of the print and as a 2.5" x 3.5" size. According to Maring, one might copy a wallet-size print, but it would be a hassle to cut out the image from the proof book. These contacts come bound in book form with matte board for the covers and the whole concept costs only $.25 per image. This system takes very little time. Instead of spending hours putting proofs in a proof album, the proofs come back deliverable and bound, book-style.

Maring then designs and prints a suggested wall portrait for the cover of the book. When they offered this concept to their couples instead of proofs, every couple preferred the smaller digital prints. No one wants to carry

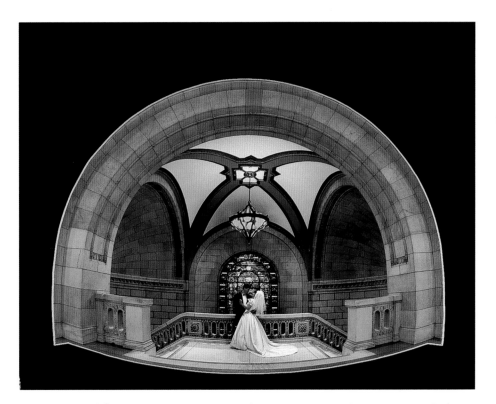

Images prepared for entering print competition show your customers that you are proud of your work and are prepared to enter it in national or international print competition. This is a competition print photographed and prepared by internationally acclaimed photographer Barbara Rice.

around a thousand full-size proofs in two full-size proof albums—and no photographer wants to pay for full-size proofs or proof albums, then spend hours on end organizing the images.

The Key Shots

■ ENGAGEMENT PORTRAIT

The engagement portrait is usually made prior to the date of the wedding, providing the time to get something really spectacular. Many photographers use this session as an opportunity to get to know the couple and to allow the couple to get to know them. Engagement portraits may involve great creativity and intimacy and are often made in the photographer's studio or at some special location.

■ AT THE BRIDE'S HOUSE OR AT THE HOTEL

Typically, weddings begin with the bride getting ready. Find out what time you may arrive and be there a little early. You may have to wait a bit, as there are a million details to attend to on wedding day, but you might find ample opportunity for still lifes or shots of the family. When you get the okay to go up to the bedrooms, understand that it may be tense up there. Try to blend in and merely observe. Shots will present themselves, particularly with mother and daughter or the bridesmaids.

■ AT THE CHURCH, BEFORE THE WEDDING

You, of course, want to photograph the groom before the wedding. Some grooms are nervous, while others are gregarious—like it's any other day. Regardless, there are ample picture opportunities before anyone else arrives. It's also a great opportunity to do formal portraits of the groom, the groom and his dad, and the groom and his best man.

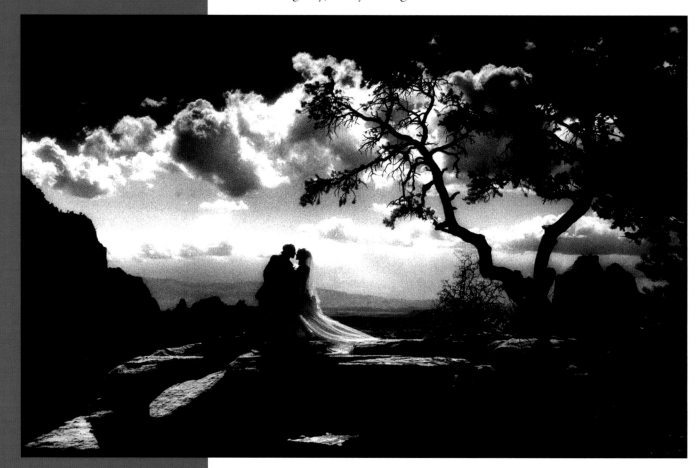

The engagement portrait has become an important part of the wedding package. It is often an item for which there is no charge and it gives the photographer and the couple a chance to get acquainted and work together. This dramatic engagement portrait is an infrared image by top wedding professional Ken Sklute.

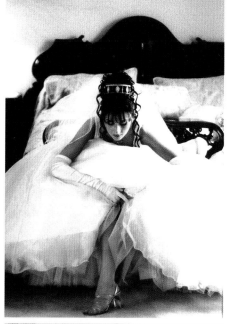

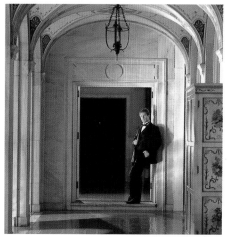

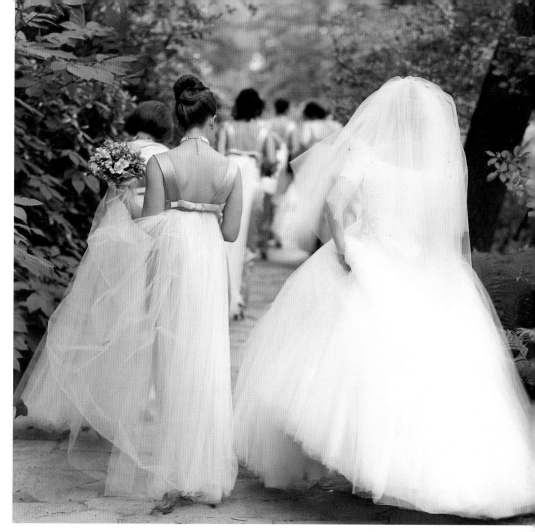

Top Left: Many of the great competition prints are made before the wedding as the bride is getting ready. It is a time of heightened emotions and often produces great images. This charming image by Anthony Cava, entitled *Shoes*, is an award winner. **Bottom Left:** Arrive at the church around the same time as the groom and his best man. That way you will be assured of getting some good portraits of the groom before the wedding. Generally a ¾-length or full-length pose works best. Photograph by Monte Zucker. **Above:** The bride and her "posse" before the wedding. Some of the best shots of the day are made when you might least expect it, such as in this situation where the bride and bridesmaids are walking away from the camera. Photograph by Phil Kramer.

A three-quarter-length portrait is a good choice. Include the architecture of the church or building if you want. Be aware of good photo opportunities with the groom and his mates.

When photographing men, always check that the ties are properly knotted, and if they are wearing vests make sure that they are correctly buttoned and that the bottom button is undone.

◼ THE CEREMONY

Regardless of whether you're a wedding photojournalist or a traditionalist, you must be discrete during the ceremony. Nobody wants to hear the "ca-chunk" of a medium format camera or see a blinding flash as the cou-

ple exchange their vows. It's better by far to work from a distance with a tripod-mounted 35mm camera with the motor off (or in quiet mode, if the camera has one), and to work by available light. Work quietly and unobserved—in short, be invisible.

Some of the situations you will need to cover are: the bridesmaids and flower girls entering the church, the bride entering the church, the parents being escorted in, the bride's dad "giving her away," the first time the bride and groom meet at the altar, the

minister or priest talking with them, the ring exchange, the exchange of vows, the kiss, the bride and groom turning to face the assembly, the bride and groom coming up the aisle and any number of two dozen variations— plus all the surprises along the way. Note that this scenario applies only to a Christian wedding. Every religion has its own customs and traditions that you need to be completely familiar with before the wedding.

Some churches don't allow photography at all during the ceremony.

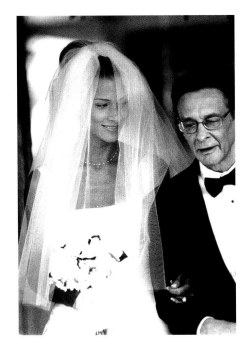

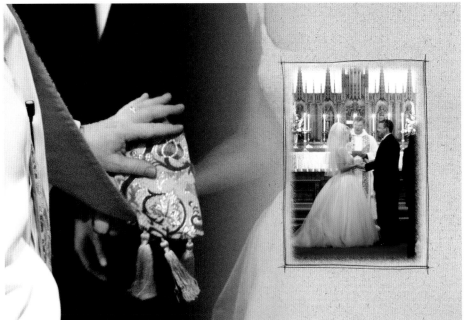

You will, of course, know this if you've taken the time to visit the minister and church prior to the wedding.

Regardless of your style of coverage, family groups are pictures that will be desired by all—both families and the bride and groom. You must find time to make the requisite group shots, but also be aware of shots that the bride may not have requested, but will expect to see. The bride with her new parents and the groom with his are great shots to make, according to Monte Zucker, but are not ones that will necessarily be "on the list."

■ FORMALS

Following the ceremony, you should be able to steal the bride and groom for a brief time. Limit yourself to fifteen minutes, otherwise you will be taking too much of their time and the others in attendance will get a little edgy. Most photographers will get what they need in under ten minutes.

In addition to a number of formal portraits of the bride and groom—their first pictures as man and wife—you should try to make whatever obligatory group shots the bride has asked for. This may include a group

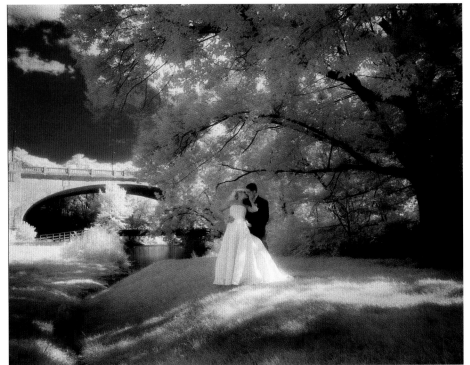

Top Left: In this image of the bride being escorted down the aisle by her dad, the look she is giving to him is full of love. Ken Sklute captured this award-winning image. Top Right: While it has become a cliché and some churches and synagogues don't permit photography during the actual ceremony, it is something that the bride and groom usually appreciate. Here, award-winning photographer Kelly Greer has included two pages of images from the ceremony in the album. Above: Ferdinand Neubauer had about an hour to photograph the bride and groom before the reception. So, after doing all the traditional portraits with his Hasselblad, he switched to his Contax 35mm loaded with Kodak High-Speed black & white infrared film. He used a 25mm Zeiss wide-angle lens and rated the film at about E.I. 400. A red 25A Hoya filter was placed over the lens. The final photograph was fine-tuned in Photoshop. Ferdy kept the image in black & white, with the exception of the sky and water, which he painted blue in Photoshop to give it a dramatically different look.

portrait of the wedding party, a portrait with the bride's family and the groom's family, and so on.

If there are too many "must" shots to do in a short time, arrange to do some after the ceremony and some at the reception. This can be all thought out beforehand.

◼ PORTRAIT OF THE BRIDE AND GROOM

Generally speaking, this should be a romantic pose, with the couple looking at one another. While a formal pose or two is advisable, most couples will opt for the more romantic and emotional formal portraits. Be sure to highlight the dress, as it is a crucial element to formal portraits. Take pains to show the form as well as the details of the dress and train, if the dress has one. This is certainly true for the bride's formal portrait, as well.

Make at least two formal portraits, a full-length shot and a three-quarter-

length portrait. Details are important, so pose the couple. Make sure the bouquet is visible and have the bride closest to the camera. Have the groom place his arm around his bride but with his hand in the middle of her back. Have them lean in to each other, with their weight on their back feet and a slight bend to their forward knees. Quick and easy!

◼ PORTRAIT OF THE BRIDE

To display the dress beautifully the bride must stand well. Although you may only be taking a three-quarter-length or head-and-shoulders portrait, start the pose at the feet. Arrange the bride's feet with one foot forward of the other, and the shoulders will be at their most flattering—one higher than the other. Have her stand at an angle to the lens, with her weight on her back foot and her front knee slightly bent. The most feminine position for

her head is to have it turned and tilted toward the higher shoulder. This places the entire body in an attractive S-curve, a classic bridal pose.

Have the bride hold her bouquet in the hand on the same side of her body as the foot that is extended. If the bouquet is held in the left hand, the right arm should come in to meet the other at wrist level. She should hold her bouquet a bit below waist level to show off the waistline of the dress, which is an important part of the dress design.

Take plenty of photographs of the bride to show the dress from all angles.

◼ THE WEDDING PARTY

This is one formal group that doesn't have to be formal. I have seen group portraits of the wedding party done as a panoramic, with the bride, groom, bridesmaids and groomsmen doing a conga line down the beach, dresses held high out of the water and the men's pant legs rolled up. And I have seen elegant, formal pyramid arrangements, where every bouquet and every

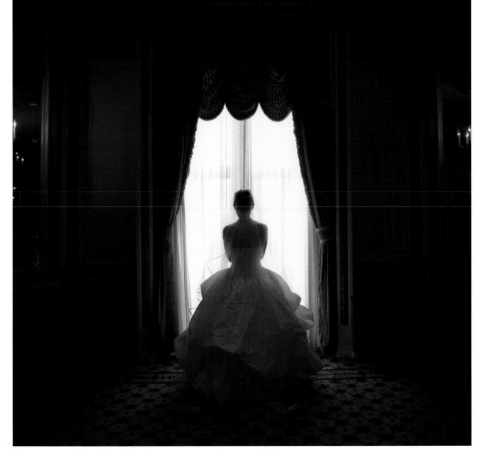

Left: Sometimes a formal portrait of the bride may be done in an unconventional way. Anthony Cava photographed her from behind in near silhouette. Only the incandescent room lights illuminated the bride. Below: If you are constantly aware of changing situations, camera ready, you might come up with an image as wonderful as this one created by Phil Kramer.

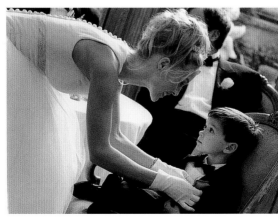

pose is identical and beautiful. It all depends on your client and your tastes. It should be a portrait that you have fun doing. Most photographers opt for boy-girl arrangements, with the bride and groom somewhere central in the image. As with the bridal portrait, the bridesmaids should be in front of the groomsmen in order to highlight their dresses.

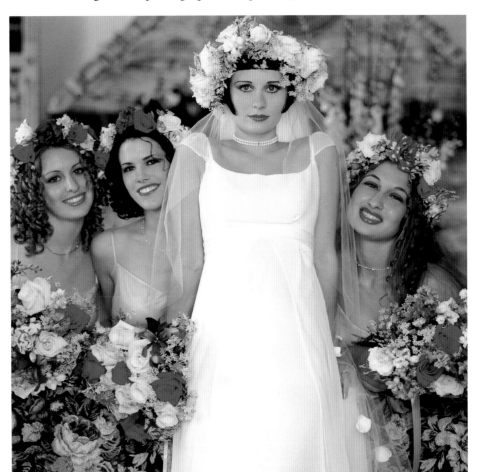

■ LEAVING THE CHURCH

Predetermine the composition and exposure and be ready and waiting as the couple exits the church. If guests are throwing confetti or rice, don't be afraid to choreograph the event in advance. You can alert guests to get ready and "release" on your count of three. Using a slow ($1/30$ second) shutter speed and flash, you will freeze the couple and the rice, but the moving objects will have a slightly blurred edge. If you'd rather just let the event happen, opt for a motor-driven 35mm SLR and a wide-angle-to-short-telephoto zoom—and be alert for the unexpected.

■ ROOM SETUP

Whenever possible, try to make a photograph of the reception before the guests arrive. Photograph one table in the foreground and be sure to include the floral and lighting effects. Also, photograph a single place setting and a few other details. The bride will love them, and you'll find use for them in the album design. The caterers and other vendors will also appreciate a print that reflects their fine efforts. Some photographers try to include the bride and groom in the scene, which

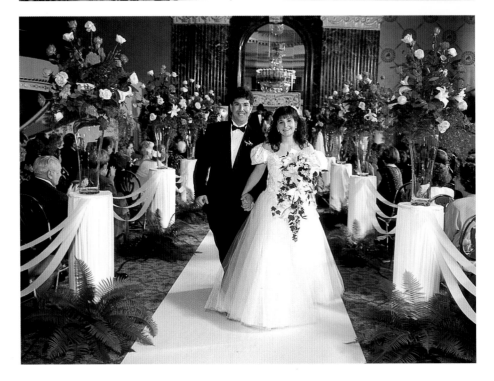

Top: Jerry D created this striking image of a beautiful bride and her bridesmaids and called it *Bouquet of Girls*. Cropping the image tightly, he wanted the bouquets and headbands to stand out, and of course, the bride. This is an award-winning image in international print competition. **Bottom:** While it is not always possible to get a good shot of the bride and groom leaving the church, it is something that is usually appreciated by the couple. This is an image not of the couple leaving the church, but entering the reception and it has wonderful expressions. Photograph by Norman Phillips.

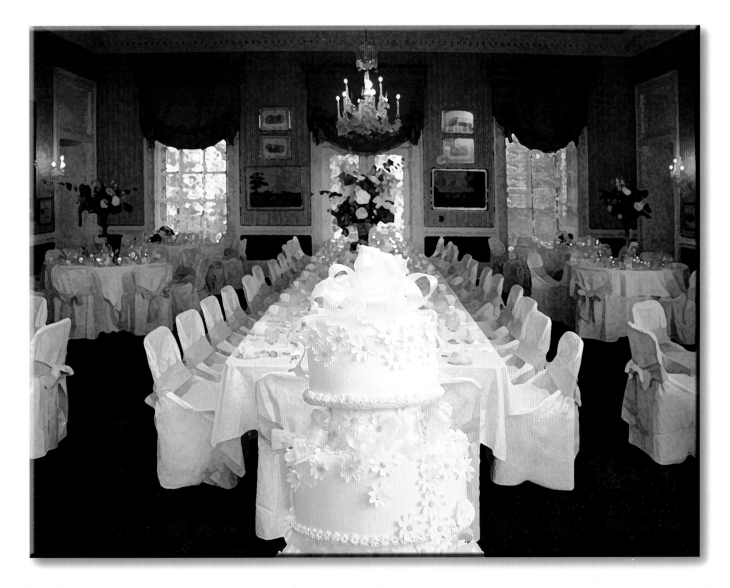

Robert Hughes created this lovely and painterly image of the reception before any of the guests arrived. Of course, all of the manipulations were done after the fact in Photoshop, but it is a beautiful memory of the couples' wedding day and many of the vendors involved would certainly appreciate a print.

can be tricky. Their presence does, however, add to the shot. Ken Sklute often photographs the bride and groom dancing slowly in the background and it is a nice touch.

■ THE RECEPTION

This is the time when most of your photojournalistic coverage will be made—and the possibilities are endless. As the reception goes on and guests relax, the opportunities for great pictures will increase. Be aware of the bride and groom all the time, as

they are the central players. Fast zooms and fast telephoto lenses paired with fast film will give you the best chance to work unobserved.

Be prepared for the scheduled events at the reception—the bouquet toss, removing the garter, the toasts, the first dance and so on. If you have done your homework, you will know where and when each of these events will take place, and you will have prepared to light it and photograph it. Often, the reception is best lit with a number of corner-mounted umbrellas,

triggered by your on-camera flash. That way, anything within the perimeter of your lights can be photographed by strobe. Be certain you meter various areas within your lighting perimeter so that you know what your exposure is everywhere on the floor.

The reception calls upon all of your skills and instincts. Things happen quickly, so don't get caught with an important event coming up and only two frames left in the camera. With 35mm systems, use two camera bodies. People are having a great time, so be cautious about intruding upon events. Observe the flow of the reception and anticipate the individual events before they happen. Coordinate your efforts with the person in

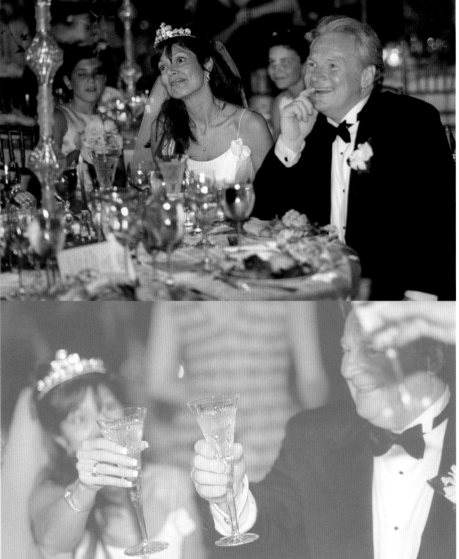

charge, usually the wedding planner or banquet manager. He or she can run interference for you, as well as cue you when certain events are about to occur, often not letting the event begin until you are ready.

■ RINGS

The bride and groom usually love their new rings and want a shot that includes them. A close-up of the couple's hands displaying the rings makes a great detail image in the album. You can use any type of attractive pose, but remember that hands are difficult to pose (see pages 36–41). If you want a really close-up image of the rings, you will need a macro lens, and you will probably have to light the scene with flash—unless you make the shot outdoors or in good light.

■ THE CAKE CUTTING

One of the key shots at the reception is the cake cutting. Whenever Monte Zucker has to make that shot, he gets on the step ladder and gathers as many people as possible around the bride and groom—the more people he can get into a group, the more the couple will like the photos.

■ THE FIRST DANCE

One trick you can use is to tell the couple beforehand, "Look at me and smile." That will keep you from having to circle the couple on the dance floor until you get both of them look-

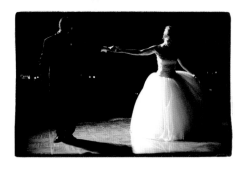

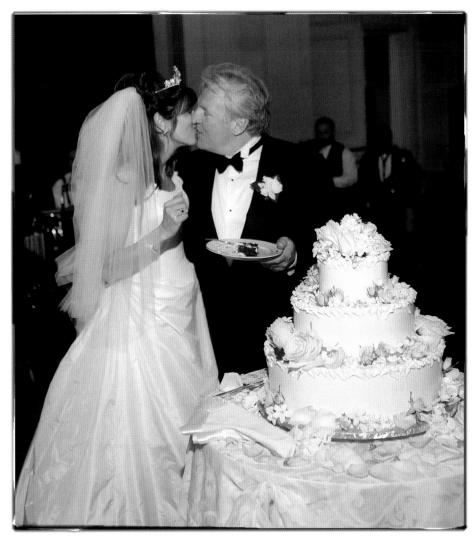

ing at you for the "first dance" shot. Or you can tell them, "Just look at each other and don't worry about me, I'll get the shot."

■ THE BOUQUET TOSS

This is one of the more memorable shots at any wedding reception. Whether you're a photojournalist or traditionalist, this shot looks best when it's spontaneous. You need plenty of depth of field, which almost dictates a wide angle. You'll want to show not only the bride but also the expectant faces in the background. Although you can use available light, the shot is usually best done with two flashes—one on the bride and one on the ladies waiting for the bouquet. Your timing has to be excellent as the bride will often "fake out" the group, just for laughs. This might fake you out, as well. Try to get the bouquet as it leaves the bride's hands and before it is caught—and if your flash recycles fast enough, get a shot of the lucky lady who catches it.

■ TABLE SHOTS

Table shots rarely turn out well, are often never ordered and they're

Top Left: David Anthony Williams will often devote an entire page to a subject from the wedding. Here, although small, this page is all about the rings. Other sections of the album might be about the architecture or the symbols of good luck. Williams is a master at the big picture as well as the details of the wedding. Bottom Left: Another popular shot is the "first dance." There are many ways to shoot this image, but the best ones seem to be where the bride and groom are not aware of their picture being made. Here, Scott Streble captures, in delicate rim light, the feeling of the first dance. Scott shot the spotlit image and was able to get just a hint of light bouncing off the bride's dress onto the groom's face. That's when he made this picture. Above: Charles Maring, for this particular album, photographed every phase of the wedding. The cake cutting shot has become somewhat of a cliché—the bride and groom "feeding" one another. It is, however, an image that the bride and groom will often look for.

tedious to make. If your couple absolutely wants table shots, ask them to accompany you from table to table. That way they can greet all of their guests, and it will make the posing quick and painless. Consider one big group that encompasses nearly everyone at the reception.

■ LITTLE ONES

A great photo opportunity comes from spending time with the smallest attendees and attendants—the flower girls and ring bearers. They are thrilled with the pageantry of the wedding day and their involvement often offers a multitude of memorable shots.

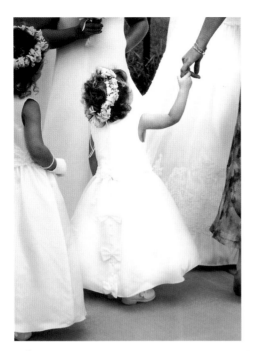
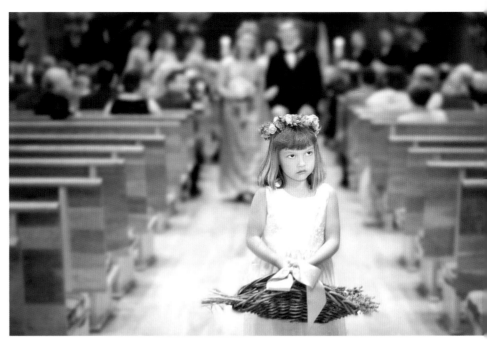

Left: Great opportunities like this only last a brief moment. Photograph by Jeff Hawkins. **Right:** This flower girl, who is quite a distance ahead of the bridesmaids being escorted into church, seems a bit perplexed by her next move. Photograph by Elaine Hughes.

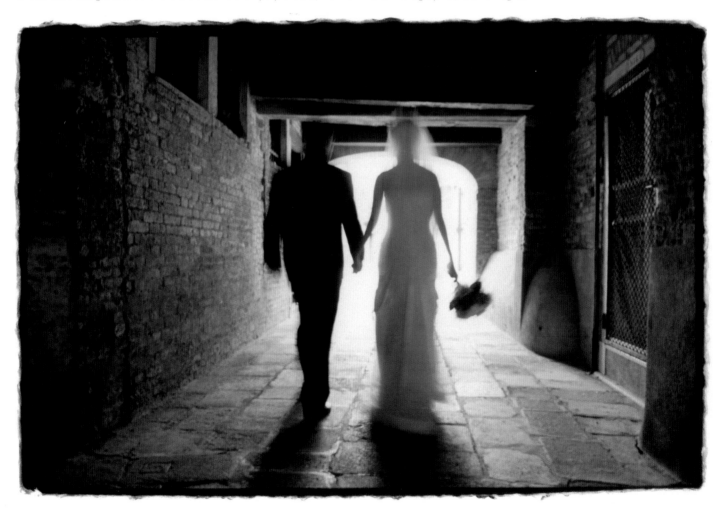

Above: When all is done and it's time to leave, there is always one more picture to be made. This one by Joe Photo is pure magic.

The Changing Face of Wedding Albums

The big payoff of the wedding day is the album. It's what every wedding photographer has worked so hard to produce and it is the object that the couple will cherish for a lifetime. The wedding album is changing drastically, as you will see. Still, album design is basically the same thing as laying out a book, and there are some basic design principles that should be followed.

Like any good story, a wedding album has a beginning, a middle and an end. For the most part albums are layed out chronologically. However, there are now vast differences in the presentation, primarily caused by the digital page-layout process. Often, events are jumbled in favor of themes or other methods of organization. There must be a logic to the layout, though, and it should be apparent to everyone who examines the album.

■ LEFT- AND RIGHT-HAND PAGES

Look at any well-designed book or magazine and study the images on the left- and right-hand pages. They are decidedly different but have one thing in common. They lead the eye into the center of the book, commonly referred to as the "gutter." These photos use the same design elements pho-

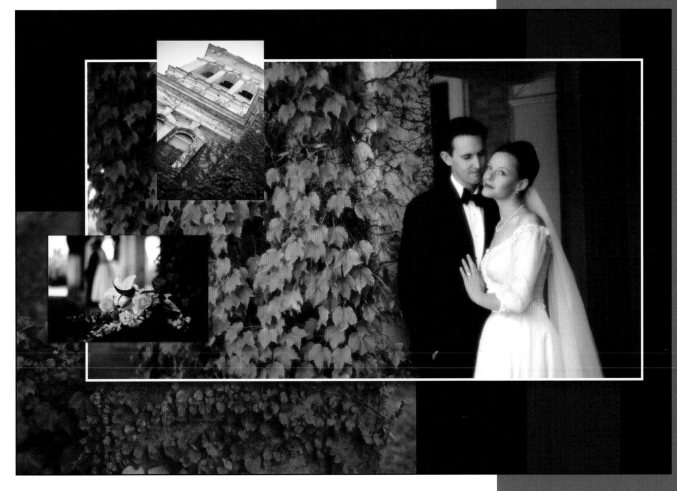

When David Anthony Williams designs composite images for his albums he is conscious of how the page elements work together. Here, the primary image of the bride and groom is designed to be a right-hand page facing in. The "gutter" is basically negative space—a little to the left of the column. The left-hand page features three images that take your eye from the bottom to the middle to the top and back across to the right-hand page. The photos are about greenery, architecture and the beauty of the wedding surroundings. Each image is interesting in itself and as part of the layout.

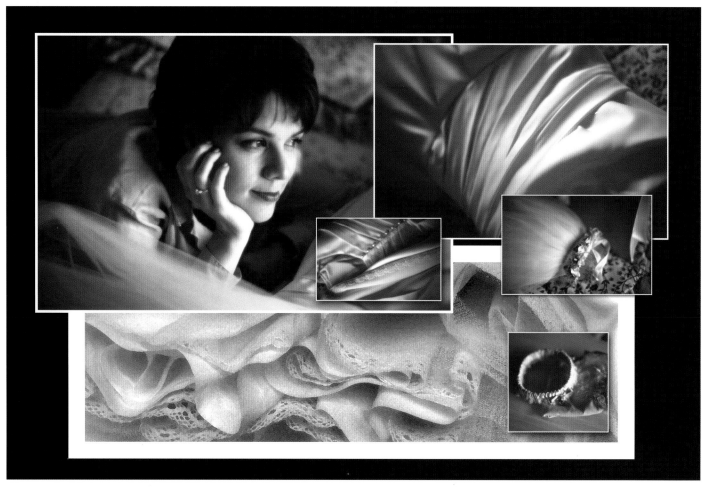

tographers use in creating effective images—lead in lines, curves, shapes and patterns. If a line or pattern forms a "C" shape, it is ideal for the left-hand page, since it draws the eye into the gutter and across to the right-hand page. If an image is a backward "C" shape, it is ideal for the right-hand page. Familiar shapes like hooks or loops, triangles or circles are used in the same manner to guide the eye into the center of the two-page spread and across to the right-hand page.

There is infinite variety in laying out images, text and graphic elements to create this left and right orientation. A series of photos can be stacked diagonally, forming a line that leads from the lower left-hand corner of the left page to the gutter. That pattern can be mimicked on the right-hand page, or it can be contrasted for variety. For instance, in the example on page 97, a

single full "bleed" (extending to the edges of the page) photo with a more or less straight up and down design produces a blocking effect, stopping the eye at the vertical within the image. The effect is visual motion— the eye follows the diagonal on the left to the vertical image on the right.

Even greater visual interest can be attained when a line or shape that is started on the left-hand page continues through the gutter, into the right-hand page and back again to the left-hand page. This is the height of visual movement in page design. Visual design should be playful and coax the eye to follow paths and signposts through the visuals on the pages.

When you lay out your album images, think in terms of variety of size. Some images should be small, some big. Some should extend across the spread. Some, if you're daring, can

Here is another winning layout by David Anthony Williams. The bride, looking far away, is dreaming about all the wonderful things she will be wearing—how beautiful they are, how much she likes them. The main image on the left-hand page starts you in the direction of the smaller images as you follow along with her daydream. Two pages designed as a "spread" usually need a unifying element that ties left to right. In this case, it is the long black & white of the folds of the dress. The tiara, the garter, the lace of the dress—each image is beautifully treated, making the whole design even more impressive.

even be hinged and extend outside (above or to the right or left) the bounds of the album. No matter how good the individual photographs are, the effect of an album in which all the images are the same size is static.

Variety can be introduced by combining black & white and color—even

on the same pages. Try combining detail shots and wide-angle panoramas. How about a series of close-up portraits of the bride as she listens and reacts to the toasts on the left-hand page, and a right-hand page of the best man toasting the newlyweds? Do not settle for the one picture per page theory. It's static and boring and, as a design concept, has outlived its usefulness.

Learn as much as you can about the dynamics of page design. Think in terms of visual weight, not just size. Use symmetry and asymmetry, contrast and balance. Create visual tension by combining dissimilar elements. Don't be afraid to try different things. The more experience you get in laying out the images for the album, the better you will get at presentation. Study the albums presented here and you will see great creativity and variety in how images are combined and the infinite variety of effects that may be created.

Remember a simple concept: in Western civilization we read from left to right. We start on the left page and finish on the right. Good page design starts the eye at the left and takes it to the right and it does so differently on every page.

■ ALBUM TYPES

Many album companies offer a variety of different album page configurations for placing horizontal or vertical images in tandem on a page, or combining any number of small images. Individual pages are post-mounted and the album can be as thick or thin as the number of pages.

A different kind of album is the bound album, in which all the images are permanently mounted to each page and the book bound professionally by a book binder. These are elegant and very popular. Since the pho-

tos are dry-mounted to each page, the individual pages can support any type of layout from "double-truck" (two bleed pages) layouts to a combination of any number of smaller images.

Digital output allows the photographer or album designer to create backgrounds, inset photos, and output the pages as complete entities. Sizing the photos does not depend on what size mats you have available, as you can size the photo infinitely on the computer. Once the page files are finalized, any number of pages can be output simply and inexpensively. Albums can be completely designed on the computer in programs like Quark XPress® or PageMaker®.

■ CHARLES MARING: THE DIGITAL ALBUM

Charles Maring describes himself as a nonfictional wedding photojournalist. He's a patient, reactive photographer who records moments unfolding rather than dreaming up an idea and then acting upon it. He feels that

every photographer has to please the families of the couple, so he and wife Jennifer segment a quarter to half hour of the day for family and couples portraiture.

His shooting style is to stay quiet and observant—but with a flair. "What separates me from other photographers is not only the photography, but also my print quality and imagination," Maring explains. By imagination, he means the digital skills of post-capture manipulation. He continues, "For example, you can sample colors from within your photograph so that every image in your album has components of that complement. You can take the time to burn or dodge, blur or soften, 'impression-ize' or desaturate, color blend or color wash, and ultimately come up with a more personal artistic interpretation of a real moment. Portrait-quality candids will be the new standard of excellence for future years of album and print competition."

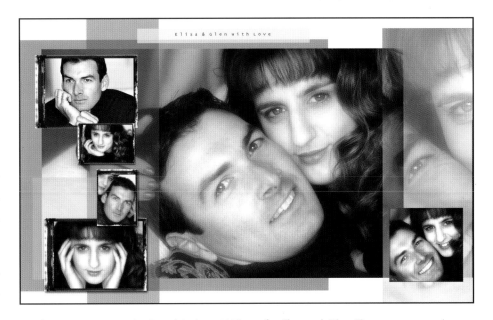

A title page composite by David Anthony Williams for Elisa and Glen. The composite is done in black & white and shows Elisa and Glen both individually and together. The piece is unified with background blocks of gray and large areas of white space. The individual images are treated with border treatments, transparent overlays and insets. The effect is mesmerizing. The panel of vertical images on the left almost reminds you of the images from a kind of very chic automated photo booth. Follow the "S" curve in the vertical panel of photos from bottom to top.

Pages 100–105 show randomly selected pages from an eighty-two-page album by Charles Maring. This album was selected as the Grand Award Album of the Year, 2001, by WPPI.

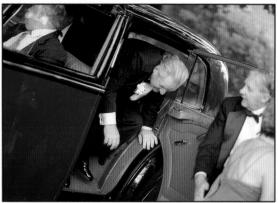

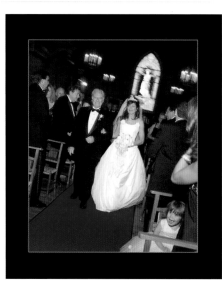

The photos on these pages are by Charles Maring.

Maring relishes these new capabilities. He is able to detail his product above and beyond the results of standard retouching, and offer creative new products for his clients. Today, every image that leaves Maring's studio is digital. Whether they capture the image with their Nikon D1s or scan the negative taken with their Hasselblads on an Imacon scanner, Maring believes there is no substitute

for print quality. "More than anything else, I watch my clients leave our studio feeling like they have finally received the product and the service that other studios simply failed to be able to offer." His clients are happier and so is he! "There is only one problem—workflow. I was doing all of the work myself, and to top it off I had to pay a higher price for digital printing than analog."

Because of digital technology, Charles Maring is now a graphic artist, a photographer, a designer and a printer. "A digital lab has little maintenance so I can hold my tolerances to a higher standard than a pro lab that is rushing to get orders out," he says. "Having a complete understanding of my capabilities has also raised the value of my work. The new photographer that embraces the tools of design will

simply be worth more than a mere cameraman or camerawoman," he says.

Here are some goals that Maring tries to use in his album designs.

Keep it Simple. Each page should either make a simple statement or tell a simple story. Don't try to clutter pages with too many photographs. On the contrary, try to narrow the focus and utilize the photographs that make the best statement of the moment.

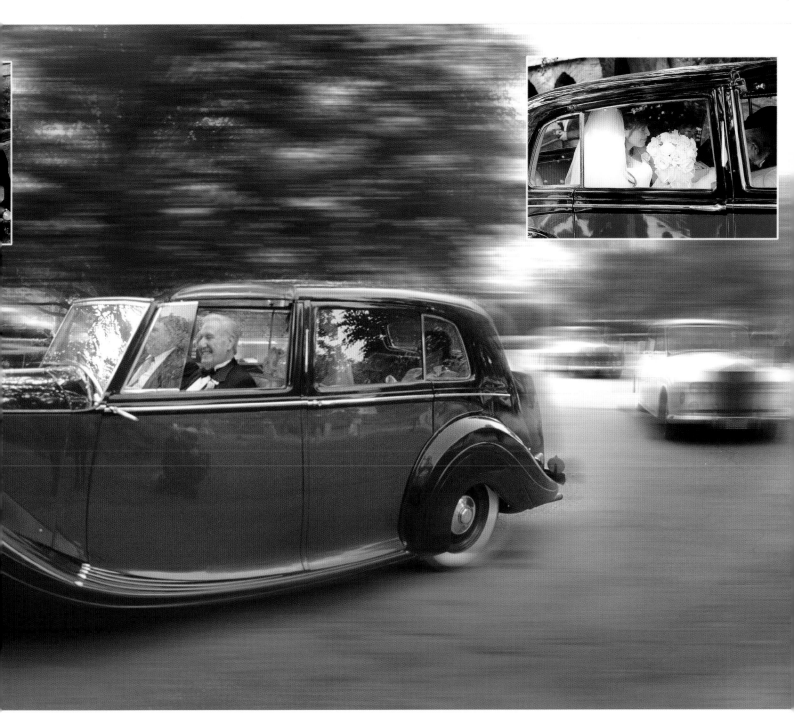

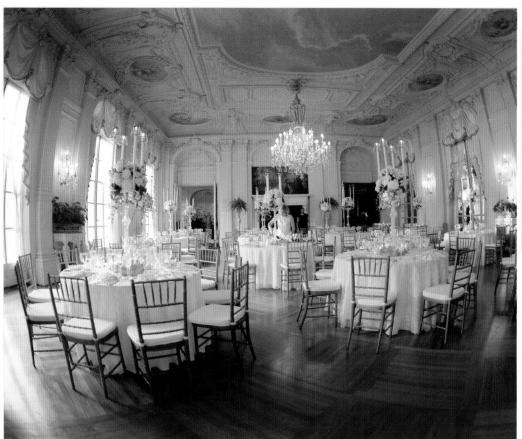

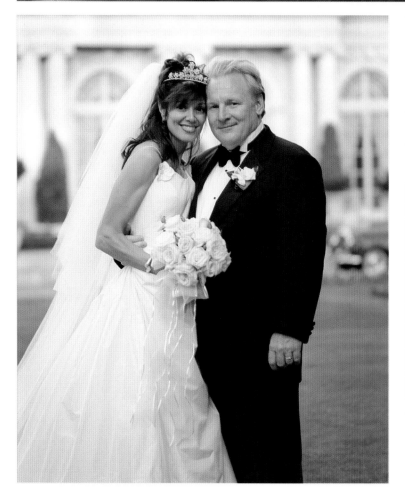

The photos on these pages are by Charles Maring.

Dream a Little. When the only tool was film, one had to settle for photographs that only showed how a still camera could capture a scene. We now have tools like motion blur, Gaussian blur and even smart blur, and film "looks" that we could never have used before. We have old films, new films, grainy films and ultrasharp films all within one digital capture—if you dream a little. Now, Maring says he thinks more like a cinematographer—he considers the moment he sees on the computer screen and creates what it truly looked like. This is not fiction, it is design around the best depiction of the moment.

Chapters in a Book. Every story has chapters. Maring tries to place scene setters that open and close each chapter. Within the chapters he

includes a well-rounded grouping of elements such as fashion, love, relationships, romance, preparation, behind the scenes, and ambiance. These are the key elements that he

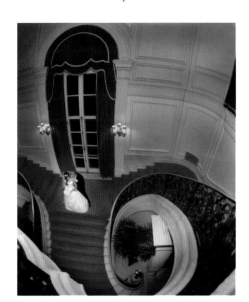

keeps in mind at all times, both when documenting the day as well as when designing the story.

Become a Painter. Charles Maring has spent time studying both new

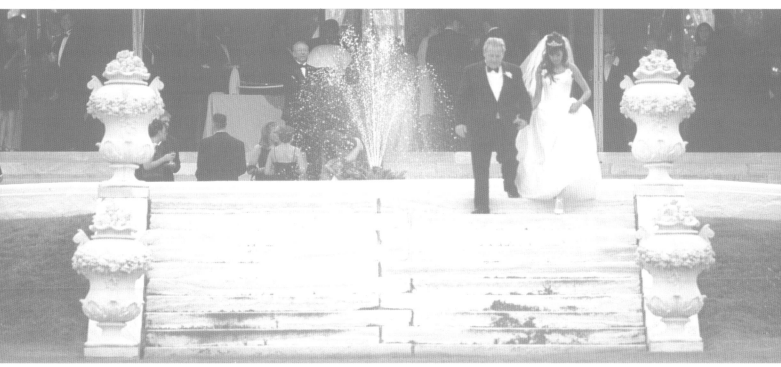

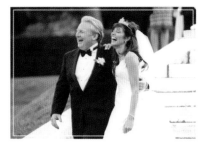
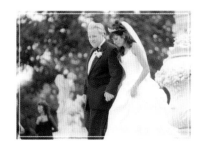

and old painters. He discovered that the rules we apply to photography get destroyed in art because in art there are no rules. In some of the most incredible paintings with depth and dimension, for example, the artist would blow out the highlights of the scene, or possibly saturate small areas of the leaves in a tree, or maybe exaggerate an element to bring a statement to life. Artists think about the details. Maring now finds himself stepping out of the photographic box and using the painterly tools to work the print to its full potential. Art has no limits and no rules and he believes that if the traditionalists of our industry could see the true art form that is developing through digital, they would see the light of a truer art form.

■ VLADIMIR BEKKER:
COLLECTIONS, NOT ALBUMS

Creativity and high-quality products are the keys to this Canadian wedding photographer's success. He believes in delivering the best service so clients will keep coming back and referring their friends and relatives. To create wonderful wedding albums, Vladimir uses a variety of focal-length lenses, including the fisheye and a panoramic camera. He also shoots color, black & white, and infrared, to produce the ultimate variety in his images. "I can switch from black & white to color in seconds, because I carry an extra film back in a pouch on my belt. The subject may have a similar pose, but the different film and focal length creates a whole new look. Suddenly, I have two different images. Hopefully, the bride will like them both. Concord's philosophy is to give clients as much variety as possible, believing that greater variety creates greater customer satisfaction and more sales.

Clients select from between 200 to 500 proofs, depending on the cover-

age they buy. Some upscale, final albums contain over 100 different-sized candid and posed images, including panoramas, instead of one large print per page. Clients also have the option of purchasing "collections," rather than traditional packages. In these collections, the actual books are included and the album prints undergo scrupulous negative and print retouching, finished with a lacquer spray or lamination. Bekker's goal is to tell a complete wedding-day story in each bride's album, creating a priceless keepsake. He recalls one bride commenting: "Once I received my superbly designed album, I don't remember looking back at the proofs again."

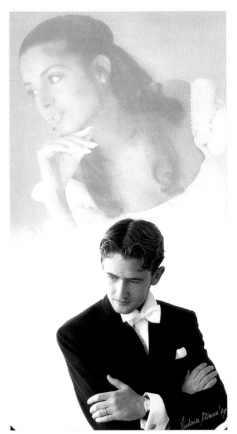

Pages 106–8 show randomly selected pages from award-winning albums by Vladimir Bekker.

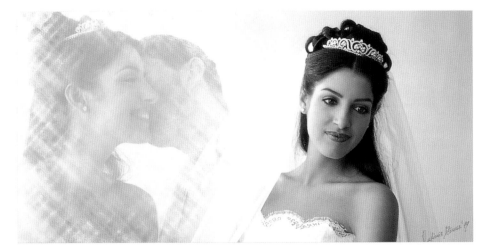

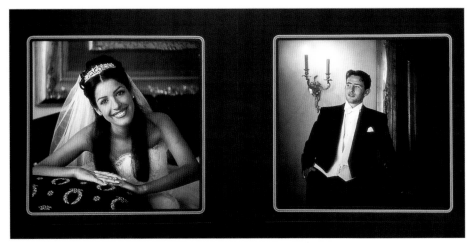

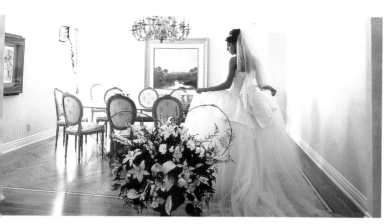
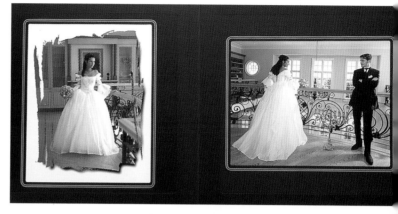
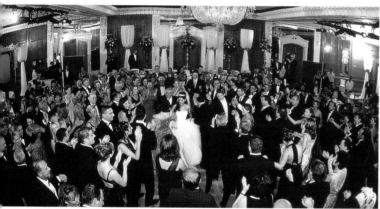
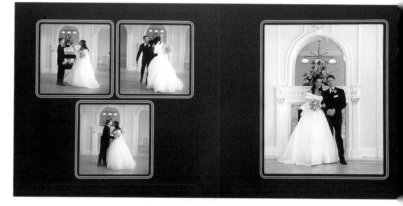
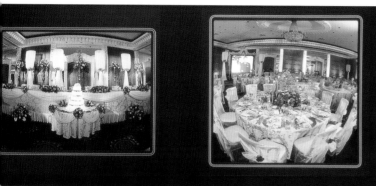
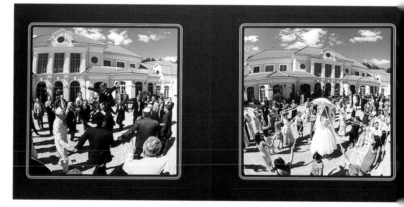
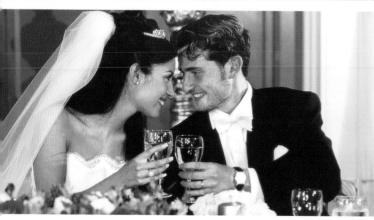
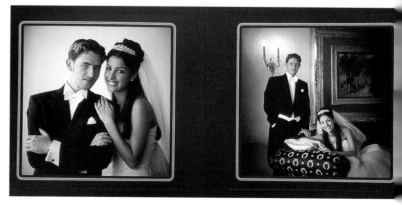

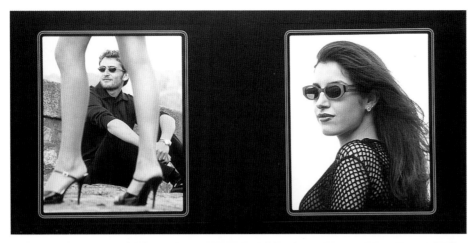

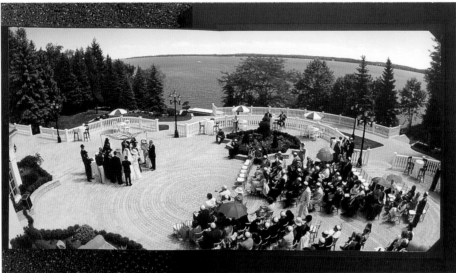

One of the fascinating things about Bekker's "collections" is that each image stands on its own as a strong and independent image.

and Zookbinder traditional wedding albums. However, the digital wedding albums by White Glove and Graphi-Studio, which the Greers sell as "European Art Books," are very popular because they are so unique.

White Glove albums are painstakingly designed and published in QuarkXPress. Both Larry Crandall and Paul Thompson, White Glove's principals, have input on the design and layout and offer suggestions and guidance as to composition, layout, graphics and color. Every layout tool is at White Glove's disposal, including drop shadows, edge effects, hand tinting, washes and just about every trick in the book available to a graphic designer. But the books are not gimmicky, they are elegant and impressive.

As of January 2002, White Glove now offers books, known as E-series books, produced with paper from the new Epson Gemini printer. These papers and inks used in the Gemini system are much closer to archival than any previous inkjet system. Photographers are able to print their own pages and send them to White Glove for binding into a book. Or, they can send everything to the company and White Glove will design and create the book. To help photographers, they are even offering a new "drag and drop" software program whereby the photographer can sit down with the client and design the book him- or herself, with the client's input.

Because Kelly Greer's The Gallery offers digital imaging services, traditional proof albums are a thing of the past. They use the ProShots system to present wedding images to their clients. Using a laptop and large-screen TV, Kelly shows couples their wedding photographs in their specially decorated wedding sales room. They go through the presentation;

The wedding coverage usually begins at the bride's and groom's homes, followed by the ceremony. Bekker carefully plans the site of the main photo session. This location should reflect the couples' personalities, as well as provide a variety of images for the final book. Throughout the event, Bekker is previsualizing the final product. Instead of just shooting the candid

event, he goes one step further and also captures the reaction of the crowd to the event.

■ KELLY GREER: EUROPEAN ART BOOKS
Kelly Greer of Lexington, Kentucky co-owns The Gallery studio with her mother, Winnie Greer. Kelly specializes in engagement portraits and weddings. The Gallery offers Art Leather

KATY
JOHN

17 April 1999

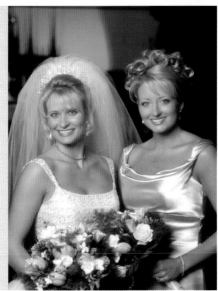

This beautiful Kelly Greer album was designed and produced by GraphiStudio, a company that works with Kelly Greer's The Gallery to produce fine digital bound albums. Sample pages are shown on pages 109—11.

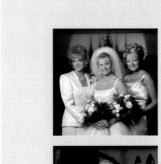

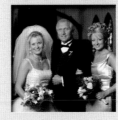

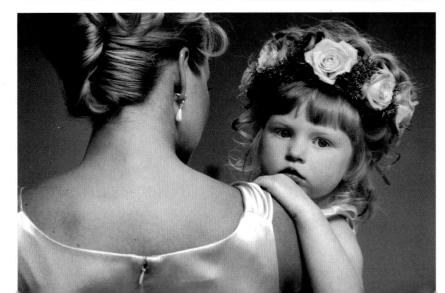

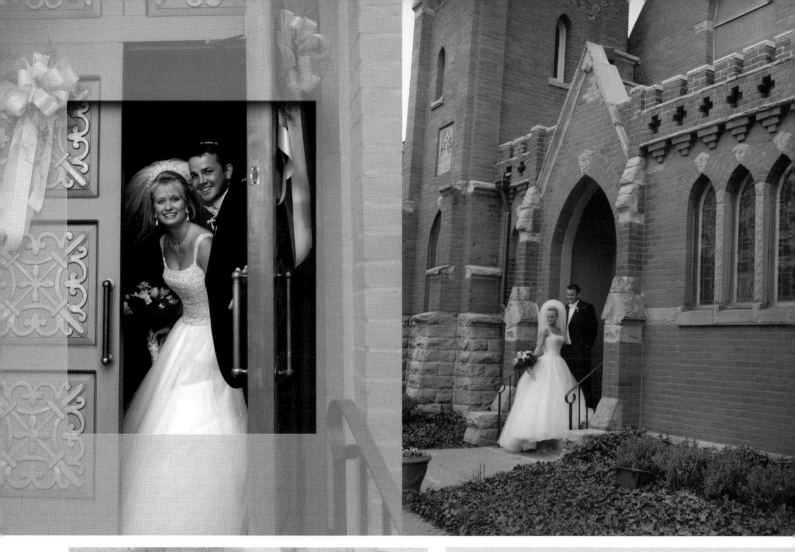

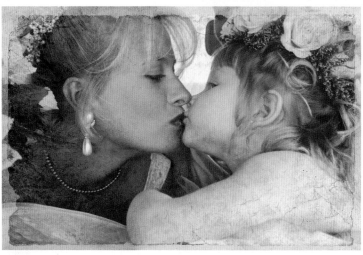

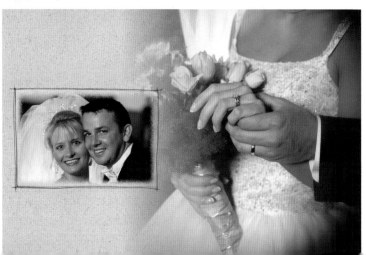

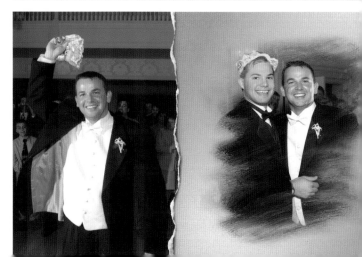

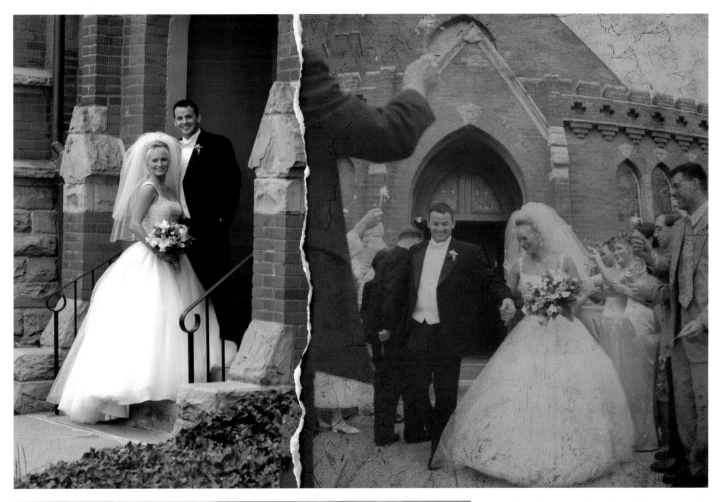

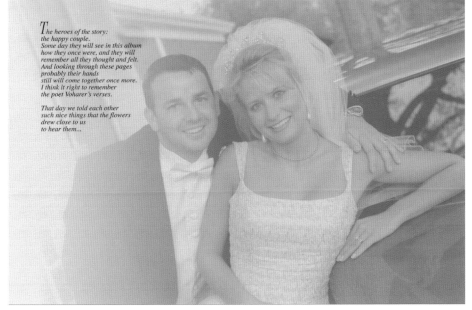

*The heroes of the story:
the happy couple.
Some day they will see in this album
how they once were, and they will
remember all they thought and felt.
And looking through these pages
probably their hands
still will come together once more.
I think it right to remember
the poet Voharer's verses.*

*That day we told each other
such nice things that the flowers
drew close to us
to hear them...*

then, after that first viewing, she helps them design and lay out their album. At that time, the wedding images are released to their web site. All the couple's friends and family members, including parents, order online. In preparation for this, they pass out business cards at the reception. These feature the couples' web site address and password.

When people call to inquire about Kelly's work, she refers them to the web site where they can see samples of her images and her wedding rates. If they like what they see, and it fits their budget, she asks that they call back and make an appointment to visit the studio. Other photographers may disagree with that approach, but, according to Kelly, it saves her a lot of time and energy.

■ MICHAEL AYERS: THE KING OF POP
Michael Ayers' albums are not the ordinary "stick-in-the-prints-and-mats" type of albums; he decided a long time ago that if his studio was to compete in the market, they would have to make a practice of being both different and better. Their books reflect that principle in many ways. Many of their pages are interactive and

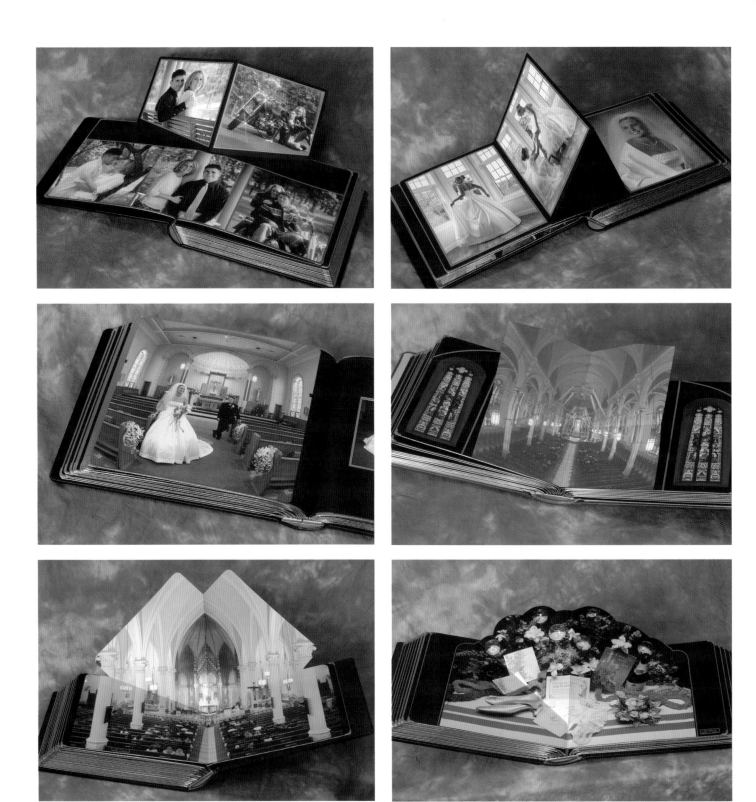

Michael Ayers' albums (pages 112–14) are typically mind-benders. He employs an architectural and engineering background to construct pages that are known as stand-ups, step-ups, A-frames, double fold-outs, panorama pop-ups, multi step-ups, plus variations on each type. He also produces beautiful hand-painted accents on the pages. While most albums are not "architectural" in their entirety, he usually includes at least a few to give the album that "wow" factor.

visually stimulating. Ayers offers pages that pop up and fold open, spring out and stand vertically, forming a myriad of intricate designs. Some pages even play musical melodies!

Michael and Pam Ayers shoot every wedding as if it were their own. Michael says, "As photographers,

we're in charge of peoples' memories. Thinking of our job that way puts greater value on the services we provide. We're not just shooting another wedding. We treat each wedding as special as those involved feel it is."

They provide every possible service during the event, from formally posed

photographs to candid, photojournalistic moments. "For me to photograph a wedding in just one style would be

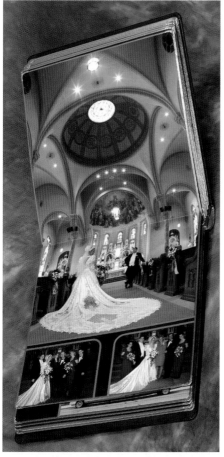

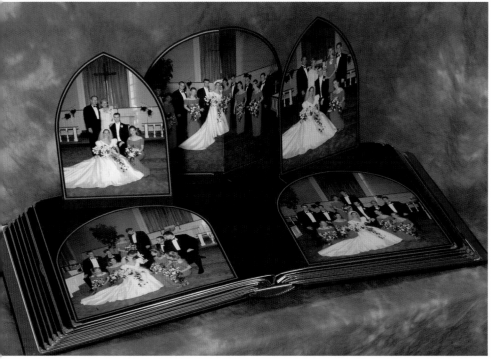

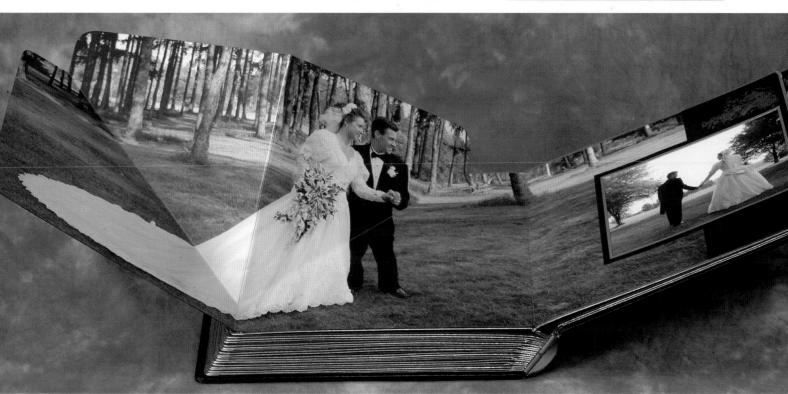

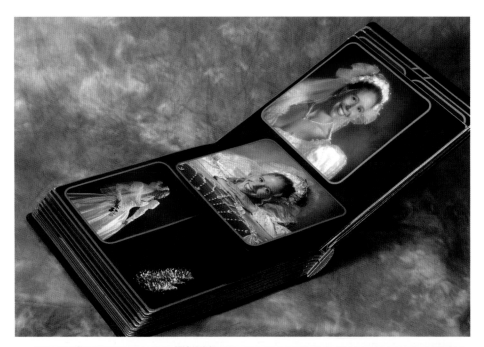

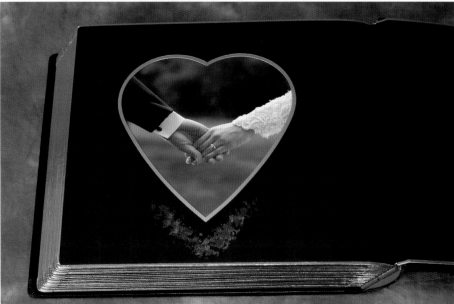

Samples from Michael Ayers' mind-bending architectural albums.

too limiting. That approach would be as confining as being limited to one camera format and one lens. We use eight different cameras at the wedding, with a variety of lenses and film types. We even use digital cameras so we can load the photographs onto our web site after the wedding."

Above all, the couple is always trying to improve, and think of new concepts for their books. It helps them to visualize the album pages on the day of the wedding. "Remember," Michael says, "you are building your wedding albums every time you expose the film!"

■ DAVID ANTHONY WILLIAMS:
A MAJESTIC APPROACH

One of the elements David Anthony Williams brings to his wedding albums is pure life. His album pages are living, moving entities. This design philosophy is the same as his theory about wedding photography. "If you've studied and practiced posing, observed lighting and learned to assess an environment, you're halfway there. But how good are the images going to be if your priorities are with the technical, and not with the activity and life happening before you?"

Williams is practiced at the art of image construction. He says, "Advertising photographers deal with them every day. But still we come back to the essential of a people picture that goes far beyond technique. And that is the photographer giving life to the creation they have assembled." His image constructions, for example, might be of the many faces of the bride's emotions, with the wedding dress as a blurry backdrop and inset photos defining her many moods. Or he might do a montage of details—the ring, the flowers, the fabric of her dress—and combine them with a pensive portrait of the bride, imagining these things. His image constructions are works of art in themselves, but when combined with the simple and elegant images, which he often lets stand alone in the album, you have an overwhelming sense of the joy and emotion of the day.

Williams also uses the technique of providing a series of eight or twelve identically sized images across two pages—a window-frame effect at first glance. The pages are laid out in perfect, brutal symmetry. However, the motion and direction come from the elements within the pictures or the content of the pictures.

He will also contrast this symmetry by creating a series of vertical image constructions within the horizontal space of the album page. Almost like raindrops, these panels beckon your attention—to examine both the content of the images and the overall flow of the design. They contrast the stark-

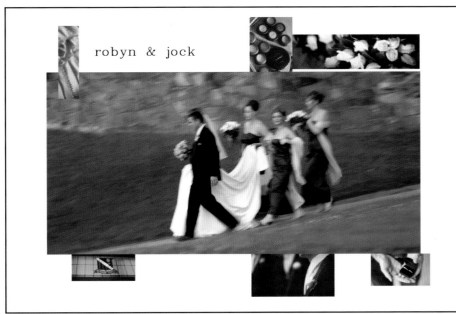

robyn & jock

David Anthony Williams' albums (shown on pages 115–117) are a delight. Pages are often organized around themes of "good luck" or architecture or sometimes pages are just composed of details that would go unobserved by most. He often uses different border treatments and will just as often take the window frame approach, laying out twelve small images across two pages.

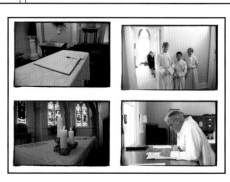

Samples from David Anthony Williams' albums are shown on pages 115–117.

ness of the white horizontal space, giving the page a startling quality.

Williams studies the great editorial portraits of our time, citing *Vanity Fair* as the ultimate in this genre. He says these portraits teach us the importance of interaction and communication between photographer and subject. He sums up his outlook this way: "The coming together of all our abilities makes us great photographers. But the absence or minimization of life in our subjects makes us professionally adequate."

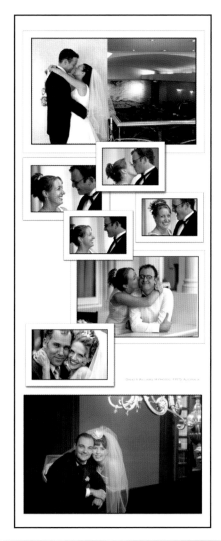

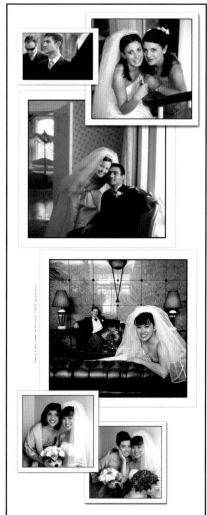

Glossary of Terms

Angle of incidence. The original axis on which light travels. The angle of reflection is the secondary angle light takes when reflected off of some surface. The angle of incidence is equal to the angle of reflection.

Balance. A state of visual symmetry among elements in a photograph.

Barn doors. Black, metal folding doors that attach to a light's reflector; used to control the width of the beam of light.

Bleed. A page in a book or album in which the photograph extends to the edges of the page.

Bounce flash. Bouncing the light of a studio or portable flash off a surface such as a ceiling or wall to produce indirect, shadowless lighting.

Box light. A diffused light source housed in a box-shaped reflector. The bottom of the box is translucent material; the side pieces of the box are opaque, but they are coated with a reflective material such as foil on the interior to optimize light output.

Broad lighting. One of two basic types of portrait lighting in which the key light illuminates the side of the subject's face turned toward the camera.

Burning-in. A darkroom or computer printing technique in which specific areas of the image are given additional exposure in order to darken them.

Butterfly lighting. One of the basic portrait lighting patterns characterized by a high-key light placed directly in line with the line of the subject's nose. This lighting produces a butterfly-like shadow under the nose. Also called paramount lighting.

Catchlight. The specular highlights that appear in the iris or pupil of the subject's eyes reflected from the portrait lights.

Color temperature. The degrees Kelvin of a light source or film sensitivity. Color films are balanced for 5500°K (daylight), or 3200°K (tungsten) or 3400°K (photoflood).

Cross-lighting. Lighting that comes from the side of the subject, skimming facial surfaces to reveal the maximum texture in the skin. Also called side-lighting.

Depth of field. The distance that is sharp beyond and in front of the focus point at a given f-stop.

Depth of focus. The amount of sharpness that extends in front of and behind the focus point. Some lenses' depth of focus extends 50 percent in front of and 50 percent behind the focus point. Other lenses vary.

Diffusion flat. Portable, translucent diffuser that can be positioned in a window frame or near the subject to diffuse the light striking the subject.

Dodging. Darkroom or computer printing technique in which specific areas of the print are given less print exposure by blocking the light to those areas of the print, making those areas lighter.

Double truck. Two bleed pages, a left and right page combined. Usually a panoramic or long horizontal image is used to "bleed" across the two pages. The photo goes to the edges of the pages.

Dragging the shutter. Using a shutter speed slower than the X-sync speed in order to capture the ambient light in a scene.

E.I. Otherwise known as exposure index. The term refers to a film speed other than the rated ISO of the film.

Feathering. Misdirecting the light deliberately so that the edge of the beam of light illuminates the subject.

Fill card. A white or silver-foil-covered reflector used to redirect light back into the shadow areas of the subject.

Fill light. Secondary light source used to fill in the shadows created by the key light.

Flash-fill. Flash technique that uses electronic flash to fill in the shadows created by the main light source.

Flash-key. Flash technique in which the flash becomes the main light source and the ambient light in the scene fills the shadows created by the flash.

Flashmeter. A handheld incident light meter that measures both the ambient light of a scene and when connected to an electronic flash, will read flash only or a combination of flash and ambient light. They are invaluable for determining outdoor flash exposures and lighting ratios.

Focusing an umbrella. Adjusting the distance between the light source and inside surface of an umbrella in a light housing to optimize light output.

Foreshortening. A distortion of normal perspective caused by close proximity of the camera/lens to the subject. Foreshortening exaggerates subject features—noses appear elongated, chins jut out and the backs of heads may appear smaller than normal.

45° lighting. Portrait lighting pattern characterized by a triangular highlight on the shadow side of the face. Also known as Rembrandt lighting.

Full-length portrait. A pose that includes the full figure of the model. Full-length portraits can show the subject standing, seated or reclining.

Gobo. Light-blocking card that is supported on a stand or boom and positioned between the light source and subject to selectively block light from portions of the scene.

Gutter. The inside center of a book or album.

Head-and-shoulders axis. Imaginary lines running through shoulders (shoulder axis) and down the ridge of the nose (head axis). Head and shoulder axes should never be perpendicular to the line of the lens axis.

High-key lighting. Type of lighting characterized by a low lighting ratio and a predominance of light tones.

Highlight brilliance. Refers to the specularity of highlights on the skin. A negative with good highlight brilliance shows specular highlights (paper base white) within a major highlight area. Achieved through good lighting and exposure techniques.

Hot spots. (1) A highlight area of the negative that is overexposed and without detail. Sometimes these areas are etched down to a printable density. (2) The center of the core of light that is often brighter than the edges of the light's core.

Incident light meter. A handheld light meter that measures the amount of light falling on its light-sensitive dome.

Key light. The main light in portraiture used to establish the lighting pattern and define the facial features of the subject.

Kicker. A backlight (a light coming from behind the subject) that highlights the hair, side of the face or contour of the body.

Lead-in line. In compositions a pleasing line in the scene that leads the viewer's eye toward the main subject.

Lighting ratio. The difference in intensity between the highlight side of the face and the shadow side of the face. A 3:1 ratio implies that the highlight side is three times brighter than the shadow side of the face.

Loop lighting. A portrait lighting pattern characterized by a loop-like shadow on the shadow side of the subject's face. Differs from paramount or butterfly lighting because the main light is slightly lower and farther to the side of the subject.

Low-key lighting. Type of lighting characterized by a high lighting ratio and strong scene contrast as well as a predominance of dark tones.

Main light. Same as key light.

Matte box. An accessory that attaches to the front of the lens and features a retractable bellows that holds filters, masks, and vignettes for modifying the image in camera.

Modeling light. A secondary light mounted in the center of a studio flash head that gives a close approximation of the lighting that the flash tube will produce. Usually high intensity, quartz bulbs.

Overlighting. Main light is either too close to the subject, or too intense and over-saturates the skin with light, making it impossible to record detail in highlighted areas. Best corrected by feathering the light or moving it back.

Parabolic reflector. Oval-shaped dish that houses a light and directs its beam outward in an even, controlled manner.

Paramount lighting. One of the basic portrait lighting patterns characterized by a high-key light placed directly in line with the line of the subject's nose. This lighting produces a butterfly-like shadow under the nose. Also called butterfly lighting.

Perspective. The appearance of objects in a scene as determined by their relative distance and position.

Reflected light meter. A meter that measures the amount of light reflected from a surface or scene. All in-camera meters are of the reflected type.

Reflector. (1) Same as fill card. (2) A housing on a light that reflects the light outward in a controlled beam.

Rembrandt lighting. Same as 45-degree lighting.

Rim lighting. Portrait lighting pattern wherein the key light is behind the subject and illuminates the edges of the subject's features. Most often used with profile poses.

Rule of thirds. Format for composition that divides the image area into thirds, horizontally and vertically. The intersection of two lines is a dynamic point where the subject may be placed for the most visual impact.

Scrim. A panel used to diffuse sunlight. Scrims can be mounted in panels and set in windows, used on stands, or they can be suspended in front of a light source to diffuse the light.

⅞ view. Facial pose that shows approximately ⅞ of the face. Almost a full-face view as seen from the camera.

Short lighting. One of two basic types of portrait lighting in which the key light illuminates the side of the face turned away from the camera.

Softbox. Same as a box light. Can contain one or more light heads and single or double-diffused scrims.

Soft-focus lens. Special lens that uses spherical or chromatic aberration in its design to diffuse the image points.

Slave. A remote triggering device used to fire auxiliary flash units. These may be optical or radio-controlled.

Specular highlights. Sharp, dense image points on the negative. Specular highlights are very small and usually appear on pores in the skin.

Split lighting. Type of portrait lighting that splits the face into two distinct areas: shadow and highlight. The key light is placed far to the side of the subject and slightly higher than the subject's head height.

Straight flash. The light of an on-camera flash unit that is used without diffusion; i.e., straight.

Subtractive fill-in. Lighting technique that uses a black card to subtract light out of a subject area in order to create a better defined lighting ratio. Also refers to the placement of a black card over the subject in outdoor portraiture to make the light more frontal and less overhead in nature.

TTL-balanced fill-flash. Flash exposure system that reads the flash exposure through the camera lens and adjusts flash output to relative to the ambient light for a balanced flash/ambient exposure.

Tension. A state of visual imbalance within a photograph.

¾-length pose. A pose that includes all but the lower portion of the subject's anatomy. Can be from above the knees and up, or below the knees and up.

¾ view. Facial pose that allows the camera to see ¾ of the facial area. Subject's face is usually turned 45-degrees away from the lens so that the far ear disappears from camera view.

Tooth. Refers to a the film surface that contains a built-in retouching surface that will accept retouching leads.

Umbrella lighting. Type of soft lighting that uses one or more photographic umbrellas to diffuse the light source(s).

Vignette. A semicircular, soft-edged border around the main subject. Vignettes can be either light or dark in tone and can be included at the time of shooting, or created later in printing.

Wraparound lighting. Soft light produced by umbrellas or softboxes that wraps around the subject producing, a low lighting ratio and open, well-illuminated highlight areas.

Watt-seconds. Numerical system used to rate the power output of electronic flash units. Primarily used to rate studio strobe systems.

X sync. The shutter speed at which focal-plane shutters synchronize with electronic flash.

Index

Other Books from
Amherst Media™

Handcoloring Photographs Step by Step

Sandra Laird & Carey Chambers

Learn to handcolor photographs with the new standard in handcoloring books. Covers a variety of coloring media and techniques with plenty of colorful photographic examples. $29.95 list, 8½x11, 112p, 100+ color and b&w photos, order no. 1543.

Family Portrait Photography

Helen Boursier

Learn from professionals how to operate a successful portrait studio. Includes: marketing family portraits, advertising, working with clients, posing, lighting, and selection of equipment. Includes images from a variety of top portrait shooters. $29.95 list, 8½x11, 120p, 123 photos, index, order no. 1629.

The Art of Infrared Photography, *4th Edition*

Joe Paduano

Practical guide to the art of infrared photography. Tells what to expect and how to control results. Includes: anticipating effects, color infrared, digital infrared, using filters, focusing, developing, printing, handcoloring, toning, and more! $29.95 list, 8½x11, 112p, 70 photos, order no. 1052

Photographer's Guide to Polaroid Transfer, *2nd Edition*

Christopher Grey

Step-by-step instructions make it easy to master Polaroid transfer and emulsion lift-off techniques . Fully illustrated every step of the way to ensure good results the very first time! $29.95 list, 8½x11, 128p, 50 full-color photos, order no. 1653.

Wedding Photojournalism

Andy Marcus

Learn the art of creating dramatic unposed wedding portraits. Working through the wedding from start to finish you'll learn where to be, what to look for and how to capture it on film. A hot technique for contemporary wedding albums! $29.95 list, 8½x11, 128p, b&w, over 50 photos, order no. 1656.

Studio Portrait Photography of Children and Babies, *2nd Edition*

Marilyn Sholin

Learn to create images that will be treasured. Includes tips for working with kids at every stage, from infant to preschooler. Features: lighting, posing and much more! $29.95 list, 8½x11, 128p, 90 full-color photos, order no. 1657.

Professional Secrets of Wedding Photography *2nd Edition*

Douglas Allen Box

Over fifty portraits are analyzed to teach you the art of professional wedding portraiture. Lighting diagrams, posing information and technical specs are included for every image. $29.95 list, 8½x11, 128p, 60 full-color photos, order no. 1658.

Photo Retouching with Adobe® Photoshop®, *2nd Edition*

Gwen Lute

Designed for photographers, this manual teaches every phase of the process, from scanning to final output. Learn to restore damaged photos, correct imperfections, create realistic composite images and correct for dazzling color. $29.95 list, 8½x11, 120p, 60+ photos, order no. 1660.

Creative Lighting Techniques for Studio Photographers

Dave Montizambert

Master studio lighting and gain complete creative control over your images. Whether you are shooting portraits, cars, tabletop or any other subject, Dave Montizambert teaches you the skills you need to confidently create with light. $29.95 list, 8½x11, 120p, 80+ photos, order no. 1666.

Storytelling Wedding Photography

Barbara Box

Barbara and her husband shoot as a team. Here, she shows you how to create outstanding candids (her specialty), and combine them with formal portraits (her husband's specialty) to create a unique wedding album. $29.95 list, 8½x11, 128p, 60 b&w photos, order no. 1667.

Fine Art Children's Photography

Doris Carol Doyle and Ian Doyle

Learn to create fine art portraits of children in black & white. Included is information on: posing, lighting for studio portraits, shooting on location, clothing selection, working with kids and parents, and much more! $29.95 list, 8½x11, 128p, 60 photos, order no. 1668.

Infrared Wedding Photography

Patrick Rice, Barbara Rice & Travis Hill

Step-by-step techniques for adding the dreamy look of black & white infrared to your wedding portraiture. Capture the fantasy of the wedding with unique ethereal portraits your clients will love! $29.95 list, 8½x11, 128p, 60 images, order no. 1681.

Photographing Children in Black & White

Helen T. Boursier

Learn the techniques professionals use to capture classic portraits of children (of all ages) in black & white. Discover posing, shooting, lighting and marketing techniques for black & white portraiture in the studio or on location. $29.95 list, 8½x11, 128p, 100 photos, order no. 1676.

Posing and Lighting Techniques for Studio Photographers

J.J. Allen

Master the skills needed to create beautiful lighting for portraits of any subject. Posing techniques for flattering, classic images help turn every portrait into a work of art. $29.95 list, 8½x11, 120p, 125 full-color photos, order no. 1697.

Studio Portrait Photography in Black & White

David Derex

From concept to presentation, you'll learn how to select clothes, create beautiful lighting, prop and pose top-quality black & white portraits in the studio. $29.95 list, 8½x11, 128p, 70 photos, order no. 1689.

Watercolor Portrait Photography

THE ART OF
POLAROID SX-70 MANIPULATION

Helen T. Boursier

Create one-of-a-kind images with this surprisingly easy artistic technique. $29.95 list, 8½x11, 128p, 200+ color photos, order no. 1698.

Corrective Lighting and Posing Techniques for Portrait Photographers

Jeff Smith

Learn to make every client look his or her best by using lighting and posing to conceal real or imagined flaws—from baldness, to acne, to figure flaws. $29.95 list, 8½x11, 120p, full color, 150 photos, order no. 1711.

Professional Secrets of Natural Light Portrait Photography

Douglas Allen Box

Learn to utilize natural light to create inexpensive and hassle-free portraiture. Beautifully illustrated with detailed instructions on equipment, setting selection and posing. $29.95 list, 8½x11, 128p, 80 full-color photos, order no. 1706.

Professional Marketing & Selling Techniques for Wedding Photographers

Jeff Hawkins and Kathleen Hawkins

Learn the business of successful wedding photography. Includes consultations, direct mail, print advertising, internet marketing and much more. $29.95 list, 8½x11, 128p, 80 photos, order no. 1712.

Photographers and Their Studios

Helen T. Boursier

Tour the studios of working professionals, and learn their creative solutions for common problems, as well as how they optimized their studios for maximum sales. $29.95 list, 8½x11, 128p, 100 photos, order no. 1713.

Traditional Photographic Effects with Adobe Photoshop

Michelle Perkins and Paul Grant

Use Photoshop to enhance your photos with handcoloring, vignettes, soft focus and much more. Every technique contains step-by-step instructions for easy learning. $29.95 list, 8½x11, 128p, 150 photos, order no. 1721.

Master Posing Guide for Portrait Photographers

J. D. Wacker

Learn the techniques you need to pose single portrait subjects, couples and groups for studio or location portraits. Includes techniques for photographing weddings, teams, children, special events and much more. $29.95 list, 8½x11, 128p, 80 photos, order no. 1722.

The Art of Color Infrared Photography

Steven H. Begleiter

Color infrared photography will open the doors to an entirely new and exciting photographic world. This exhaustive book shows readers how to previsualize the scene and get the results they want. $29.95 list, 8½x11, 128p, 80 full-color photos, order no. 1728.

High Impact Portrait Photography

Lori Brystan

Learn how to create the high-end, fashion-inspired portraits your clients will love. Features posing, alternative processing and much more. $29.95 list, 8½x11, 128p, 60 full-color photos, order no. 1725.

The Art of Bridal Portrait Photography

Marty Seefer

Give every client your best and create timeless images that are sure to become heirlooms. Seefer takes readers through every step of the bridal shoot, ensuring flawless results. $29.95 list, 8½x11, 128p, 70 full-color photos, order no. 1730.

Beginner's Guide to Adobe® Photoshop®

Michelle Perkins

Learn to make your images look their best, create original artwork or add unique effects to any image. Topics presented in short, easy-to-digest sections that will boost confidence and ensure outstanding images. $29.95 list, 8½x11, 128p, 150 full-color photos, order no. 1732.

Professional Techniques for Digital Wedding Photography

Jeff Hawkins and Kathleen Hawkins

From selecting the right equipment to building an efficient digital workflow, this book teaches how to best make digital tools and marketing techniques work for you. $29.95 list, 8½x11, 128p, 80 full-color photos, order no. 1735.

Lighting Techniques for High Key Portrait Photography

Norman Phillips

From studio to location shots, this book shows readers how to meet the challenges of high key portrait photography to produce images their clients will adore. $29.95 list, 8½x11, 128p, 100 full-color photos, order no. 1736.

Photographer's Lighting Handbook

Lou Jacobs Jr.

Think you need a room full of lighting equipment to get great shots? Think again. This book explains how light affects every subject you shoot and how, with a few simple techniques, you can produce the images you desire. $29.95 list, 8½x11, 128p, 130 full-color photos, order no. 1737.

Professional Digital Photography

Dave Montizambert

From monitor calibration, to color balancing to creating artistic effects, this book provides photographers skilled in basic digital imaging with the techniques they need to take their photography to the next level. $29.95 list, 8½x11, 128p, 120 full-color photos, order no. 1739.

Lighting and Exposure Techniques for Outdoor and Location Portrait Photography

J. J. Allen

With this book, you'll learn to meet the challenges of outdoor and location shoots with techniques that help you achieve great images every time. $29.95 list, 8½x11, 128p, 150 full-color photos, order no. 1741.

The Art and Business of High School Senior Portrait Photography

Ellie Vayo

Learn the techniques that have made Ellie Vayo's studio one of the most profitable senior portrait businesses in the US. Covers advertising, customer service, shooting, and more. $29.95 list, 8½x11, 128p, 100 full-color photos, order no. 1743.

Photo Salvage with Adobe® Photoshop®

Jack and Sue Drafahl

This indispensible book will teach you how to digitally restore faded images, correct exposure and color balance problems and processing errors, eliminate scratches and much, much more. $29.95 list, 8½x11, 128p, 200 full-color photos, order no. 1751.

More Photo Books Are Available

Contact us for a FREE catalog:

AMHERST MEDIA
PO BOX 586
AMHERST, NY 14226 USA

www.AmherstMedia.com

Ordering & Sales Information:

INDIVIDUALS: If possible, purchase books from an Amherst Media retailer. Write to us for the dealer nearest you. To order direct, send a check or money order with a note listing the books you want and your shipping address. For domestic and international freight charges, call or fax the number below, or visit us on-line at www.AmherstMedia.com. Visa and MasterCard accepted. New York state residents add 8% sales tax.

DEALERS, DISTRIBUTORS & COLLEGES: Write, call or fax to place orders. For price information, contact Amherst Media or an Amherst Media sales representative. Net 30 days.

(800)622-3278 or (716)874-4450, FAX: (716)874-4508

All prices, publication dates, and specifications are subject to change without notice. Prices are in U.S. dollars. Payment in U.S. funds only.